W9-BYG-683

Cityscapes of Boston

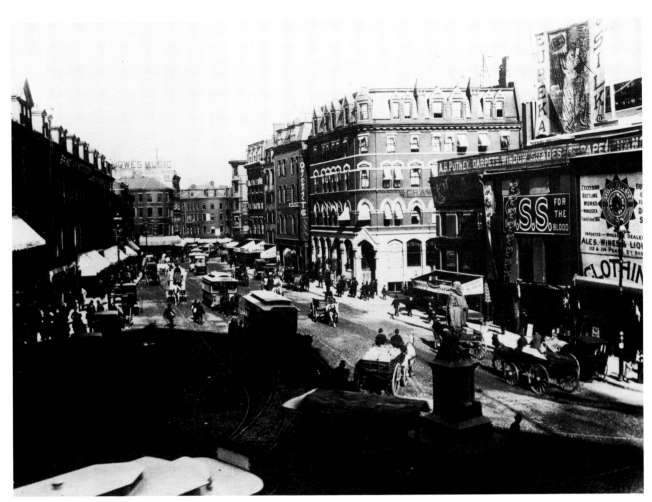

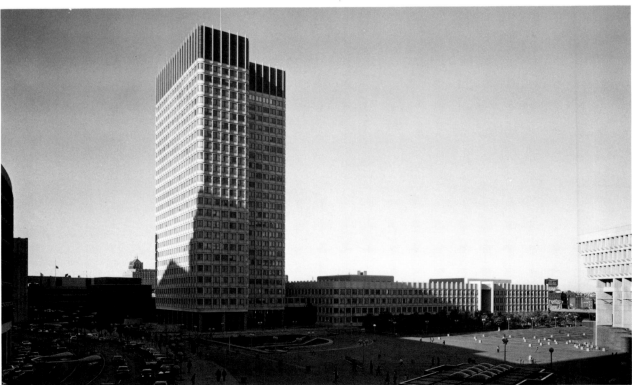

The ever-changing city: Scollay Square (1884) turns into Government Center (1991).

Cityscapes of Boston

An American City Through Time

Text by Robert Campbell
Photographs by Peter Vanderwarker

A Peter Davison Book
Houghton Mifflin Company

Boston New York

Copyright © 1992 by Robert Campbell and Peter Vanderwarker
All rights reserved

For information about permission to reproduce selections
from this book, write to Permissions, Houghton Mifflin Company,
215 Park Avenue South, New York, New York 10003.

Library of Congress Cataloging-in-Publication Data

Campbell, Robert, date.
 Cityscapes of Boston : an American city through time / text by
Robert Campbell ; photographs by Peter Vanderwarker.
 p. cm.
 "A Peter Davison book."
 Includes bibliographical references and index.
 ISBN 0-395-58119-2 ISBN 0-395-70065-5 (pbk.)
 1. Architecture — Massachusetts — Boston. 2. Boston (Mass.) —
Buildings, structures, etc. I. Vanderwarker, Peter. II. Title.
NA735.B7C36 1992 91-43513
711'.4'0974461 — dc20 CIP

Printed in the United States of America

KPT 10 9 8 7 6 5 4 3 2 1

The map on pages xii–xiii was prepared by Jacques Chazaud.

Book design by Larry Webster

For Linda Garmon, who made the place where this book happened

— Robert Campbell

To my wife, Richie, a woman of great beauty, generosity, and kindness

— Peter Vanderwarker

CONTENTS

PREFACE

T HIS IS A BOOK about Boston, but it is also a book about how to make good cities in general — and how not to make them. Ideas mean most when they are embedded in the texture of life. We think we can learn more about all cities by looking closely at one of them than by any amount of abstract analysis.

It is a book that is primarily about the physical city, not the social city nor the economic one. Those cities are equally important, but they're in much less danger of being ignored today. The physical city — the city of architecture, of bricks and streets and parks and piers and trees, the city you can move through and touch — that is our subject. We want to learn how to read it. We think it encodes a great deal of information about the people and values that built it and continue to build it.

The book grew from a series of photographic essays by the authors, published in the *Boston Globe Magazine* under the title "Cityscapes."

The method is simple. In an archive somewhere an old photograph of a scene in Boston is discovered. The photographer goes out to make a new photograph of the same scene as it appears today, taken from the same point of view. The text then comments on the pair of photographs.

Rephotographing a time-layered city like Boston in this way is exhilarating. A wonderful feeling comes when you are sure you have arrived at the exact spot where a photograph was taken fifty or one hundred years ago. Distant objects line up perfectly. There's a lot of change, but some things remain the same. Someone was *exactly* here, doing the same thing, long ago. Carefully the camera puts a new frame around an old print.

Soon the old view has an offspring. The two documents tell some truth about a city over time, even about all cities. The photographer's own offspring — a son and daughter — are perhaps posing somewhere on the street. Maybe this will all be repeated again fifty years from now.

The rephotographing must be done with a view camera, a tool so good at photographing architecture and cities that its design has not changed since 1840. The camera is too big to be held by hand, so the tripod, the photographer, and the dark cloth become part of the urban scene. People stop to watch. Soon they notice a Polaroid of the new view pinned to the camera beside a photocopy of the old. They get to look back in time right there. Often they have stories to tell.

Finding the old view is worth the hours spent searching through the fine collections of photographs that are represented in this book. Many wonderful old prints do not work when rephotographed: some pairs show too much change (Boston's West End), others not enough (Beacon Hill). Sometimes when you are looking through collections of old photos, a print will appear that eerily matches a favorite you have taken yourself: photographers' tastes do not change all that much.

The photographs tell a lot because they leave out a lot. The city looks beautiful, but it was and is smelly and dirty and noisy and hot. By ignoring all the senses but sight, the photographs help us look at what we have built. They remind us that it is never too late to imagine a better city.

Each of these pairs of portraits shows us a face of Boston recorded at two different ages. Some faces grow old gracefully, some get tarted up,

and many disappear to make way for something younger. Whatever has happened, there is usually a lesson to be drawn.

The text has been completely rewritten from the original *Globe* articles, and many of the photographs have been reshot. The essays are arranged roughly in order of the date of the buildings shown in the older photo. Thus, if the book is read from beginning to end, it should offer a fair chronology of the city, its history, and its architecture. But the book needn't be read that way. Each essay is intended to stand alone as a little fable about some aspect of the city. Most of them contain a moral, as fables often do.

To each essay a quotation is appended. These are thoughts about Boston or about design or about life that the authors happen to enjoy. We love the practice in older books of sprinkling quotations through the text, at the heads of chapters, for example. We don't necessarily agree with all of our quotations. Sometimes they are relevant to the essays they are printed with, but just as often they've flown in from left field. Like the book itself, they are meant to stimulate reflection.

Robert Campbell
Peter Vanderwarker

ACKNOWLEDGMENTS

THIS BOOK IS in no sense a work of original research. We have relied heavily on the true scholars of Boston for history and information. Many readers, too, have written us over the years with memories and sometimes corrections. This book is richer for their trouble.

The original idea for what became this book was suggested by Peter Blake in 1976. Peter has long been an expert at informing the public about the built environment.

At the *Boston Globe Magazine*, the editors and staff have done a superb job of publishing "Cityscapes" since 1983. Our thanks go to Ande Zellman and Louisa Williams, among many others.

We would like to thank Peter Davison, our publisher at Houghton Mifflin, without whom nothing would ever have happened, and our manuscript editor, Peg Anderson, whose deft improvements appear in almost every paragraph. And Erica Landry, Larry Webster, Sandy Goroff-Mailly, and Holly Bishop.

A timely grant from the Graham Foundation for Advanced Studies in the Visual Arts supported our work.

The book would not have been possible without the people and organizations that maintain the rich collections of historic photographs of Boston. These collections keep the past alive, and we would be much poorer without them. Sinclair Hitchings of the Boston Public Library saw the value of this work in the late 1970s and helped tremendously by opening up his collection. Ellie Reichlin and Lorna Condon of the Society for the Preservation of New England Antiquities were incredibly generous with time and support. Phil Bergen of the Bostonian Society researched, collected, corrected, and advised over the years, read the entire text, and suggested many improvements. He has been a constant and indispensable help. Alex Krieger read much of the text, and Benjamin Schreier of his office redrew the maps. Leslie Larson also read the entire text.

Factual information came from numerous references, guidebooks, and histories, to whose authors we owe a huge debt. Among too many to name, we cite the *A.I.A. Guide to Boston* by Michael and Susan Southworth; *Blue Guide to Boston and Cambridge* by John Freely; *Built in Boston* by Douglas Tucci; *The City Observed: Boston* by Donlyn Lyndon; *Frederick Law Olmsted and the Boston Park System* by Cynthia Zaitzevsky; *The Houses of Boston's Back Bay* by Bainbridge Bunting; *Lost Boston* by Jane Holtz Kay; *Boston: A Topographical History* by Walter Muir Whitehill; and the files and reports of the Boston Landmarks Commission, whose former director, Judy McDonough, was a frequent resource.

Finally, our thanks to the architects of Boston. They are the ones who build our dreams.

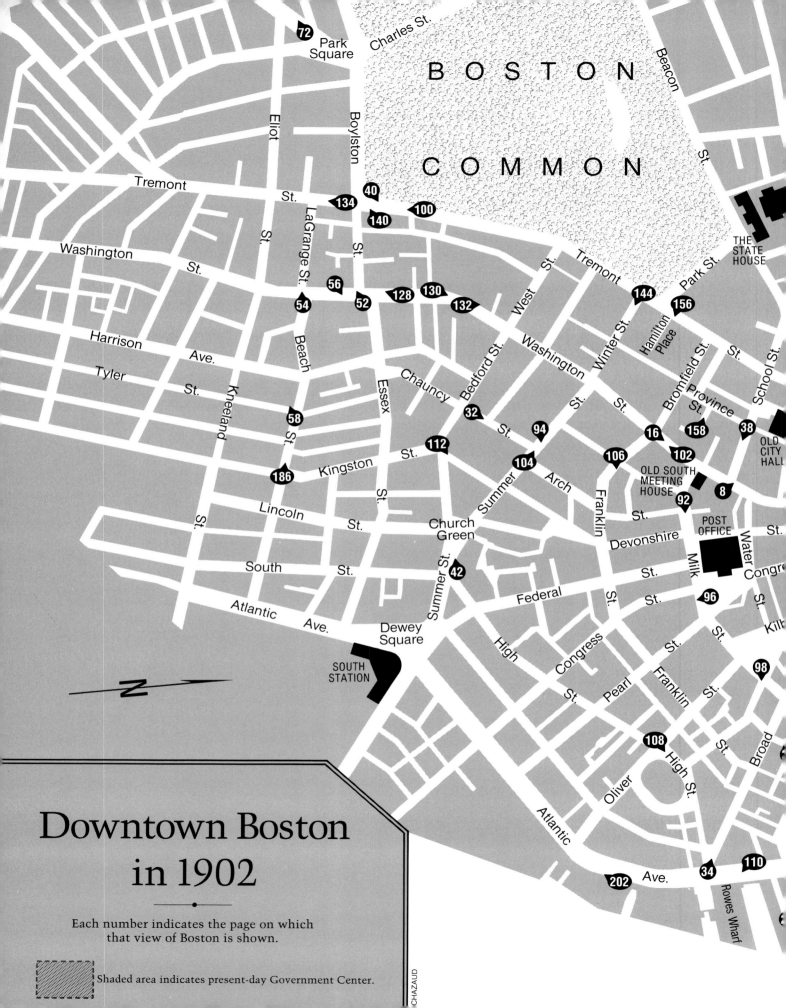

Downtown Boston
in 1902

Each number indicates the page on which
that view of Boston is shown.

Shaded area indicates present-day Government Center.

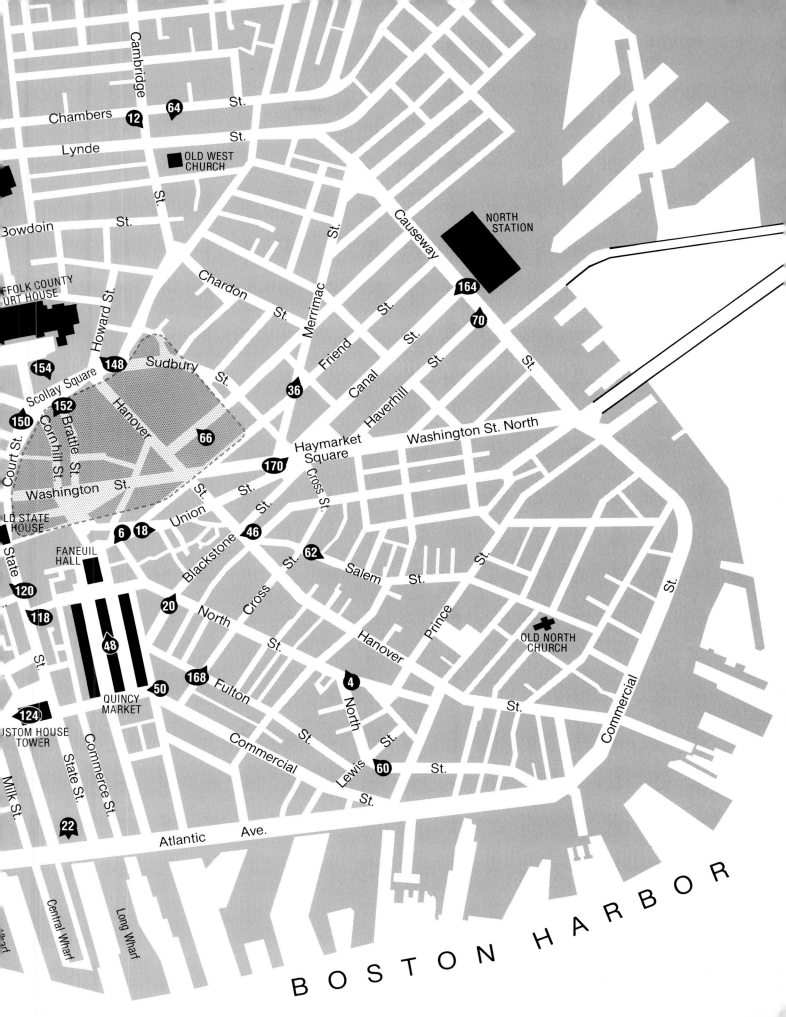

We apprehend the human condition with pity and terror not in the abstract but always in relation to a given place and time, in one particular province, in one particular country.

— Czeslaw Milosz, *The Witness of Poetry*

I

THE FIRST BOSTON

MANY AMERICAN CITIES have reshaped the geography on which they stand, but no other has done so as radically as Boston. The first Boston was clustered on a tiny tadpole of land, the Shawmut Peninsula, that clung by its tail to a vast unknown continent. William Blackstone, the earliest permanent inhabitant, arrived about 1625, half a dozen years after the Pilgrims landed at Plymouth, and built a lone house on the south slope of Beacon Hill — an attractive address ever since — near what is today the junction of Charles Street and Boston Common. In 1630 arrived John Winthrop, the first governor, with a colony of 1,800 persons, most of whom settled in Trimountaine (so called for the three peaks of Beacon Hill), which they quickly renamed Boston. The first Boston was a hill town of steep slopes and narrow twisting streets and buildings of a modest cottage scale. Nobody was ever more than a few blocks from the busy harbor, the precious source of both civilization and wealth. Gradually the hills were cut down, both to make them easier to build on and to supply landfill to extend the city's perimeter. Boston began a physical metamorphosis that has never stopped.

The landmass of Boston circa 1640

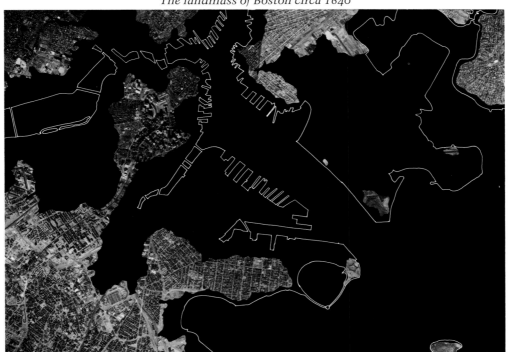

How They Used to Etch the Streets into the City

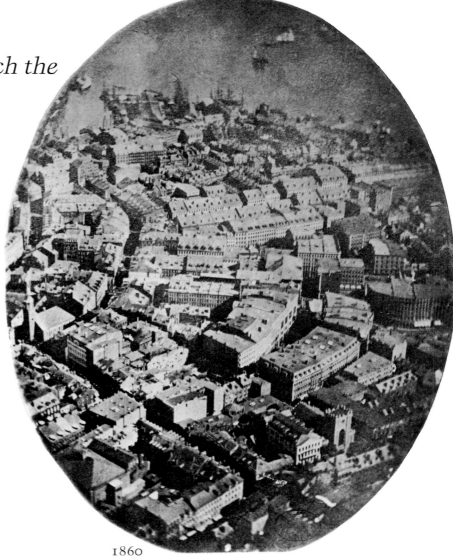

1860

THIS OLD PHOTO of Boston is a famous one. It is the first successful aerial photograph ever made of an American city. In 1860 the photographer, J. W. Black, positioned himself in a hot-air balloon tethered 1,200 feet above the streets — more than 400 feet higher than the top of the tallest Boston building of today, the Hancock Tower. The new photo was made from the same spot in 1981 by Alex MacLean.

No pair of pictures could tell us more about the history of Boston — about Boston the physical, built entity as opposed to Boston the society of people. In the old view the streets seem to be etched deeply into a solid mass of building. These streets are like the letters chiseled by a stonecutter into a block of granite. They are like the gullies a retreating flood might carve into a bank of clay.

Traditional cities were like that, made of narrow streets that twisted like tiny rivulets among close-packed buildings. As anyone knows who has walked the streets of a surviving old European town, like Siena in Italy or Córdoba in Spain or Mykonos in Greece, the experience is one of intense drama. You are always nervously rounding some mysterious corner or emerging from beneath some dark, narrow archway into the wide blaze of a public square. The city becomes a series of unexpected encounters, and your passage through it feels as rich in choices and patterns — and risks — as a dance.

The new view shows how cities have changed. Most of the street alignments survive, but now the streets are much wider and much less sharply defined at their edges. They no longer seem carved into a solid surface. What before was

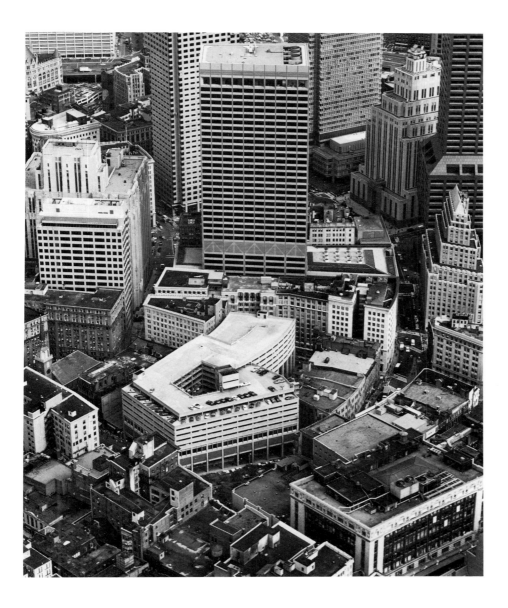

an almost continuous low mass of building has been broken up. It has become a group of taller, more separated structures that look like boxes grouped on a table. The City of Spaces is now a City of Boxes. Gone are most of those tight passageways and courtyards that once made people so intensely aware of urban space. In the modern city you're much more aware of the buildings you're looking at than of the space you're standing in.

Much of the transformation we see here can be explained by two inventions, the passenger elevator and the steel building frame — innovations that changed all cities by making possible tall buildings. Equally important, though, was a purely Boston event that occurred just a dozen years after J. W. Black's daredevil balloon ride. The Great Fire of 1872 destroyed almost every-

thing in this view, all the way out to the docks and boats in the harbor.

People today — Americans, anyway — think of Boston as a city of old buildings. Yet in fact only one, the tiny Old South Meeting House at the far left side, has survived from 1860 to the present.

Improvement makes strait roads; but the crooked roads without Improvement are roads of Genius. — William Blake

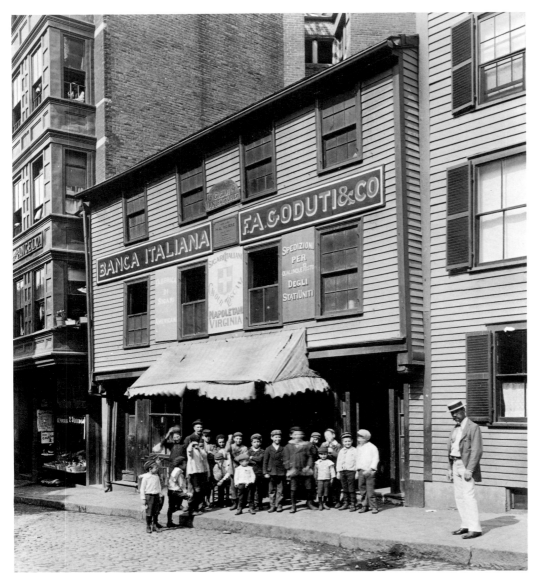

*A Revered
Old House —*

circa 1900

THE MOST FAMOUS BUILDING to survive from the first Boston is the Paul Revere House in the North End — but whether it is really a survival or only a reinvention is a question to frazzle a philosopher.

Some buildings get modernized; others get antiqued. Antiquing has been the fate of the Revere House. Most of the change took place between 1905 and 1908, when the house, threatened with demolition, was saved by a private group of citizens, the Paul Revere Memorial Association. They bought the house and restored it to an approximation of somebody's best guess as to its appearance when originally built in 1680. The "restorers" removed the house's third story, which was in place during the years the house was occupied by the famous metalsmith and patriot Paul Revere. He acquired it in 1770, when it was already almost a century old.

Today the Revere House is a museum, much visited by tourists. It is called the oldest surviving building in Boston. Such a claim addresses the very concept of identity, because little — perhaps nothing at all — remains of the physical substance of the original house.

Nevertheless, the house and its exhibits are a priceless evocation of what a dwelling in early Colonial Boston must have felt like. Its tiny, gloomy rooms are clustered for warmth around a great chimney, much as the small buildings of the first Boston clutched one another close against the thunder and danger of a vast unknown continent. Its exterior skin of wood clapboards seems tightly buttoned against the weather, with only a few small windows. Lapped over one another, these clapboards not only keep out the rain but, equally important, can be seen to do so; they not only *are* waterproof, they also *express* waterproof-

ness. And their horizontal ruled lines make a pattern on the surface of the house regardless of whether the sun is shining.

In all those ways, the Revere House prefigures much of the characteristic later architecture of New England. When New England buildings, whatever their architectural style, are responsive to the climate of the region, they tend to be made of materials, like clapboard or brick, that retain their color and pattern on gray days. (Such materials are expressive of New England in another way, too, since both clay and cedar are native.) New England buildings usually lack the kind of bold overhangs, deep voids, and richly sculpted ornaments that need bright sunshine to bring out their form and chiaroscuro. If there is decoration, it is usually flat, appearing almost to be drawn by pencil onto the building, like the lines of these clapboards. And like the Revere House, traditional New England buildings, compared to those of other American regions, tend to have an unpretentious, buttoned-up, squall-proof appearance — traits once also attributed to the native Yankee citizen.

The Revere House boasts a varied history. During the nineteenth century it served at different times as a tenement, a candy factory, and a grocery store. In this 1900 photo, it appears to be mostly a cigar factory. The group in front of it is presumably on a school outing. The new photo shows a similar group on morning recess from St. John's Parochial School, across North Square from the house.

We shall find that the God of Israel is among us, when ten of us shall be able to resist a thousand of our enemies; when he shall make us a praise and a glory, that men shall say of succeeding plantations [colonies], *"The Lord make it like that of New England."* — John Winthrop (1630)

Or Is It a New One?

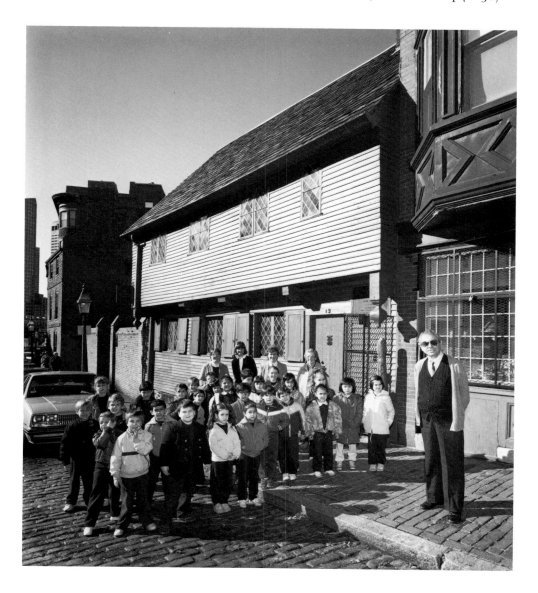

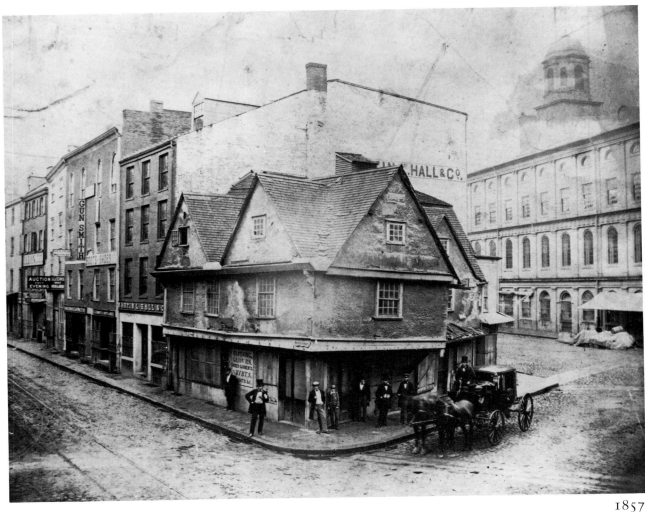

1857

A Good Motif for Sunday Painters

THE FIRST BOSTON was a place of tiny buildings that usually looked like houses, no matter what their true function.

One of them, a rare survival into the age of photography, is the many-gabled little building in the foreground of the older view. The building is believed to have been built in 1680. In its last years — it was demolished in 1860 — it was known as the Old Feather-Store after one of the many uses it had served during a long lifetime. In the photo, a sign on one wall reads, "CLOTHING, GLOVES, UNDER GARMENTS, SHIRTS, CRAVATS, C."

In its early years, before Boston Harbor was filled, the little house must have been at the very edge of the sea, almost touched by the high tide. Architecturally it looks like something that might have been built in London in the days of Queen Elizabeth. Early Boston imported its culture from England and felt itself to be very much at the end of an umbilical cord that stretched across the Atlantic to the mother country. The building, constructed with overhanging floors called "jetties," was framed in hand-hewn oak timbers and covered in cement plaster — materials and techniques that would soon be abandoned in the New World. Embedded in the plaster were fragments of broken glass and bottles, and on the surface were ornaments in diamond motifs and fleurs-de-lis.

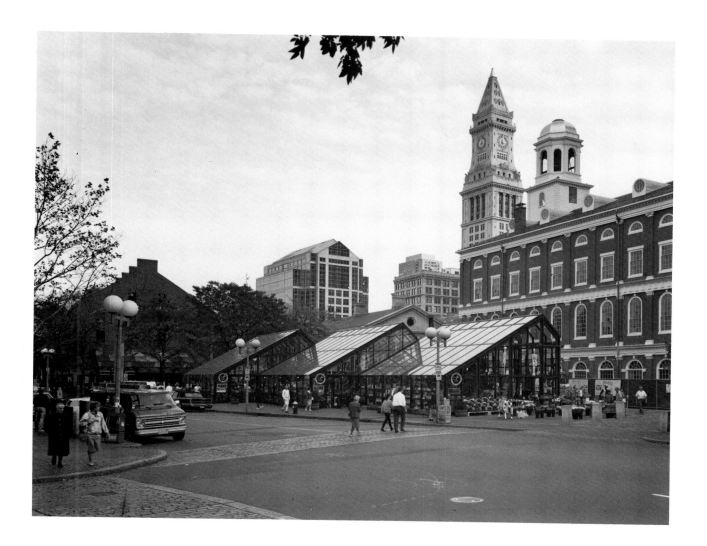

The Old Feather-Store was regarded as a landmark and was the subject of many paintings and drawings. For those who equated art with comfortable nostalgia, the store must have been appealing, rather like the picturesque red fishing shack of our own day in Rockport, Massachusetts, which Sunday painters wryly refer to as "Motif No. 1" (and which, unlike the Feather-Store, was cynically rebuilt after a collapse so it could go on posing). Probably the Feather-Store's antiquity is the reason it is being photographed here. The eight men and boys who appear self-consciously in front of it are apparently idlers, drawn by the rare sight, in 1857, of an outdoor photographer. They must be holding themselves very still to appear so unblurred.

Only one building, Faneuil Hall, survives from the old photo to the new. It is the one on the right with the cupola. The Old Feather-Store and its ramshackle neighbors have long been swept away, replaced in the mid-1970s by a crisp glass flower market designed by Benjamin Thompson Associates of Cambridge. The market's glassy gables are intended, perhaps, as an abstract, modern, ghostly remembrance of the picturesque landmark.

All beautiful lines are mechanically drawn and organically transgressed. — John Ruskin

Making the Past Visible — Maybe Too Visible

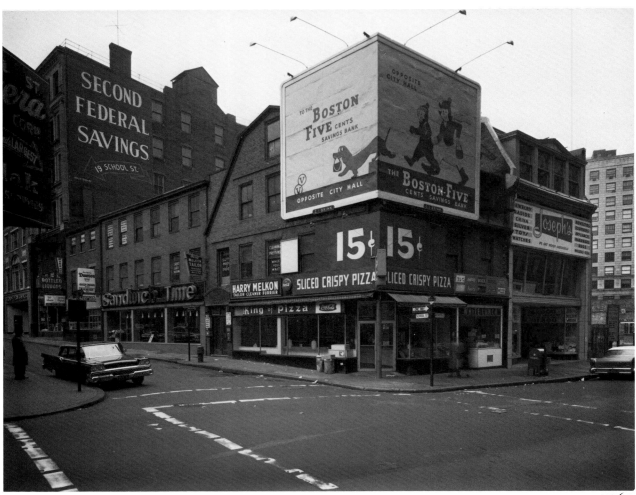

1960

Two photos of the building generally known as the Old Corner Bookstore show us how the best of intentions can museumize a city, can flatten it into something a little cleaner, a little duller than need be.

The old photo isn't very old. The year is 1960, the month October. Perhaps it's a weekend: there aren't many people around. But as is so often true in past photographs of cities, life is provided, even in the absence of people, by the signs. The signs become surrogate inhabitants of the city, talking and shouting their wares and flashing their duds. The big Boston Five billboard, obscuring windows, is a little too loud, a sort of sidewalk bully. But the other signs are engaging and sociable Especially charming is the bold "15¢ SLICED CRISPY PIZZA" sign, turning the corner with insouciant elegance.

As today's photo shows, the little pizza building wasn't as anonymous as it seemed. Built in 1711, it is one of only three eighteenth-century houses remaining in downtown Boston and is older, for example, than any surviving building at Harvard. In the nineteenth century it gained a further claim to fame as the nub of literary Boston in the city's cultural heyday. It was the premises of the famous Ticknor & Fields, publishers of the *Atlantic Monthly* magazine and of the likes of Ralph Waldo Emerson, Henry David Thoreau, and Charles Dickens.

In the early 1960s the house was threatened with demolition by so-called urban renewal. An organization called Historic Boston Inc. arose to save it. Historic Boston chose to restore the building to its approximate appearance in 1828, the year Timothy Carter remodeled it as a print shop

and bookstore. This restoration is what we see in the new photo. The restored house is again selling books — New Englandiana, mostly — as the Globe Corner Bookstore.

Certainly it was right to save the Old Corner. But it would have been better to save it without attempting to re-Colonialize it. Today it looks a little stagy, a little bland. A city is richer when the layers of time lap over one another, when the past is a shape you have to work to see, looming only vaguely through the mist of the present. In a classic book, *What Time is This Place?*, Boston planner Kevin Lynch said it best:

> There is a pleasure in seeing receding, half-veiled space or in detecting the various layers of successive occupations of the city as they fade into the past — and then in finding a

few fragments whose origins are remote and inscrutable, whose meanings lurk beneath their shapes, like dim fish in deep water.

Once an eighteenth-century house lurked like a dim fish beneath the Sliced Crispy Pizza. Hooked and dragged into the sunlight, it has lost its life and mystery.

Things aren't helped, either, by the new parking garage. Its big scale trivializes the Old Corner, making it seem too small to be real, like a dollhouse.

To lift the past to the surface by means of systematic restoration or archeological exhumation is to petrify it. — Pierre Schneider

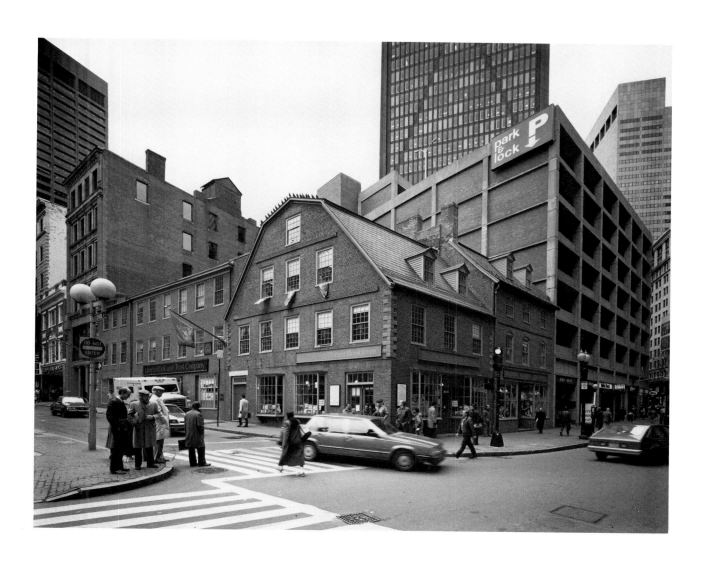

Inventing a Past in Charlestown

W<small>E CHOOSE THE PAST</small> we need, and we choose it — or perhaps we invent it — when we need it.

The 1970s arrived after two decades of disruption in America's cities. Riots, poverty, and the flight of the middle class were the symptoms of unhealth. Massive clearance and urban renewal were proving to be cures that were worse than the disease. By 1970 many Americans felt overwhelmed and disoriented. They were ready to rediscover and cherish anything they could find that looked small, old, or peaceful.

Such a place was the Warren Tavern, believed to be the oldest extant building in the town (now a Boston neighborhood) of Charlestown. Like much of Charlestown, the tavern deteriorated almost to the point of invisibility in the early part of this century. The neighborhood's population dropped from more than 40,000 people in 1900 to fewer than 16,000 in 1970. Since then Charlestown has come back. Its revival is dramatized by these two photographs of the tavern.

The biggest change is the disappearance of the blight (as well as the excitement) of the elevated railroad that screeched and roared through City Square and out Main Street from 1901 until 1975. By the time the el came down, the forgotten Warren Tavern had already been renovated. It reopened as a bar and restaurant in 1972.

The Warren Tavern spans Boston's history as do few other buildings. It was built soon after Charlestown burned in the fighting that culminated in the Battle of Bunker Hill. A leading revolutionary, Joseph Warren, died in that battle, and the tavern took the hero's name, with a painted sign of Warren flashing his finery as a

1971

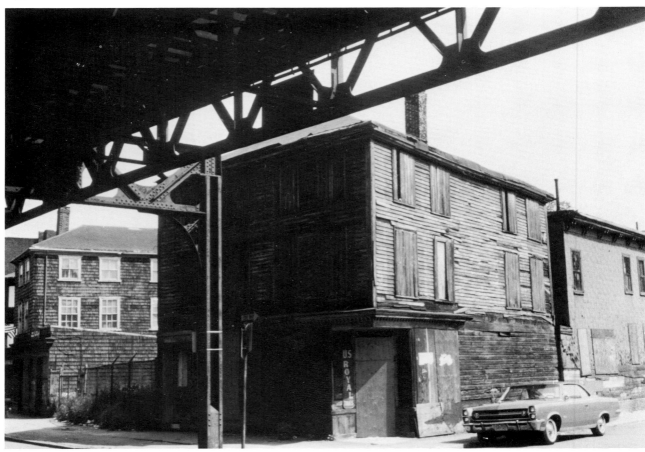

grand master of the Masons. Paul Revere, another grand master and a pal of Warren's, hosted Masonic meetings here, and George Washington visited after he had become president. In its more recent incarnation, the Warren served as the haunt of another kind of hero, the detective of television's "Spenser: For Hire."

Architecturally the Warren is a modest but characteristic example of the style known as Georgian, named after the four British kings named George, all more or less idiots, who reigned from 1720 to 1820. In America, Georgian is often called Colonial, since the future united states were British colonies during most of the Georgian era. But "Colonial" is a vague term, often extended to include two later styles more properly known as Federal and Greek Revival, both of which flourished after American independence.

Typical Georgian features of the Warren Tavern are the symmetrical boxy shape, the trim that emphasizes corners, the high, visible hipped roof, the boldly framed windows, and the little arched and gabled pediments over the two entries.

A fancier example of Georgian is visible just to the left of the Warren. This is the Timothy Thompson, Sr., house of about 1794. Several other fine eighteenth-century houses stand in the same three-block area, known today as the Thompson Triangle.

If architecture has a crisis — and I believe that it has — it is a crisis of authenticity, a crisis about locating value in an age of simulation.
— Michael Sorkin

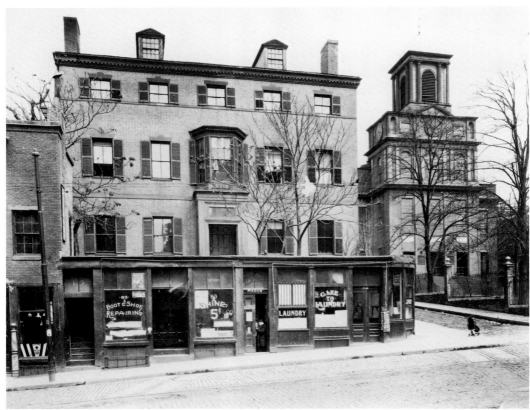

1916

Good Architecture Makes Bad Cityscape

HARRISON GRAY OTIS loved to give parties, especially in brand-new mansions. He built three houses in Boston in ten years, moving from one to another in what must have been a continual family turmoil of trunks and toasts.

John Quincy Adams, himself a noted dud at all aspects of social life, once wrote: "It has not fallen to my lot to meet a man more skilled in the useful art of entertaining his friends than Otis." When not unloading furniture, Otis found time to make a fortune in real estate and to run successfully for mayor, congressman, and U.S. senator.

We see here the first Harrison Gray Otis House, built on Cambridge Street in 1796. The others also survive nearby on Beacon and Mount Vernon streets. All three were designed by the leading architect of the day, Charles Bulfinch, who created the Massachusetts State House, Faneuil Hall, and University Hall at Harvard.

What's fascinating about these photos is the paradox that while the older view displays better cityscape, it's the new one that's supposed to be showing us great architecture.

The old view dates from about 1916. In that era the mansion was no longer a mansion but was instead serving as a rooming house, with shops at the street. The new view, from 1991, shows the house restored as if by magic to its original appearance and used as headquarters of the Society for the Preservation of New England Antiquities (SPNEA).

The 1916 incarnation is the more lovable of the two. By then the West End had long since become an entry point for immigrants. With roomers above and a laundry and shoe repair below, the Otis House participated fully in the life of the street.

That same year the Otis House was purchased by the new Society for the Preservation of New England Antiquities. Like other well-meaning philanthropies of the period, SPNEA was really engaged in the hopeless crusade of trying to preserve the myth that America was still a WASP culture, uncontaminated by newer ethnic groups. In the same decades Harvard was engaged in an Anglophiliac orgy of neo-Colonial architecture, and the Rockefellers were soon to go to work on Williamsburg in Virginia.

Bulfinch copied this first Otis House closely from a mansion he had seen in Philadelphia —

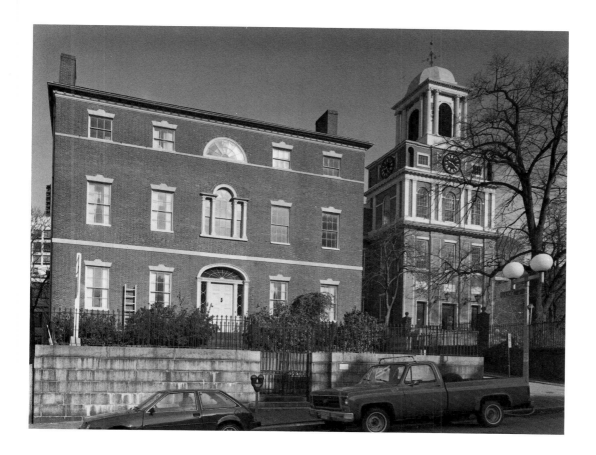

not an unethical practice in that era of pattern-book architecture. He made his own refinements, and the result is a classic example of the style called Federal (because it happened to coincide with the early years of the federal union). Federal is a light, elegant, understated style of simple shapes, flat surfaces, and delicate linear ornament. Unlike its predecessor, Georgian, it never feels massive or bulky. It derives largely from the work of the architect Robert Adam in Britain, where the style is called Adam. In America, Federal flourished from about 1790 until 1810.

The Otis House exhibits most of the Federal trademarks in a pure form. The brick façade is so flat it seems not so much built as drawn on a sheet of paper. It's a simple rectangle in shape, uncluttered by a visible roof or by any corner trim. At the entrance is the shallowest possible porch, with a flattened fanlight over the door. Above it a Palladian window at the second floor, and an arched one at the third, mark the stair landings. Such ornament as exists is slender and fleshless. This is elegant understatement carried to an extreme, the opposite of the heartier, beefier Georgian it succeeded.

Over the years SPNEA restored the Otis mansion to its original appearance, both inside and out. In 1926, when Cambridge Street was widened, the house was moved back forty feet and joined with two others on a side street. Today the ceremonial front rooms depict the life and times of Otis, the basement is a museum of architectural artifacts, and the upper and rear floors are offices for SPNEA.

To the right of the Otis House, in both photos, stands Old West Church, another Federal classic, by Asher Benjamin. In 1916 it was a branch library, but now it is again a church.

Chilly and withdrawn behind its granite wall and front lawn, the Otis House of today offers little interest or pleasure to the passer-by. It is the architectural embodiment of an elitist withdrawal from a pluralist city — though such a characterization would be quite unfair to the SPNEA of today. The Otis House is proof that high-style architecture and good cityscape can be very different things.

Kitsch is life interpreted and lived by some ideal of perfection. . . . Kitsch is taking pleasure in being moved by a mask of beauty.
— Milan Kundera

A Forgotten Masterpiece

ONE OF THE HIDDEN triumphs of Boston architecture is the Shirley-Eustis House. Built in the town (now neighborhood) of Roxbury in 1747, it was the home of not one but two governors of Massachusetts and was visited by the Marquis de Lafayette, George Washington, Benjamin Franklin, and Daniel Webster. It was a barracks and hospital for the British during the Revolution. Yet its existence is hardly known beyond the small world of historians and preservationists. In 1867 it was moved sixty feet to make way for a new street and was cut up into a dozen or more small apartments. It fell vacant in 1911 and has remained so ever since.

William Shirley built the house during his years as royal governor of the colony of Massachusetts. The designer was probably Peter Harrison, the architect of the famous King's Chapel in downtown Boston. Harrison employed the blocky, solid style of architecture known as Georgian, giving the house a high stone base, square profile, tall hip roof, and bold row of Corinthian pilasters across the front.

Damaged during the Revolution, the house was rebuilt by James Magee in about 1800. Magee was one of the shipping merchants who took over Boston from the former ruling class after the Revolution and who made quick fortunes in the China trade. Magee adapted the Georgian house to the more delicate Federal style. His architect, perhaps the celebrated Charles Bulfinch, placed thinner, more refined ornament on the outside and performed an act of remarkable fakery by raising the tops of the second-story windows higher than the ceilings of the rooms behind them, so as to give the exterior an airier, lighter

1970

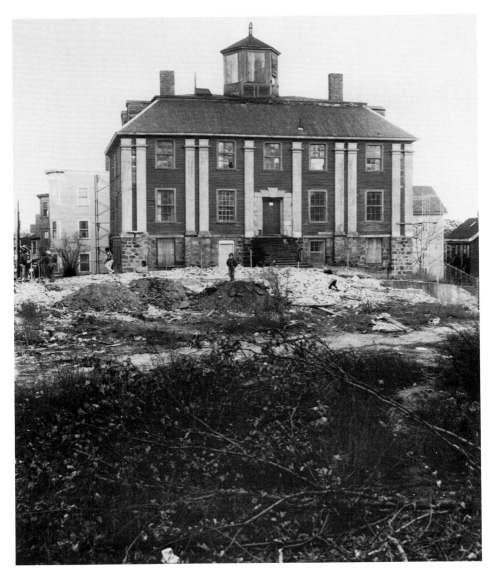

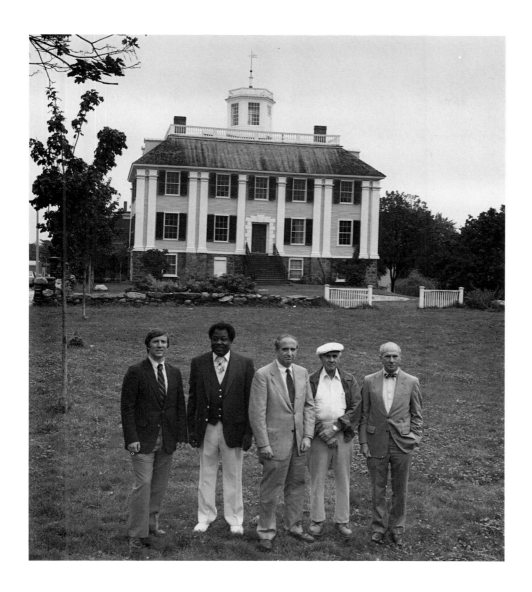

appearance. Inside, a curving stair was added to the main hall, permitting more dramatic movement during social events.

Aside from the windows, Bulfinch, if it was he, didn't do a lot that was breathtakingly original. He adjusted the language of an architectural tradition that already existed, the Federal, and he wasn't embarrassed, here or elsewhere, to reveal his debt to his predecessors. The result is a minor masterpiece.

The alterations made the house fashionable enough to attract a second governor, a former Continental Army surgeon named Dr. William Eustis, who arrived in 1819. Eustis served two terms as chief official of the Commonwealth of Massachusetts from 1823 to 1825.

The photographs show the Shirley-Eustis House as it looked in 1970 and as it looks now. Since 1970 restoration (to the Federal era) by a private group has been slow but continuous. New floors, ornamental plaster, woodwork, paint, and wallpaper have been added, all carefully authenticated by preservation experts. Donors have offered funds, furniture, and objects. Today the Shirley-Eustis House, its renovation still far from complete, is open as a museum. Some of the restorers stand on the lawn. From the left they are Frederic Detwiller, historian and director of the house association; Mannie Payne, the painter who matched the antique colors; Anthony Cassisi, the plasterer who restored the moldings and ornamental detail; David Mittell, its president; and Marlowe A. Sigal, treasurer of the association.

The greatest genius is the most indebted man.
— Ralph Waldo Emerson

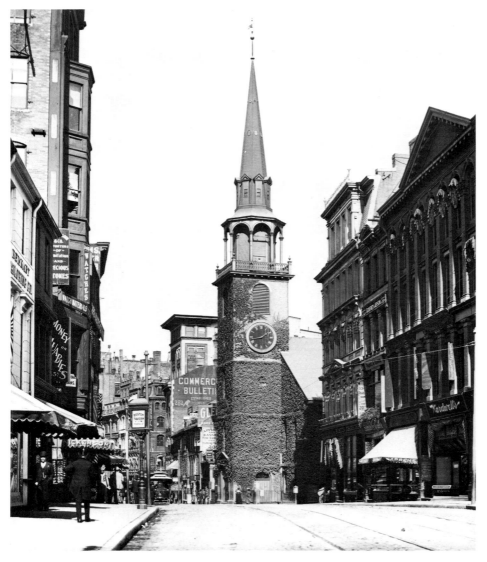

circa 1905

The Still Point of the Turning World

TIME STANDS STILL. In both photos it is 1:43 by the clock on the Old South Meeting House bell tower. Like T. S. Eliot's "still point of the turning world," Old South has remained while much around it has changed.

Old South dates from 1730. (It replaced an earlier church of 1669, in which Benjamin Franklin was baptized the day he was born in 1706.) The architect, Joshua Blanchard, pushed its Georgian steeple high into the air as a symbol of aspiration toward God and of the primacy of the church in the city. Today the steeple, dwarfed by skyscrapers, has lost any sense of tallness. Architecture always graphs the power structure and the belief system of a society. Old South is humiliated in a Boston where the big symbols on the skyline are the towers of commerce rather than the spires and domes of church and state.

Two such skyscrapers loom behind Old South. They are Devonshire Towers, a luxury apartment tower, and Exchange Place, a mirror-glass office building. Both display vast repetitive façades. One is striped and the other is gridded, thus pretty much exhausting the possibilities of façade expression in the modernist style. The two remind you of the classic Dorothy Parker line about an actor: "He ran the gamut of emotions from A to B." But architecture is never without meaning, whether it's intended or not, and both buildings make clear statements. By not having tops, they tell us that they are merely boxes of leasable cubic footage, to be sliced off arbitrarily as soon as there is enough. And by their endless repetition of identical elements, they inform us that their inhabitants and purposes are anonymous and interchangeable.

Two older and better buildings are also visible. To the left of Old South is the flat-lidded Winthrop Building, named after the early settler John Winthrop, on whose one-time estate it stands. Designed in 1893 by Clarence Blackall, who also created most of Boston's theaters, the Winthrop is one of Boston's loveliest small buildings, richly clad in burnt-orange brick and terra cotta. It also happens to be the city's earliest example of steel-frame construction. To Old South's right is the Boston Transcript Building, done in 1873 by Gridley J. Fox Bryant, the master of granite who designed Boston's Old City Hall, Charles Street Jail, and Mercantile Wharf. This building was the home, for fifty years, of a newspaper — once Boston's largest — that inspired another memorable, if snooty, Eliot passage:

> The readers of the Boston Evening Transcript
> Sway in the wind like a field of ripe corn.

No Boston building has witnessed more history than Old South Meeting House. Citizens rallied there in 1773 to foment the Boston Tea Party. In 1776 the British, under General Burgoyne, ripped out the pews and turned the church into a military riding school. A century later, in 1876, Old South sparked the historic preservation movement in Boston. By then it was an abandoned former post office, planned for demolition, until a group of Bostonians raised money to save it. Today, restored to its appearance at the time of the Revolution, it is a museum of itself, part of the Boston National Historic Park.

Sucky bottom with green ooze. — Note on an old navigator's map of Boston Harbor

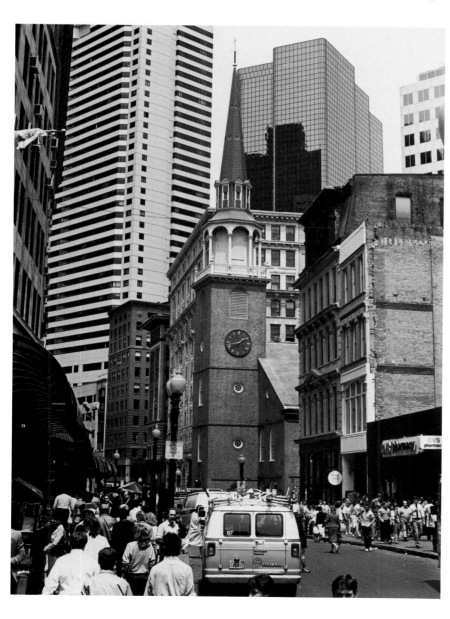

the 1950s

Suburbanizing the City

HERE WE SEE THE RESULTS of a misguided effort, typical of Americans in the 1970s and 80s, to turn a genuine city into something more like a suburb — really into a suburban museum of the urban past.

The photos are of Union Street, known to most Bostonians as the site of the landmark Union Oyster House.

You can't make out the Oyster House very clearly, but it's about halfway down the right side of the street in both shots. It's part of a tiny neighborhood of twisting lanes known as the Blackstone Block. The Oyster House occupies two former brick houses that date from 1717 and 1724. The restaurant, although it is believed to be the oldest in the United States, is a relative newcomer in this setting. It didn't open until 1826.

What we see in the older view is a vital city street, a visually rich, functionally lively corridor, made up in this case largely of appliance stores. Those were the days before the arrival of the big suburban chain outlets. People still came downtown for many of their needs. Stores of one kind tended to congregate in the same place, making the city itself a huge outdoor department store.

Now the whole left side of Union Street has been torn down, replaced by a thin strip of useless greenery called Curley Park. The park is notable only for two wonderful statues, by sculptor Lloyd Lillie, of Boston's legendary Mayor James Michael Curley, who served four terms in City Hall and

two in jail. In one statue, Curley the Statesman stands erect, orating; in the other, Curley the People's Friend slumps congenially on a park bench.

Aside from the statues, Curley Park is a sad example of the current lust for open space in American cities, most of which already have far too much of it. Too often the effect of the open-space lobby is merely to transform dense, vital cityscape into vacuous green suburb. Surrounded as it is by traffic, Curley Park offers no pleasure. And with the demolition of one of its two sides, Union Street has lost the sense it once possessed of being a container filled with life. After the development of the nearby Faneuil Hall Market-place, the whole of the Blackstone Block became largely a tourist area, a place to be "experienced" rather than used — a self-conscious museum, in

fact, for the performance, display, and purchase of what once was city life.

In the 1990s Curley Park is to acquire a Holocaust Memorial, another step in the retooling for tourism of this key chunk of Boston. Open space is valuable in cities. But it must be purposefully designed, and it must go where it counts. It should be a foil to the built world, not a replacement for it. And the best and most memorable open spaces, in any city, are its good streets.

How doth the city sit solitary, that was full of people! How is she become as a widow!
— Lamentations

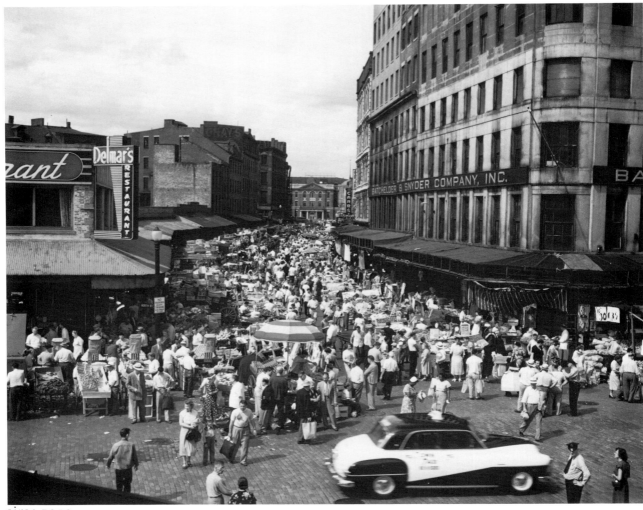

circa 1950

Murdering Another Street

WE'RE OVER ON THE OPPOSITE side of the Blackstone Block, looking up Blackstone Street toward the neighborhood of the North End. Block and street are both named after Boston's first permanent inhabitant, the Reverend William Blackstone, who built a house on Beacon Hill about 1625.

The Blackstone Block is a warren of narrow streets with evocative names — Scott Alley (once Scottaw's Alley), Marsh Lane, Salt Lane, Creek Square — names that remind us the block was once oceanfront land. These streets, though not the buildings along them, date from before 1700. They now provide the only place where you can savor something of the tiny scale of Colonial Boston. The Blackstone Block is now on the National Register of Historic Places.

The street market, called the Haymarket, remains from the old photo to the new, but nearly everything else has changed. All the buildings on the right side are gone, demolished in the 1950s for the Central Artery, Boston's downtown overhead expressway.

Comparing the photos, we see both gains and losses. The corner of the Bostonian Hotel, a sensitive addition to the historic block, is visible on the left of the new photo. Traffic, bad as it still is, has certainly been speeded by the Artery. But the street itself and its famous outdoor produce market have suffered. When Blackstone Street was walled by buildings on both sides, rather than only one, it was an outdoor room that shaped and enclosed the market. Today the market, lacking a defined space to live in, seems merely a fringe clinging to the buildings at the edge of the Blackstone Block.

A project is under way to bury the Artery in a tunnel. When that's been accomplished, perhaps it will be possible to knit up the huge wound this roadway made in Boston and regain the sense of a city of enclosed streets.

Stadtluft macht frei (city air makes people free). — German proverb

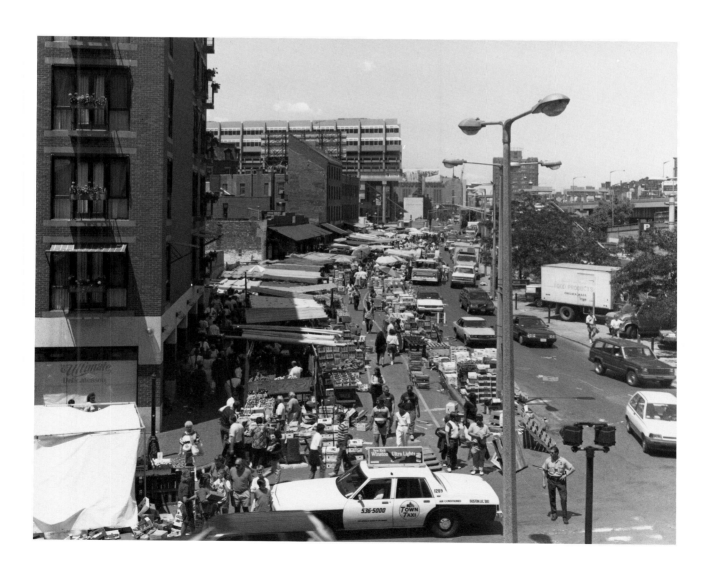

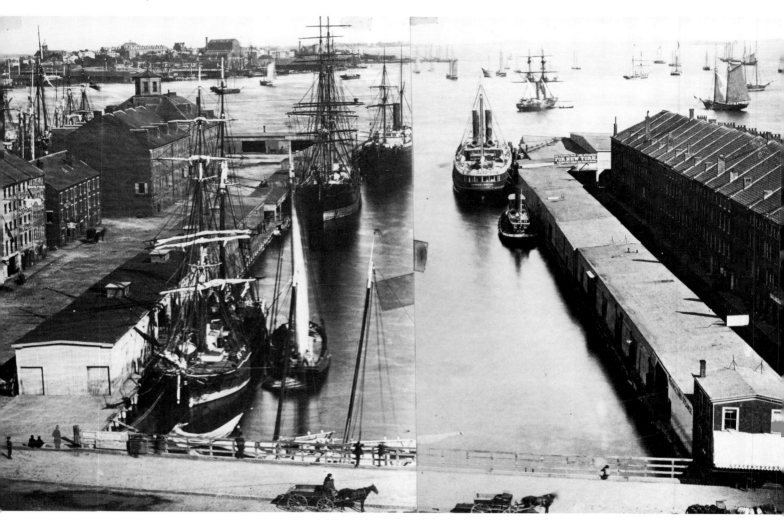

A Waterfront Workplace Becomes a Playpen

THE FIRST BOSTON clung tenuously to the edge of a continent, looking ever back across the ocean toward Europe, its waters filled with the ships that were its vital quick messengers across the Atlantic. Even the long piers seem to stretch eastward, like fingers, toward home.

These two panoramic views of the Port of Boston document its transformation from that working waterfront of ships, wharves, and warehouses into the stylish neighborhood of today, a place of residential, cultural, and recreational uses. Both views were made by splicing four separate photographs. They show the port as it looked in the 1870s, just after the era of the great clipper ships, and as it looks now.

Photography required time in the 1870s. If you are sharp-eyed, you can make out a single sailing ship that appears in all four segments of the old panorama, moving from right to left as it reduces sail and heads toward a berth somewhere

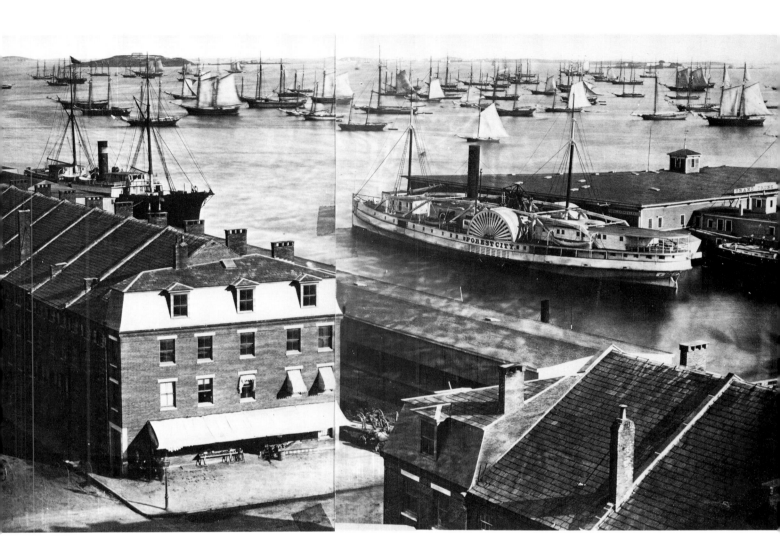

in East Boston. Is it perhaps a deliberate joke? Shown are three of Boston's major wharves: Long Wharf on the left, Central Wharf in the middle, and the tip of India Wharf on the right. At India lies the sidewheel steamer *Forest City,* which ran between Boston and Portland for nearly forty years. Elsewhere the New York and Philadelphia steamers are also visible. More than eighty ships in all, most of them two-masted coastal traders, crowd the harbor. At the bottom is Atlantic Ave-

nue; in 1868 it sliced through the middle of Central Wharf, which previously had been a grand row of fifty-four brick stores, 1,300 feet in length, built in 1817.

In the new photo nothing remains of these buildings on Central Wharf. They were demolished for the Central Artery, or for a relocated Atlantic Avenue, or for the New England Aquarium. The Aquarium is the squarish building at the end of the wharf, a hugely successful attrac-

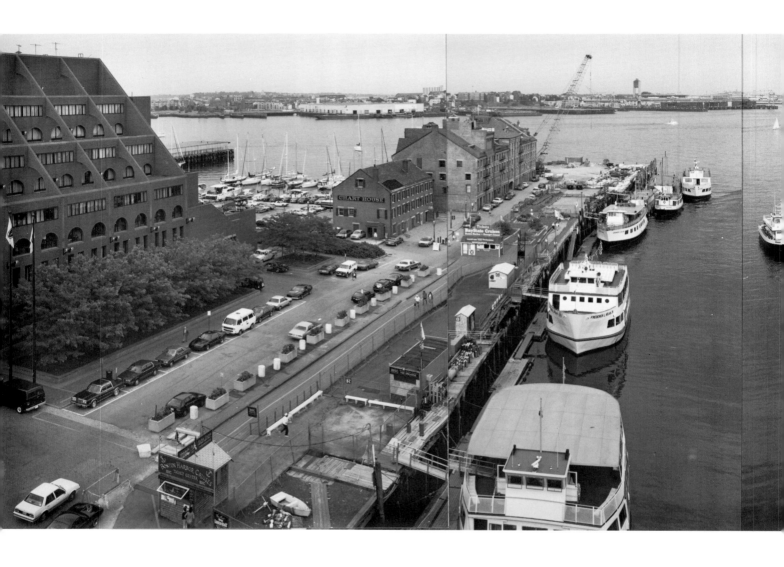

tion designed by Cambridge Seven Associates and
built in 1969.

Elsewhere we see old wharfs and warehouses
converted to condominiums, taverns, and restau-
rants. Harbor tourist cruise ships now line Long
Wharf, where stands a new Marriott Hotel
designed by Araldo Cossutta (also the architect of
Boston's Christian Science complex) in a style
reminiscent of the old pier warehouses. At right,
on India Wharf, are the Harbor Towers condomin-

iums, designed by Cossutta's former partner at
I. M. Pei & Partners, Henry Cobb.

Boston Harbor, the source of most of Boston's
early wealth, lost its prominence as a port
because of its shallowness and its failure to com-
pete successfully with New York. Today,
according to historian Bainbridge Bunting, Boston
handles less tonnage in proportion to its sur-
rounding population than any other East Coast
port. Long dilapidated, it experienced a second

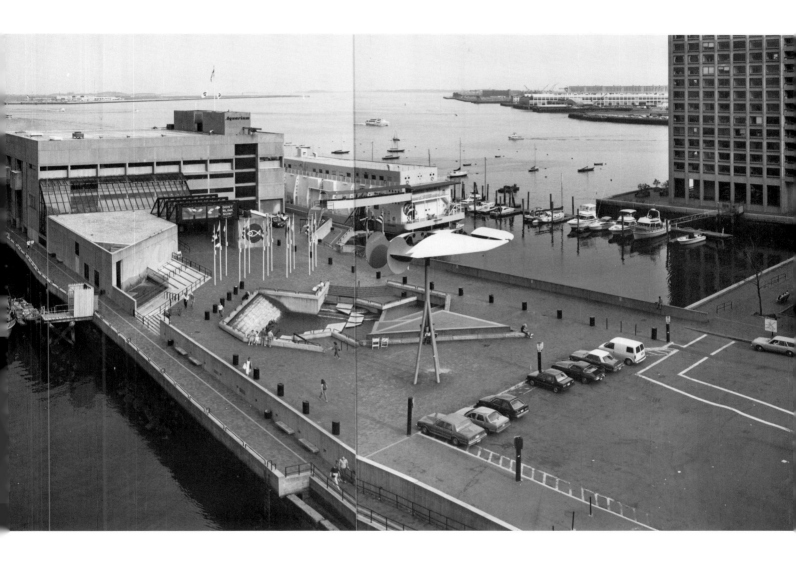

coming as a residential neighborhood in the 1970s.

Like so much of America today, the Boston waterfront has been severed of any visible connection with work, production, or nourishment. When a fishing industry becomes an aquarium, theater replaces life. "The waterfront died the day you couldn't any longer get breakfast at 5 A.M.," comments one sad old-timer. But despite a loss of gritty reality, the waterfront remains a busy and inviting place.

Out of the mist in Massachusetts Bay comes riding a clipper ship, with the effortless speed of an albatross. — Samuel Eliot Morison

The Ghost of Customs Past

THE PRESENCE OF THE PAST in a city can be many-layered. Here the ghost of a forgotten landmark haunts the façade of a forgotten warehouse which, in turn, haunts the façade of a new office building on the Boston waterfront. Got it?

In the center of the old photo is a building that bears the sign and eagle of a United States Custom House. Don't be fooled: it never was one. It was a private commercial building that plucked those emblems from a real Custom House that had earlier stood on the site.

That true and original Custom House, built in 1810, gave its name to this street, still Custom House Street today. The Custom House functioned during some of the greatest boom years of the China and East India trade, years that brought fabulous wealth to Boston merchants, who were renowned worldwide for their hard business sense and who founded most of what were later known as the Boston Brahmins, the city's first families. Nathaniel Hawthorne, the novelist, recorded cargoes here from 1838 to 1840. Even by Hawthorne's time the building was too small, and in 1847 a new Custom House opened two blocks away. This was the building we know today as the Custom House Tower, although the tower part wasn't added until 1915. When the new Custom House opened, the earlier one was demolished, replaced by the building with the eagle and sign we see in the old picture.

Courtesy of SPNEA, Boston.

circa 1888

26

The newer photo shows the scene today. An office building called simply 20 Custom House Street opened in 1988. Its architects, Bruner-Cott Associates of Cambridge, inscribed a memory of a memory on the front of their building by giving it a peaked pediment with a round window, visible at fourth-floor level. As the two photos show, the shape is a deliberate reminiscence of the Custom House that wasn't a Custom House — which itself, thanks to its sign and eagle, was a reminiscence of the real Custom House.

A few decades ago, there was a cleaning product called Dutch Boy cleanser. On the box was a picture of a Dutch boy holding a box of Dutch Boy cleanser, on which was a picture of a Dutch boy holding a box of Dutch Boy cleanser, on which was a picture of a Dutch boy holding . . .

The Custom Houses, and the not-Custom Houses, of Custom House Street are a little bit like those boxes. They seem to stretch back infinitely into the past. A city, they remind us, is a temporal collage.

When you are dealing with 'em [Bostonians], you must look upon 'em as at cross purposes, and read 'em like Hebrew backward; for they seldom speak and mean the same thing, but like Watermen, Look one Way, and Row another.
— John Dunton (1686)

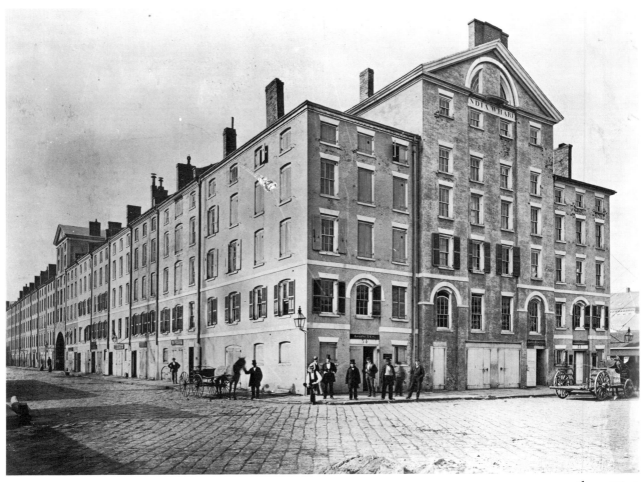

the 1860s

Using Art to Say "Keep Out"

THOSE BIG SHINY THINGS on the plaza aren't solar collectors, nor are they tracking devices for passing satellites. They're stainless steel sculptures created in 1972 by artist David von Schlegell. When you stand among them, they frame a strangeness of space and reflection that is mildly interesting for a few moments. But their real function — intentional or not — is to signal that this plaza is private turf. Barren, abstract, and puzzling, they proclaim louder than words: "Not for the general public. For art appreciators only."

The elite appreciators of art, one assumes, live in the Harbor Towers condominiums you can see behind Schlegell's sculpture in the newer

photo. Designed by Henry Cobb, the two towers weren't very successful at attracting occupants in their early years. For that reason, a proposed third tower never was built, nor were three other towers once planned for the end of Lewis Wharf nearby.

Judging by Harbor Towers, Boston is lucky the waterfront tower-building stopped when it did and that a lower, busier, more public waterfront began to evolve instead. With its arid plaza and fenced-in swimming pool, Harbor Towers is an outrageous grab of downtown waterfront land — a public resource — for private use.

Putting towers on waterfront sites is dubious planning at best. As seen from the water, a good city should rise in tiers, starting with low buildings at the water's edge and heaping up gradually to the skyscrapers, if any, farther back. More of

28

the city will gain a view of the ocean, and the city itself will suggest a family of related buildings. High-rises like Harbor Towers feel badly out of place at the water's edge.

The 1860s view shows the site when it was known as India Wharf. Built in 1807 of brick, trimmed in red sandstone plus a little marble here at its ocean-facing end, this great wharf contained thirty-three five-story warehouses, used by merchants trading in goods from the East and West Indies — hence the name India — and in southern cotton. India Wharf was designed by Charles Bulfinch as part of a commercial neighborhood he planned for a group of investors — the Broad Street Association — among whose leaders were Harrison Gray Otis and Uriah Cotting.

The wharf is another example of Federal architecture, with the typical Federal understate-ment but also with some flourishes. There is play — a little ironic? — with the motif of round arches in this basically square-cut, no-nonsense commercial building, for instance in the astonishing thrust of a chimney through the arch at the high front gable, or the placement of arched windows inside other arches at the second floor. In those days before elevators, the second floor of such a building was the choice location, sometimes called the "bosses' floor."

This end of India Wharf survived until 1962, when it finally came down for a parking lot — and for Harbor Towers.

They paved paradise, And put up a parking lot. — Joni Mitchell ("Big Yellow Taxi")

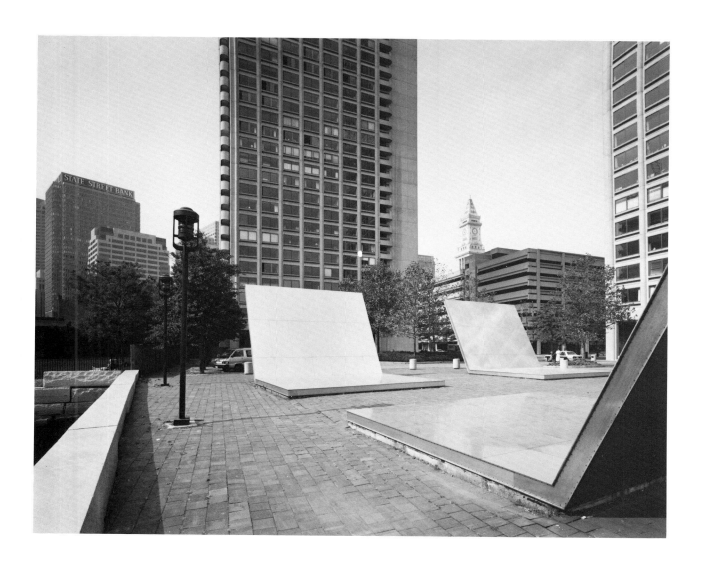

II

HOUSES WITH HATS AND FACES
IN A CITY OF OUTDOOR ROOMS

As BOSTON SURVIVED the American Revolution and grew in prosperity, it aspired to a more mannerly, more urbane character. Because the basis of its economy was trade with Europe, the West Indies, and the Orient, it became a quite cosmopolitan place, considering that it was still a small and remote city. It achieved its goal of urbanity in part through two analogies: the building regarded as a person, and the city regarded as a building. Houses and other structures composed their faces and donned hats and something rather like fancy dress, frills denied earlier to all but lavish mansions and public buildings. And the city plan, on the European model, became a loose system of outdoor rooms (such as Louisburg Square) linked by narrow streets which, thanks to the nearly continuous building façades that edged them, felt very much like corridors. Meanwhile, the growth of the peninsula continued: Beacon Hill cut down, South Cove filled in.

The landmass of Boston circa 1795

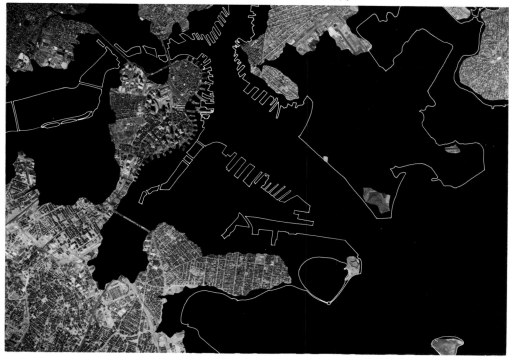

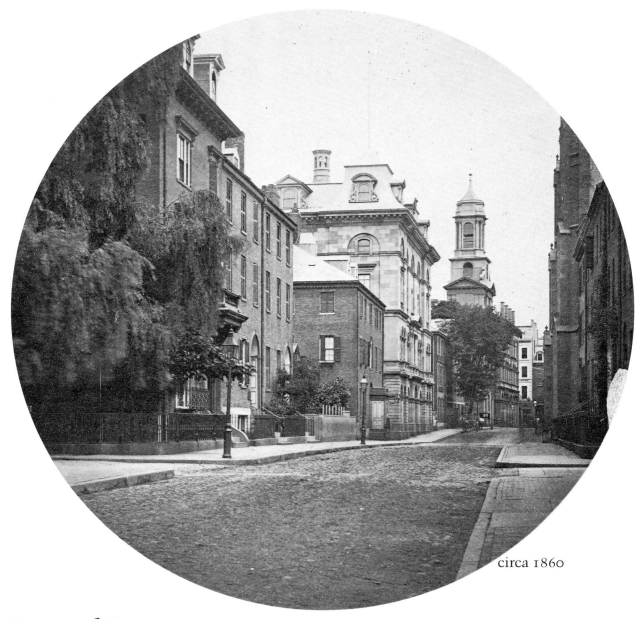

circa 1860

Hats and Faces

WHEN ARCHITECTS PROVIDE their build-
ings with hats and faces, they offer us one
way of relating to the architectural environment.
As we walk through the city, we feel we are walk-
ing among welcoming, congenial beings not
unlike ourselves.

 This beautiful photograph of old Boston
shows, as poignantly as any could, the value of
such humanoid features. Each of the buildings is
wearing a hat — as a building should, logically,
when it appears in public, especially in a climate

like Boston's. Equally logically, the most impor-
tant buildings are identified by the tallest and
fanciest hats. The tallest of all is the cupola of
First Church, silhouetted against the sky at the
right of the photo. To the left of First Church the
Massachusetts Charitable Merchants Association
wears a dignified hat with a curved, sloping shape
known as a mansard roof.

 The plainest hats belong to the plainest
buildings, the houses toward the left of the photo.
At the time of this 1860 photograph, Chauncy

Street was a fashionable residential district. We're looking north from its intersection with Exeter and Rowe places, small side streets that still exist.

Beneath the hats are faces. Some of the windows, for instance, possess the architectural equivalent of eyebrows and lashes. We are reminded of the way a small child draws a house, with a roof that is like a hat, two windows like eyes, and a door like a mouth. We realize how like ourselves buildings really are. They stand on the ground, they have public fronts and private behinds, they have orifices where fuel goes in and waste comes out, and they have windows, like our own eyes, through which intelligences may be looking out.

The new photo shows a sadly changed scene. Although the location is nearly the same (actually a few yards farther north, at the corner of Bedford Street), it is unrecognizable. Poor Chauncy Street has been reduced to little more than a service alley for the vast Jordan Marsh department store and the Lafayette Place mall and hotel complex, seen at left. Faceless and hatless, the new buildings fail in any way to engage our sympathy or imagination.

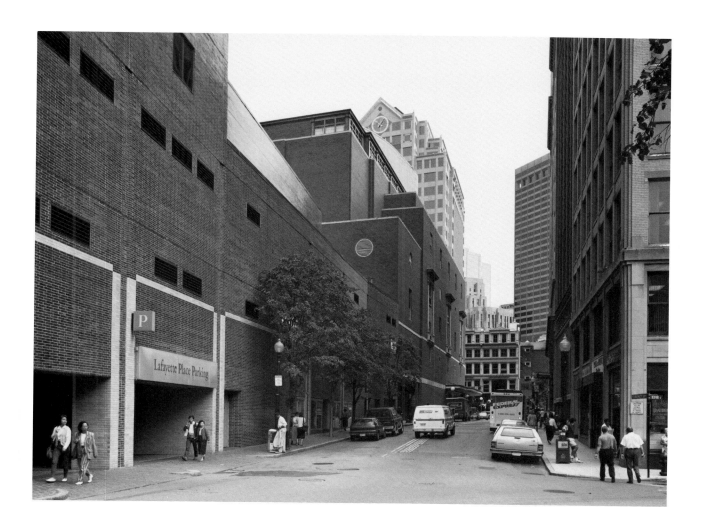

Every roof is agreeable to the eye, until it is lifted; then we find tragedy and moaning women, and hard-eyed husbands.
— Ralph Waldo Emerson

33

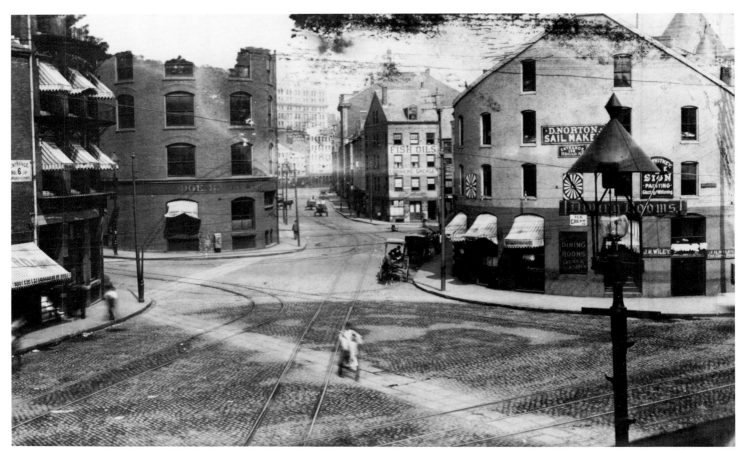

circa 1900

Buildings that Dance with the Street

IT'S ABOUT 1900 in the older view. We can
guess the date because there aren't yet any
cars, but the landmark Ames Building, finished in
1889, is visible — in a ghostly way — at the far
end of Broad Street, the street that fades back
through the middle of the photo.

In the new view, the Ames is blotted out by a
controversial office tower of the 1980s called 75
State Street, notable for its zigzag golden hat in a
revival of the art-deco style of the 1920s. The
jazz-age hat recalls the little poem with which F.
Scott Fitzgerald prefaced *The Great Gatsby:*

> Then wear the gold hat, if that will move her;
> If you can bounce high, bounce for her too,
> Till she cry, "Lover, gold-hatted, high-bouncing
> lover,
> I must have you!"

Alas, 75 State doesn't bounce high. It squats.
The city forced the owner to lower the proposed
height, but the owner refused to give up any floor
area, so the building got fatter as it got shorter.

The unforgettable image is the old one. The
intersection in the foreground is one of those
pleasantly crazy Boston junctions that seem to
have been laid out by wandering drunks. Here
three curved buildings stand on three round street
corners. Each building follows the arc of its street
corner as closely and sympathetically as a dancer
might follow the movement of a partner. Seen
together, the three buildings seem to be swirling
in an urban waltz.

Such harmony is the opposite of the city of
square towers on odd-shaped sites, the kind of
mismatch that became common in the Boston

of the 1960s and 70s. Square towers on curved and angled sites like Boston's tell us quite clearly: "We don't care where we are. We could be anywhere." By contrast, these older buildings fill out their sites as a fair wind fills a sail. We sense their tact, their fit, their response to the place they are in. They help shape a street space that looks rather like a stage set, ready for the enactment of the drama of urban life.

Theatrical, too, is the astonishing gas lamp in the extreme right foreground, a delicate concoction of glass bulb and metal parasol that looks like a Chinese mandarin out for a stroll.

Today's Broad Street is less remarkable, but it's still a lively place. It is now the heart of the Custom House District, a preservation area established by the Boston Landmarks Commission.

Old Boston with its zigzag streets and multitudinous angles, (crush up a sheet of letter-paper in your hand, throw it down, and there is a map of old Boston.) — Walt Whitman

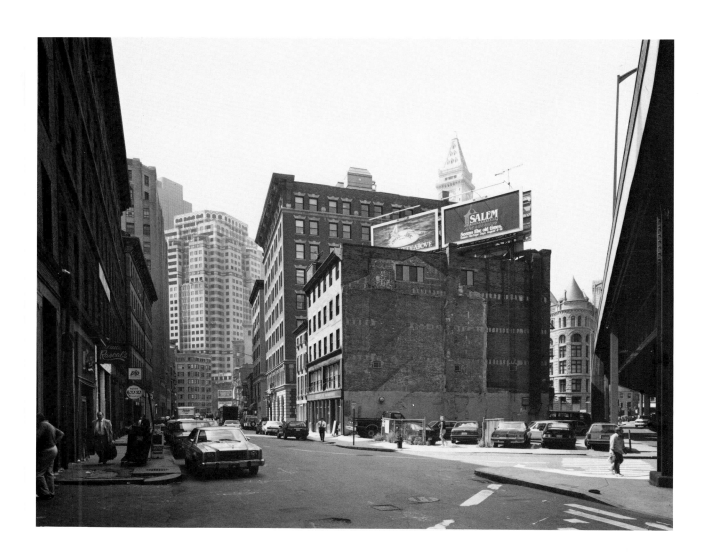

A Steam Engine Covered with Signs

ANOTHER BUILDING BOLDLY turns and defines a corner. This one, too, seems to be in motion, a little steam locomotive chugging through Boston, pulling a train of smaller buildings behind it.

"Merrimac House," the sign says, advertising a hotel or rooming house. Close inspection of the older photo shows that the Merrimac was once probably two buildings. The rounded part — perhaps an addition? — displays Greek Revival details that suggest a date of around 1850, the era when the first railroads came into Boston, changing this neighborhood from residential to industrial use. The site, at the corner of Merri-

mac and Friend, stood between one railroad station at Haymarket and another near today's North Station. Like most of Boston, the land here was once part of the harbor. The neighborhood was created on fill moved from the top of Beacon Hill in the early nineteenth century.

Besides the brilliance with which it anchors the corner, this modest building offers other lessons in city design. The top floor is set forward by the thickness of one brick, for instance, and it seems to rest on two-story-high flat brick pilasters. This subtle architectural move gives the simple façade just enough bigness of scale to command its prominent corner site. At the

1914

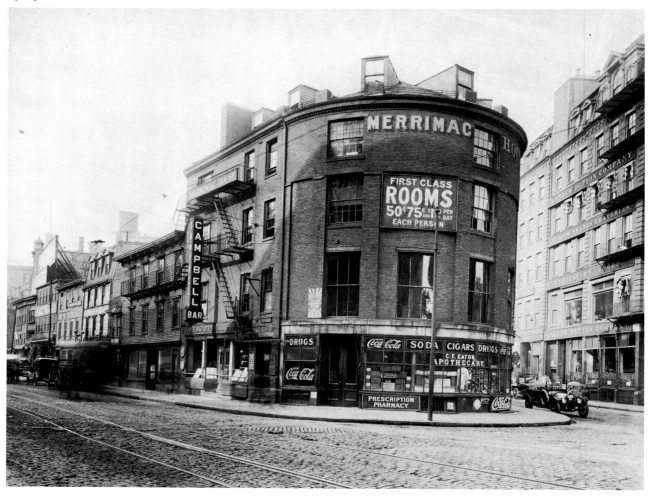

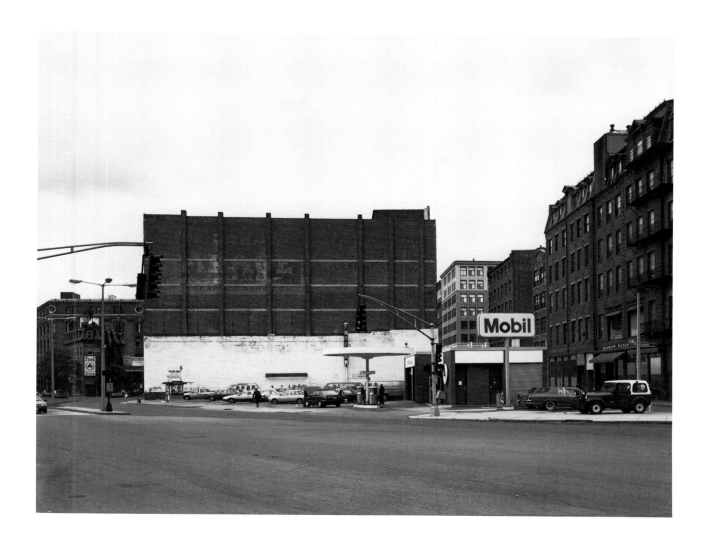

ground floor, the lively variety of shops is banded coherently together by the belt of stone trim above them.

Also worth noting are the signs. This is architecture as text. Like the carved names of great thinkers on the façade of the Boston Public Library, or like the sculptures of saints around the doors of a Gothic cathedral, the signs on this small building advertise its contents. They give it life and meaning. And unlike so much signage of our own day — the Mobil sign in the new photo, for instance — they are not the colonizing flags of international corporations. Instead they are local and particular, respecting the character and scale of the building so well that they become a valu-

able part of its architecture. They are integral, readable ornament. Because of them, the Merrimac embodies another metaphor: it is a closed book with titles on its spine.

About the contemporary photograph, the less said the better. The blank wall and trivial gas station replace the shapely corner with empty chaos.

Sometimes — often in science and always in art — one doesn't know what the problems were till after they have been solved.
— Gregory Bateson

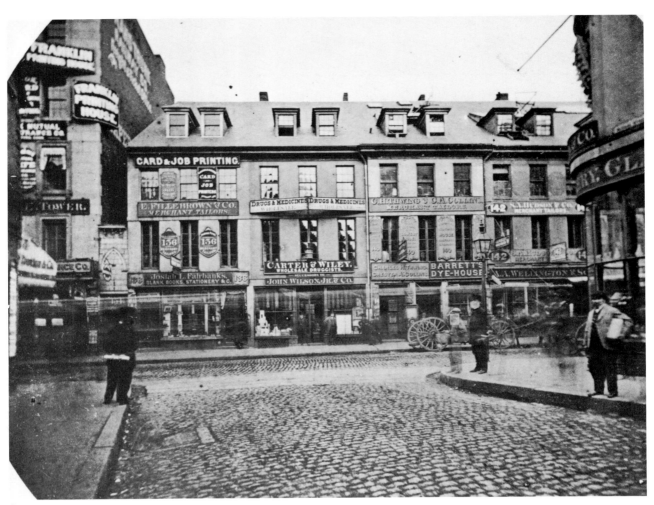

the 1860s

A Good Corner Then,

AGAIN WE SEE THE CITY as text in the older view of the corner of Washington and School streets, an intersection that's been near the nerve center of Boston for three hundred years. The flat-fronted buildings with their vertical rows of windows look like bookcases, and their well-proportioned signs, like shelf labels in a bookstore, gives them a curious captioned character — almost as if the buildings were a cartoon chorus, with speaking parts, in the theater of the city.

The older view is the work of the noted early photographer Josiah Johnson Hawes. Like most old views of cities, it is misleading. Hawes's glass plates needed long exposure times, so he tended to work in the early morning when few moving creatures — such as horses or people — were around to blur the photograph. This practice lends the city scenes of Hawes and other early photographers an atmosphere of eerie calm, an atmosphere that may make us assume old Boston was more serene than it really was.

In the new photo, all is changed. You can now see the Old South Meeting House because the buildings at the corner of School Street were carved back in a sweeping curve in the 1960s for a planned street realignment that never occurred. Old South's congregation used this building only until about 1870, when it moved to a church in the fashionable new Back Bay called, with impeccable logic, New Old South. In future, perhaps, this logical congregation will again relocate, to some place like Andover or Marblehead, and rechristen itself New Old South North.

To the left of the Meeting House is the Old South office building, a gem of 1904 in buff brick and terra cotta by architect Arthur Bowditch, who designed the richly frosted Berklee College

38

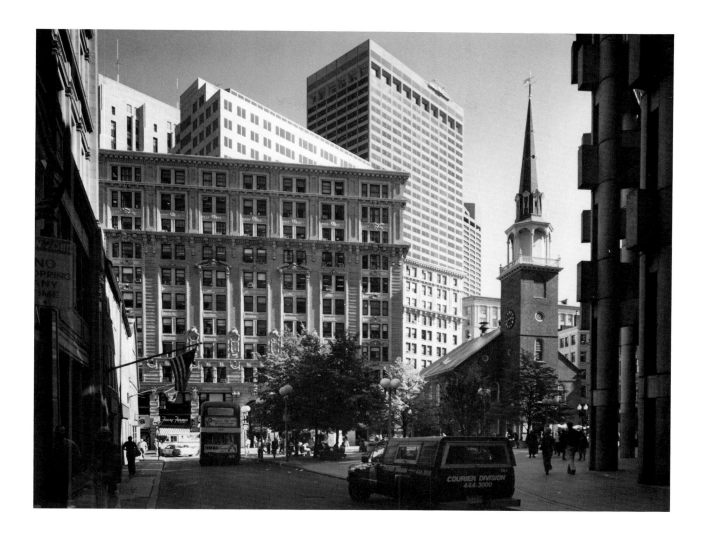

a Good Corner Now

of Music on Boylston Street. Behind it rise the towers of the new Boston, the tallest being the Shawmut at One Federal Street, whose beetle-browed top-floor windows announce, for those in the know, the presence behind them of the Harvard Club.

To the right of the Meeting House is a bit of the façade of the Boston Five Cents Savings Bank, curving to match that fictitious realignment of School Street. The Five is designed in a Tinkertoy style out of pieces of concrete that appear to be plugged into one another. Tinkertoy architecture enjoyed a brief vogue in the 1960s, when it was supposed to be telling us that buildings would soon be assembled, like cars, out of standard interchangeable parts. The designers were Kallmann, McKinnell & Wood, perhaps Boston's leading architects of the present era, authors of Boston City Hall, the Hynes Convention Center, and Back Bay Station.

Today's intersection is unmistakably modern in its fragmentation. Compared to the old, it is broken up and dispersed, with abrupt, angular, dissonant juxtapositions. It lacks the older scene's feeling of an enclosed, serene, horizontal, cobblestone-carpeted, book-paneled outdoor drawing room. Yet the modern jostling of big buildings and small, of old and new, enjoys its own kind of urban vitality. It accurately expresses the more pluralistic society of our own time.

In a city there must be regularity and fantasy, relationships and oppositions, and casual, unexpected elements that vary the scene: great order in the details, confusion, uproar, and tumult in the whole. — Abbé Laugier (eighteenth century)

Boston Fails to Make a Fire with One Log

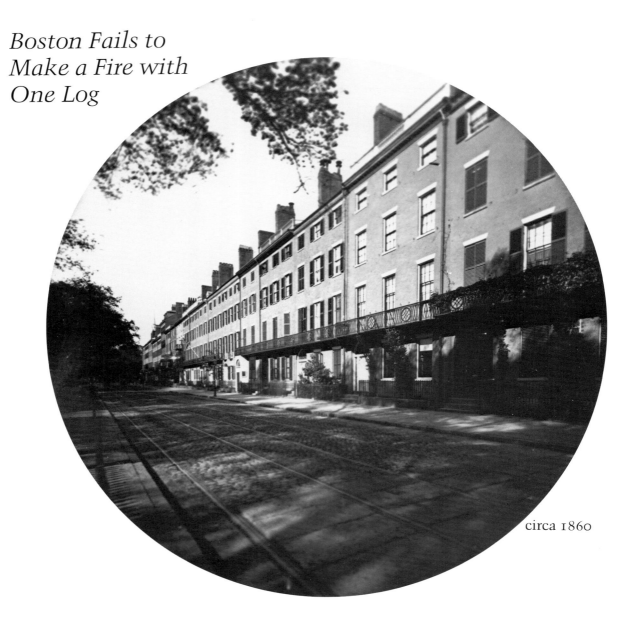

circa 1860

FANS OF WALTER MUIR WHITEHILL, the late director of the Boston Athenaeum and author of *Boston: A Topographical History* — probably the best book ever written on the architecture and physical form of Boston — may recognize the older photograph. In Whitehill's book it appears cropped into a rectangle; here it looks as it did when it was made by Josiah Hawes around 1860.

Hawes's subject is Colonnade Row, a line of nineteen houses designed by Charles Bulfinch and built in 1810. Colonnade Row filled Tremont Street from West Street to Mason. Hawes shot it with a wide-angle lens that was smaller than his eight-by-ten-inch format, creating a circular image within dark borders. The new photograph imitates Hawes's technique and his thirty-second exposure.

Whitehill, who died in 1978, wrote: "This row for several decades remained one of the most agreeable places to live in Boston, for from its windows occupants looked out across the Common to distant water, hills and the sunsets of a western sky."

Colonnade Row, now long gone, was an example of the Federal style of architecture, although it had a more European look than some Federal buildings and could easily, in fact, be mistaken for an Adam-style square in Dublin.

Whitehill is right in suggesting that this strip along Tremont Street ought to be one of the best building sites in Boston. Yet it never again, after

Colonnade Row, held a collection of buildings equal to its potential. The worst of them today is the tall, blank-sided building farthest away in the new photograph, the ungainly and offensive Tremont-on-the-Common apartment block. Some of the other buildings are better, especially the turn-of-the-century ones nearest us, but many aren't, and the retail stores at the sidewalk are largely boarded up.

We are witnessing a generic problem. Single-sided streets like this, overlooking parkland, work beautifully for residential uses. One thinks of Fifth Avenue or Central Park West in New York, or Boston's Beacon Street on another side of the Common, or the great terraces of John Nash along Regent's Park in London. But shopping streets are different. If they are not two-sided, they usually won't generate enough activity to survive — just as you can't generate a successful fire with only one log. That is the reason these buildings, all of which contain commercial uses on at least the ground floor, fail so miserably at being the row of tall, strong, prosperous presences that ought to be looking out over Boston Common and the Public Garden.

When we build, we must think of ourselves as building a piece of the whole world. We should ask: What would the world become if it were all done like this? — Leon Krier

An Urban Parlor

ONLY THE NAME REMAINS to remind us that Church Green, at the intersection of Summer and Bedford streets, near South Station, was once the site of a graceful church. Another design by the prolific Charles Bulfinch, the New South Church stood here from 1818 until 1868.

New South was an octagon in its floor plan and was built of granite from Chelmsford that was barged down the Middlesex Canal to Charlestown, where the prisoners at Charlestown Prison — itself a Bulfinch building — performed the finish work on the stone. Often considered Bulfinch's best church, New South nevertheless survived only fifty years before being demolished for a store.

New South would doubtless have succumbed in any case to the Great Boston Fire of 1872. It was in 1873, right after the fire, that the present occupant of the site was erected. This five-story pile, shown in the new photo, is one of the handsomest of the sturdy Boston Granite style mercantile buildings of the nineteenth century. It is still known as the Church Green Building, although there is no church here now,

1860

42

and no green. The name lingers in the air, like an inexplicable echo from a forgotten past.

The original Church Green must have been one of the best of early Boston's outdoor rooms. We can guess so from the old photo, in which the church stands like a fireplace at the end of a parlor, and the façades of the houses on either side function like the paneled walls of the room. The Renaissance architect Leon Battista Alberti said it best: "The city is like a large house and the house, in turn, like a city."

Behind Church Green now rises the office building at 99 Summer Street, a modest low tower, also made of granite, that fits comfortably into its Victorian surroundings. Memorable for its bright red roof, it was designed by the firm of Goody, Clancy and Associates and opened in 1987. Like other buildings of the post-modern style, it is concerned to say both that we are connected to the past and that we must grow forward from it.

If you live long enough, you will see all your buildings destroyed. After all, it is only the IDEA that really counts. — Louis Sullivan

Village Green and High Spine

SOME CITIES ARE HIGHLY VISIBLE to themselves. Vain San Francisco is a good example, always admiring itself from every hill and island.

Boston, by contrast, is a city that to an astonishing degree is hidden from itself. Highways, rivers, and arms of the sea slice it into discrete sections. Even trees can conceal; San Francisco's lack of them helps open it up to self-awareness. Neighborhoods in Boston sited cheek by jowl may yet remain barely aware of each other's existence.

An example is the little village green that surrounds the First Church of Roxbury. So sharply isolated is Roxbury, by barriers both physical and sociological, that it comes as a shock to realize that the distance from First Church to the Prudential Tower is about the same as the eight blocks from Arlington Street to Massachusetts Avenue in the Back Bay. Few residents of the Back Bay have ever visited, or even heard of, this lovely place.

First Church feels more like a traditional New England country church than any other in the city. Crisp and austere in form, pure white in color, it stands with pride and presence atop a knoll overlooking John Eliot Square. It is now the oldest wooden church in Boston, yet it is the fifth to have occupied this site. The membership, now Unitarian, was originally a Congregationalist group that gathered around the Reverend Eliot in 1632. The present building dates from 1804. William Blaney was its architect, and Paul Revere cast the bell that hangs in its tower.

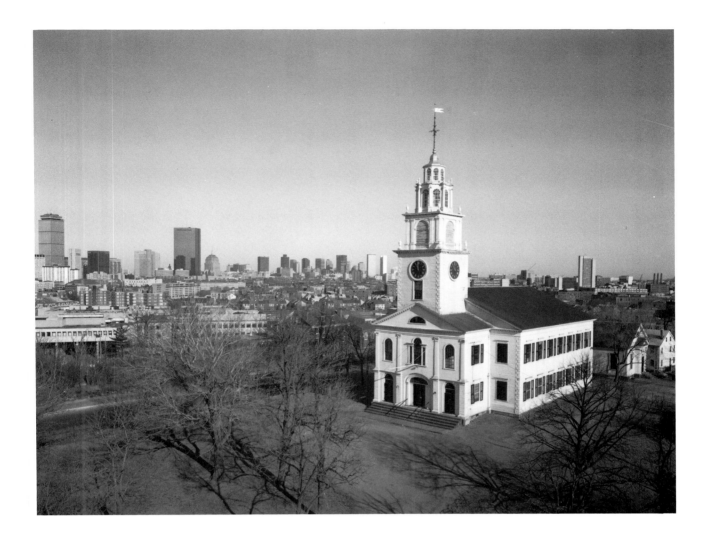

First Church has changed little in a century but its surroundings have changed very much. Once a quiet, middle-class streetcar suburb, incorporated into Boston only in 1868, Roxbury became, during the twentieth century, a port of entry first for Irish, then Jews, then blacks. Today it is troubled by poverty and depopulation.

The spacious houses at the left of the church in the 1880s are gone. In their stead is vacant land that fails to provide the church's oval green with the firm edge it needs to preserve its physical shape and its sense of being the center of a community.

On the horizon are the towers of Boston's High Spine. The concept of the High Spine, invented by the Boston Society of Architects in the late 1950s, proved to be one of the most seminal urban-design ideas in Boston's history. The notion was that in a city of so many historic neighborhoods, the best place for new high-rise growth was a ragged corridor of underused land that extended outward from downtown between the Back Bay and the South End. Always used for transportation, the corridor now contains the Amtrak line, the Orange Line subway, and the Massachusetts Turnpike.

The High Spine today, as the new photo shows, is a long dorsal fin of skyscrapers that snakes through Boston along this corridor, served by the transit lines beneath it. The spine has given Boston an overall shape and definition it lacked. Because of it, the city is no longer quite so invisible to itself, and places like First Church are at last in visual contact with other parts of town.

Ye are the light of the world. A city that is set on a hill cannot be hid. — Matthew

A Mysterious Blank Panel

LIKE A BAR GRAPH on a business report, this downtown Boston building has marked the ups and downs of economics by gaining or losing height.

The older photo shows the building at a proud five stories. The top floor is obviously an addition. No doubt it was added to gain rentable space during a time of economic prosperity — probably the Gilded Age of the 1860s or 70s, judging by the slope-sided mansard architecture.

But 1933 was not a prosperous year, so it's not surprising that we see a "Floors to Let" sign at the third floor. The new photo helps us guess that these floors never were let. It shows our building

reduced to three stories — decapitated to reduce the tax assessment, as were many others in this old warehouse neighborhood during the economic depression of the 1930s and 40s. The missing upper stories are replaced by a brash billboard. In the foreground is the Haymarket, Boston's open-air weekend produce market.

The site is on Hanover Street at a corner of the old Blackstone Block. The chic Bostonian Hotel of 1982, just visible at left beneath the Custom House Tower, reminds us that prosperity comes and goes. It's now gone again, as the "Office Space $11" sign attests. But our building, like Alice in Wonderland, may again grow taller, with an added floor or two like those that sprouted, during the prosperous 1980s, atop many old downtown buildings.

The past leaves mysterious marks on a city,

1933

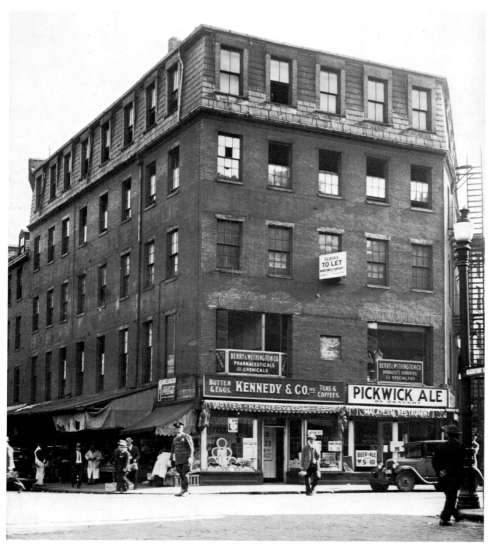

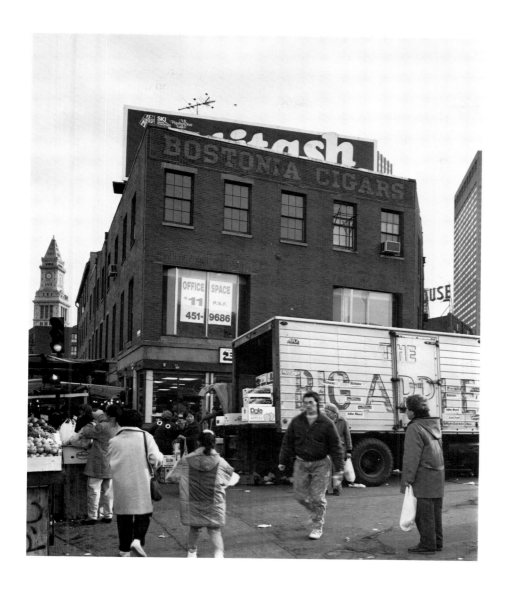

strange rubrics that only an initiate can decode. Finding and solving them is one of the joys of urban living. You can make out one such mark in the old photo. It is the small blank square on the second-floor end wall, above and to the left of the Pickwick Ale sign.

In this square, until 1933, was set a carved wood panel known as the "Painter's Arms" of Thomas Child. The panel is believed to have been made in England before 1700 and brought to Boston by Child about 1701, when he set up a paint shop on this corner. The wood panel was Child's license to practice, granted by the Painters' Guild of England. It now resides in the collection of the Bostonian Society in the Old State House.

In an alley behind the building is a more famous artifact of Child's. This is the so-called Boston Stone, originally the stone with which the painter ground his pigments. After Child's death the stone was found by a tavern keeper, who inscribed on it the date 1737 and the words "Boston Stone." He set it into a wall, where it remains, in imitation of the London Stone, from which distances to other towns were measured.

When Child died in 1706, he was eulogized by the celebrated Colonial diarist Judge Samuel Sewall in an early example of black humor:

> This morning Tom Child, the Painter, died.
> Tom Child had often painted Death,
> But never to the Life, before:
> Doing it now, he's out of Breath;
> He paints it once, and paints no more.

The more you know, the more beautiful everything becomes. — George Santayana

A Halfway House for Suburbanites

BOSTON'S GRANDEST CORRIDOR is really an indoor street, lined with shopping stalls on both sides. Doric columns separate the stalls, transforming the building into a ceremonial arcade, almost like the nave of a church. The building is one that few Bostonians will fail to recognize. Since 1976, when it reopened, Quincy Market has been among the most visited places on earth.

Quincy Market began 150 years earlier, in 1826, as an expansion of Boston's wholesale produce market, until then housed in the basement of nearby Faneuil Hall. It was popularly dubbed Quincy Market in honor of Boston's greatest mayor, Josiah Quincy, who built it on filled land over the former town dock and piers. The architect was Alexander Parris, a protégé of Bulfinch.

Parris chose the architectural style known as Greek Revival, which was then displacing Federal as the mode. He placed a Greek temple front, like those of the Parthenon in Athens, at each end of his building.

Two blocks of warehouses were built to serve the new market along its north and south sides. In the 1970s all three buildings were restored by the city and then converted, by James Rouse (as developer) and Benjamin Thompson (as architect), into Faneuil Hall Marketplace. No one predicted the market's astonishing success. Boston banks refused to finance it until the mayor, Kevin White, muscled them into joining New York banks in a consortium to spread the supposed risk. Faneuil Hall Marketplace was the first of the "festival marketplaces" that Rouse has since cloned all over the country.

circa 1890

The photos show that although the market has kept its physical form, it has lost some pungency. Instead of purveying raw meat to wholesalers, it now retails snacks to consumers. Some call it a packaged representation of what it once was. But to say so is to ignore the market's true mission, which isn't so much selling food as it is selling Boston.

A city, by definition, is a place where the most happens in the least area. It is congested and unpredictable. Faneuil Hall Marketplace succeeds because it offers a celluloid version of that genuine kind of urbanity. Carefully stage managed, it possesses the city's dense vitality, but lacks its dirt, traffic, mess, uncertainty, confusion, and danger — and, therefore, the excitement of reality. A generation of Americans who grew up in the suburbs have employed the Market-place as a halfway house, a cautious way of reintroducing themselves to city life. In that role it has proved invaluable.

It has also proved invaluable to Boston, attracting hordes of out-of-towners and out-of-staters to spend their money in an orgy of tourism that has become one of the city's largest industries.

In short, These Bostonians enrich themselves by the ruine of Strangers; and like ravenous Birds of Prey, strive who shall fasten his Tallons first upon 'em. — John Dunton (1686)

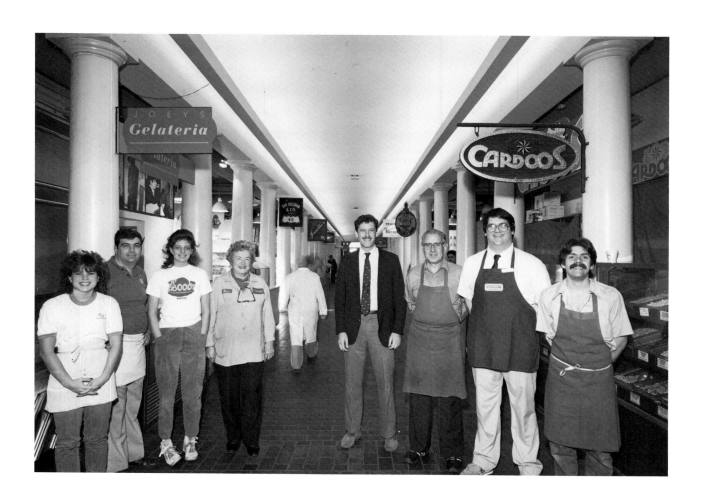

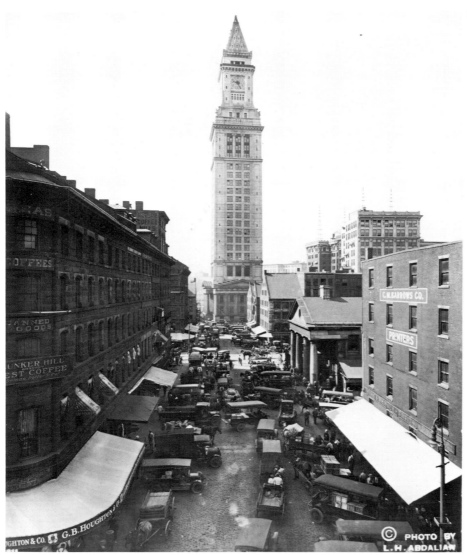

A Landmark on Top of a Landmark

IT'S AS IF CITY PLANNERS had discovered a deadly gas that eliminates only vehicles. Swept clean of the mess of trucks and wagons, the scene shown in the new photo has gained in spaciousness and ease but lost in vitality and interest. A world of work has metamorphosed into one of leisure and consumption.

Both views show us one of the marvelous chunks of Boston cityscape. We are looking down a short section of Commercial Street, with the elegant Custom House Tower rising at the far end. The seething nest of delivery vehicles in the old photo is serving the many businesses — mostly woolen and textile companies, produce and coffee wholesalers — that once filled Commercial Street. Today the busy trucks are replaced by strolling shoppers, who seem too few to occupy the scene. As a result, although the room-like urban space remains delightful, it suffers from an emptiness, like that in the paintings of Giorgio De Chirico.

In both photos the columned, Greek-templed end of Quincy Market pokes into the street from the right. Everything on the left in the modern photo is new. The former beefy granite warehouses (designed in the 1840s by Gridley J. F. Bryant, architect of Charles Street Jail and Old City Hall) have been torn down, some in the early 1950s for the Central Artery and some in the 1970s for the Marketplace. In their place is an odd-looking but serviceable extension of the Marketplace, known as Marketplace Center.

The Custom House Tower crowns both pictures, as it crowned Boston for so many years. The first Boston skyscraper, it is a strange but marvelous concoction, a big tower stuck awk-

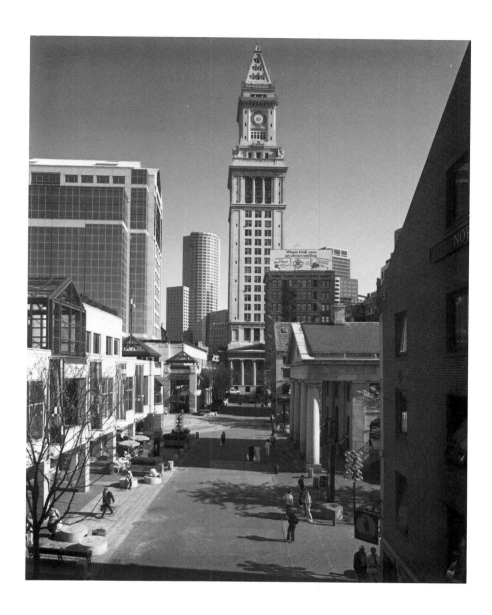

wardly on top of a little temple. The temple, with its row of columns beneath a low pointed gable, dates from 1847 and was designed as a U. S. Custom House by the noted architect Ammi B. Young. The equally handsome tower was added by Peabody and Stearns in 1915 to provide more office space. Because the Custom House was a federal building, it could ignore the city height limit.

The tower looks a lot like the famous Campanile, or bell tower, in the Piazza San Marco in Venice. Why a Renaissance bell tower was the right shape to contain a stack of government offices wasn't the kind of question that troubled architects in that era. The Venice Campanile was in the news, as it happens, being slowly rebuilt after a celebrated collapse in 1902.

Today the Custom House Tower is a Boston icon. Some people use it to argue against the concept of historic preservation. They claim that in today's preservation-conscious world, the idea of building a tower on top of an architectural landmark would be regarded as ludicrous. They are, of course, right. Just such proposals have recently been quashed, with horror, in the cases of Grand Central Terminal and the New York Historical Society.

Society is a partnership of the dead, the living and the unborn. — Edmund Burke

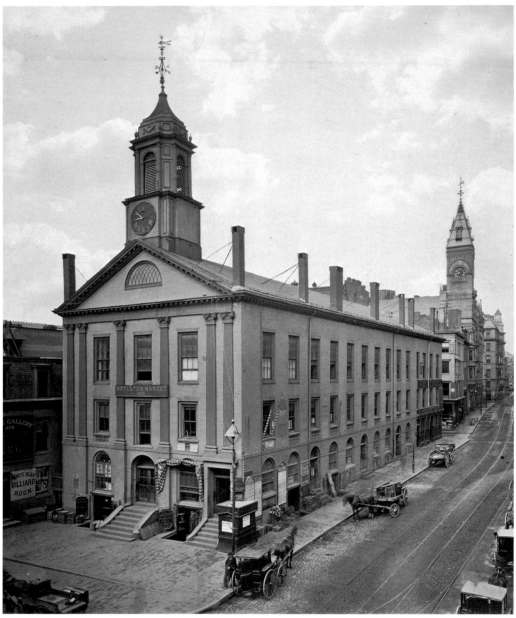

The Case of the Wandering Cupola

AS A CITY GROWS and changes, its parts sometimes migrate from one place to another. Eventually, for the urban detective, the city becomes a kind of vast puzzle of displaced pieces. The pleasures of detection can be unexpected. It is a shock, for example, to visit a tavern in Orlando, Florida, and recognize the chandeliers that once graced a distinguished Boston bank.

Few members of the Calvary United Methodist Church in Arlington, Massachusetts, are aware that their church's clock and cupola once topped the Boylston Market at Boylston and Washington streets in downtown Boston.

You can see the cupola in the foreground of the older photograph. Boylston Market looks very much like Faneuil Hall, which is not surprising since both were designed by the great architect Charles Bulfinch. Like Faneuil Hall, Boylston Market comprised market stalls on the ground floor and a big hall above.

The hall was used at first by the Handel & Haydn Society and later as a school, church, and gymnasium. When the building was demolished in 1887, the cupola and its clock began a strange migration through precincts of the profane and the sacred: removed first to a brewery in Charlestown and later to the Arlington church.

Farther back along Boylston Street, at No. 48, you can see another clock tower, topping the Boston Young Men's Christian Union, which opened in 1875. The YMCU was founded by Harvard students as a religious discussion group, and its building was designed in the Gothic style by Nathaniel J. Bradlee. The tower came down in 1912, but the rest of the YMCU remains. An official Boston landmark, it's the little building with the white wall and angled chimney on the right in the new photo.

A landmark, too, is the big structure with rows of arched windows that occupies the old Boylston Market site. This is the handsome sandstone Boylston Building, designed by Carl Fehmer in 1887 in a mix of Romanesque and Renaissance styles as an office-warehouse. After years of vacancy, except for a pizza parlor and a porno peepshow, it reopened in 1988 as the China Trade Center.

Architects are cannibals if they are not parrots.
— Sir Hugh Casson

A Stone in a Stream of Change

FROM THE 1960s through the 1980s, LaGrange was Boston's Street of Shame. This one-block thoroughfare, which runs from Washington Street in the Combat Zone up to Tremont, was lined day and night with prostitutes who operated out of its bars and strip clubs, serving a parade of slow-moving cars.

The photos show LaGrange before that era began, and again as it is coming to an end. LaGrange today is part of something the city calls the Midtown Cultural District, an area that, it is fondly hoped, will some day throb with galleries and theaters.

Already the most notorious of the Combat Zone bars, Good Time Charlie's at No. 25, has

disappeared, its former quarters occupied by an art and performance space. The space is named Good Times, both from nostalgia and from a frugal desire to recycle the old sign (Good Times is visible just behind the man wearing a coat). Across LaGrange at No. 12, just to the left of the four men, a gay-oriented new eatery, the Downtown Cafe, recently opened, then closed, then reopened around the corner. LaGrange is teetering, but it may be on the way back.

The figures in the new photo are active in the revival of LaGrange. From left to right, they are Andre La Palme, poet and waiter at the Downtown Cafe; Nick Flynn, who operates Good Times; Daniel Holmes, owner of the Downtown

circa 1933

Cafe; and Mark Lynch, associate director of the Boston Theater District Association.

The old photo depicts a very different and thriving streetscape of tailors, hatters, shoemakers, and picture framers — small businesses, the kind that thrive on inexpensive side-street locations, catering to the needs of nearby businessmen. Many of the buildings go back to 1828, the year LaGrange was first laid out for twenty houses on the site of a former distillery. That was shortly after the last visit to Boston of the Marquis de Lafayette, and LaGrange was named, according to legend, in honor of Lafayette's home in France.

One stone stands unmoving in the stream of change that is LaGrange Street. Hand the Hatter, at No. 20, has been operated here for fifty-five years by the same owner, Arthur A. Stephens. The business itself goes back at least a century. Stephens believes he is the only custom hat maker left in Boston.

A race [Yankees] whose typical member is torn between a passion for righteousness and a desire to get on in the world. — Samuel Eliot Morison

1961

Hidden Masterpieces

POTENTIAL GEMS IN A CITY can easily become lost beneath a rotting crust of inappropriate use and incongruous signage. Nowhere is this more true than in the Combat Zone, a small area that retains the ornate scale of a Victorian downtown and boasts one of the best collections of buildings, architecturally, in Boston.

Five of the Combat Zone's buildings have received landmark designation by the city; others deserve it. One of the five, the Liberty Tree Building, is the subject of these photographs. It takes its name from a famous elm that stood here at the corner of Washington and Essex (then Orange and Frog Lane) in Revolutionary times. Dissident colonists, calling themselves the Sons of Liberty, met here in the years leading up to the Revolution, and the space sheltered by the tree came to be known as Liberty Hall. Soon after the war

began, British troops and Tory sympathizers marched on the Liberty Tree and chopped it into fourteen cords of firewood. Legend states that the patriotic tree killed two of the axmen by clobbering their heads with falling branches.

The Liberty Tree Building today is a lovely but hideously deteriorated structure, designed in brick and stone by an unknown architect in a style that falls between Greek Revival and Italianate. A unique feature is a five-by-eight-foot carving of the Liberty Tree, made by ship carvers and set into the second-floor façade. Around and beneath the tree are carved the words "Liberty 1776/Law and Order/Sons of Liberty 1766/Independence of Their Country 1776."

Great changes have overwhelmed the lower Washington Street area in the years since the older photo was made. Striptease clubs and pros-

titution drifted here in the 1960s from Scollay Square, then being redeveloped as Government Center. The city accepted the Combat Zone, as the area became known, as a fact of life. In 1974 it was declared an "adult entertainment zone" in a successful effort to contain Boston's X-rated activities within one small area. The results can be read in the newer photo. A cafeteria has become a strip club, a pawnshop has become a peepshow arcade, a deli has become another peepshow. Above the ground floor, a fire has destroyed the Liberty Tree Building's interior.

The current view shows the Combat Zone at what may prove to be its economic nadir. With the spread of home video, its pornographic uses are in decline. In the 1980s the zone shrank, pressured by expanding development on all sides — by an active Chinese community, by the growing New England Medical Center, and by private developers. Such growth, now slowed, may in future threaten the historic buildings, but at the same time it offers hope for restoring them.

Time may be short for some of the zone's forgotten masterpieces. A recent fire nearly destroyed the Hayden Building, another Boston landmark then serving as a gay bathhouse. Designed by the greatest Boston architect, H. H. Richardson, it is just down the street from the Liberty Tree.

I believe the right question to ask, respecting all ornament, is simply this: Was it done with enjoyment — was the carver happy while he was about it? — John Ruskin

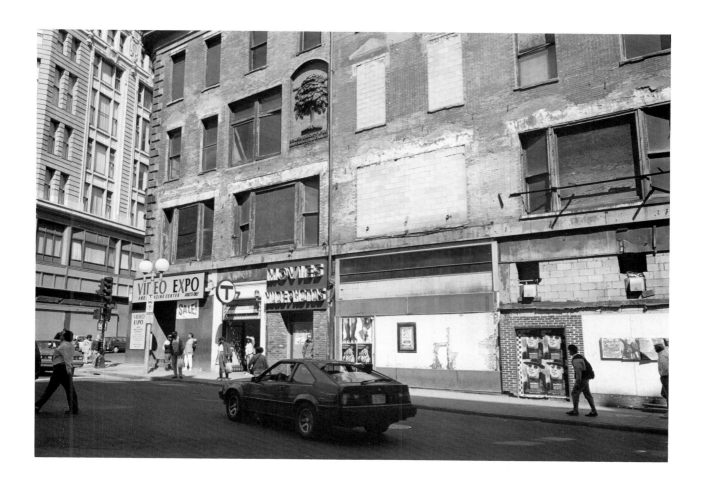

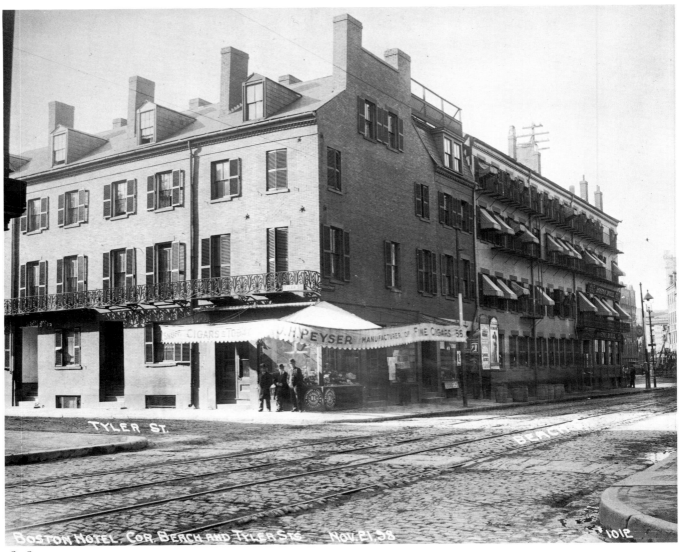

1898

Posing for the Album

Photographs and photographers were once rare. Old photographs of cities are usually records of special occasions.

Here at the corner of Tyler and Beach, in what is now Chinatown, three men pose beneath a canopy, which reads "Snuff Cigars & Tobacco J. H. Peyser Manufacturer of Fine Cigars." We are, surely, witnessing the opening of a new business.

The simple six-story loft building that now occupies the site may once have been handsome in a workaday way — its details are surprisingly subtle — but it isn't now, because its original

58

windows have been replaced by ugly fake stone at street level and by metal-and-glass curtain-wall above.

And the former cobbled street, with its flat granite crosswalks and street railway tracks, has given way to the characterless asphalt and choked traffic of today. Of course old Boston wasn't really so vacuously free of traffic. The photographer probably chose a Sunday for this album photograph.

Like most of Boston, the land in these pictures is artificial. This area was created by the filling of the South Cove in the 1830s. The Boston and Worcester Railroad, wishing both to speculate and to gain space for a new terminal and yards, filled fifty-five acres in those years, cre-ating three miles of new streets, including most of today's Chinatown and Leather District. The landfill was completed in 1839. As early as 1900, there were 500 Chinese in what was to become Boston's Chinatown.

But architecture cannot progress by the fits and starts that a succession of revolutionary ideas involves. Nor, if it exists perpetually in a state of revolution, will it achieve any kind of public fol-lowing, since public interest thrives on a capacity to admire what is already familiar and a need to label and classify. — J. M. Richards

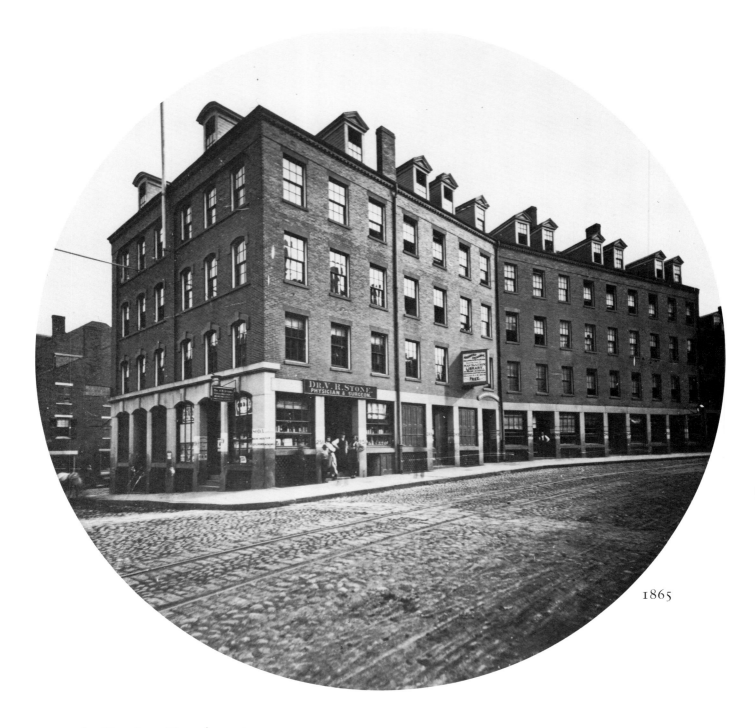

1865

A Quiet Perfection

PART OF A NICE OLD BUILDING has been demolished and replaced by a squat modern intruder at the corner of North and Lewis streets in the North End, as demonstrated by this pair of photos.

Or has it?

Deciphering changes in the city over time isn't always as simple as it looks. A closer look at the photos disproves one's first assumptions.

It's a detective game. By counting windows and figuring angles you realize that Lewis Street — the one on the left — must have been realigned at some point. Not only the one-story brick box on the corner (now a social club), but also the building beyond it — the one that's three

60

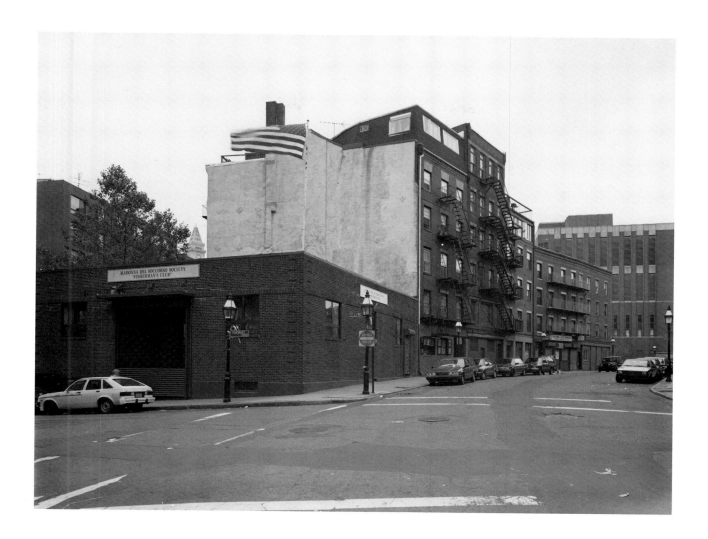

windows wide, with a sloping attic studio —
must have arrived after the date of the old photo.

Buildings in cities shouldn't be too high, but
they shouldn't be too low either. The clubhouse
here — Madonna del Soccorso Society/Fisher-
man's Club — spoils the harmony of the street
and the corner, not only by being so blank but
also by not being tall enough to be a satisfactory
wall to the street.

It has ruined a streetscape of quiet perfection.
In the old buildings the ground floor is a strong
base of granite that frames big openings for shops.
Above come three stories of a lighter material,
brick, punctured by windows. At the top are still
lighter dormers, made of wood, standing like a
row of little cottages along the roof, engaging the
sky and reaching out for daylight. Poetry and
logic are equally on display.

There are other changes. At the old corner
stands a pharmacy. Other signs advertise nautical
services — a Mariners Exchange, a Navigation

Library — for the waterfront, only a block away,
where Lewis Street becomes Lewis Wharf. There
are cobblestone pavers, granite crosswalks, and
iron tracks for horse-drawn trolleys, all now
replaced by bland asphalt and painted lines. The
dormers have disappeared, sometimes making
way for new fifth and sixth floors. Storefronts
have been filled in. Fire escapes and balconies
improve the safety but not the appearance of the
street.

Finally, quaint new streetlights, imitations of
gas lamps, fake the past without equaling it. This
is one of those sad scenes in which nothing that
is new is as good as what it has replaced.

YOURS FOR THE REVOLUTION — Jack London
There won't be no Revolution — H. G. Wells
— Entries in the visitors' book of the Tavern
Club, Boston

A Hole in Time

I N T H E M I D D L E of the new photo two people stand holding up a print of the old one — as if it were a hole in time, a glass window from the present into the past. The two are Frank Susi, co-owner of the Abruzzese Meat Market at 94 Salem Street, and Nancy Lavita. Susi keeps the print on display in his store.

It's the nature of cities that new things keep happening in the same old places — as opposed to the world of the suburbs, which are always spreading outward, like rings of water, so that new things are more likely to occur in formerly vacant places. Time laminates in cities, like the seven layers of Troy dug up by the archeologists.

You almost feel that you could, indeed, cut a window in the present and watch a very different past being enacted.

We are looking at Salem Street in the North End. We are reading a tale of unstoppable change, even among the buildings themselves, even here in the oldest residential neighborhood in one of the nation's oldest cities. On this stretch of Salem, believe it or not, only two small town houses show up in both the old photo and the new, though they are but three generations apart in time.

The people change too, of course. The Hebrew characters on the banner, advertising reli-

1901

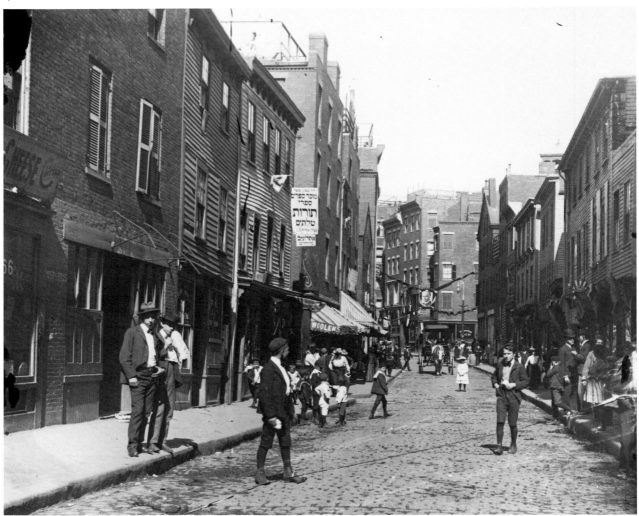

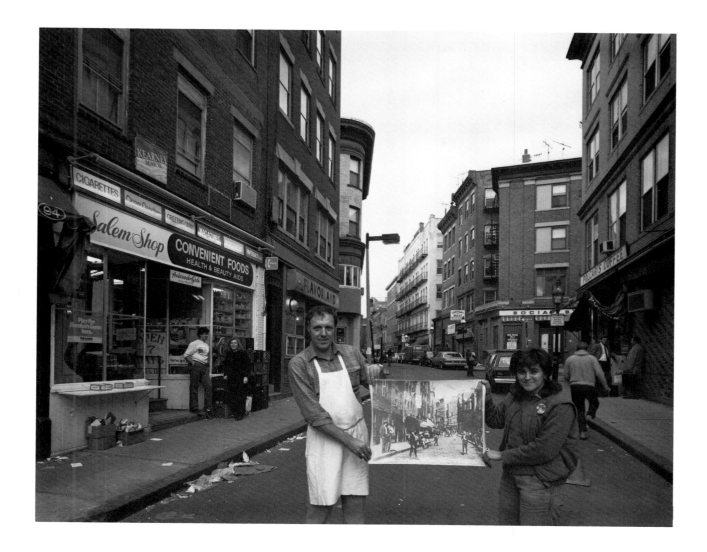

gious goods, remind us that the North End wasn't always Italian. It was first Yankee, then heavily Irish, then heavily Jewish. A third of the buildings in the old photo are still made of wood. Many have railings on the roofs, presumably for drying clothes; these are replaced in the new view by TV aerials. At some time between the making of the two photos, Salem Street has been widened, a fact that may account for the demolitions, but it remains one of the narrowest important streets in Boston and quite possibly, though not at the moment of the new photo, the most congested. Its congestion makes Salem feel like the place where the action is, the kind of street we're drawn to.

Inside the old photo, strangely enough, there is also a smaller photo being held up — not by people, this time, but by black crepe-covered ropes. Hanging just above the horse and buggy, it is a portrait of President William McKinley, who had just been shot and killed in Buffalo. (The two surviving town houses are behind McKinley.) Visible, too, if you look hard, is a huge, flag-bedecked McKinley poster just above what today is Centofanti's Meat Market.

City Life. Millions of people being lonely together. — Henry David Thoreau

Fields and trees teach me nothing, but the people in a city do. — Socrates

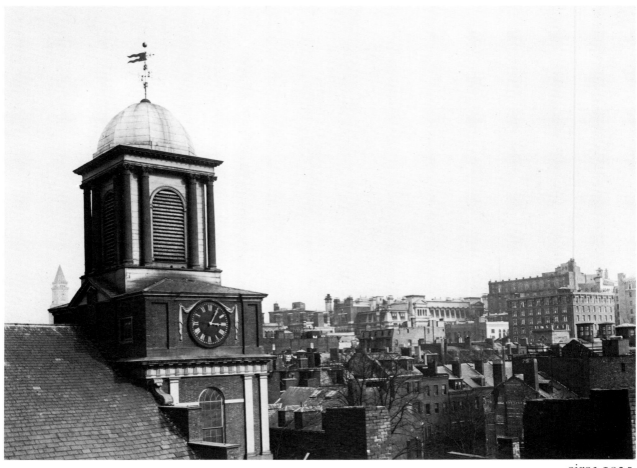

circa 1925

The Bureaucrats Build

Two of the dumbest, ugliest buildings in recent Boston history hulk like thugs above the delicate town houses of Beacon Hill in the newer photograph. Rarely has the faceless mask of government bureaucracy been so accurately expressed in architecture.

They are the Saltonstall (left) and McCormack (right) state office buildings, also known respectively as 100 Cambridge Street and One Ashburton Place. Both are the work of Desmond & Lord, now defunct, a firm of architects more notable for political connections than for sensitive design. Former U. S. Senator Leverett Saltonstall and former U.S. Speaker of the House

John McCormack deserve better memorials than these twin blockheads.

At left in both photos is the tower of Old West Church on Cambridge Street, now a National Historic Landmark. Built in 1806 as a Congregational church, it was designed by one of Boston's remarkable architects, Asher Benjamin (1773–1845). Its architecture is in the slim, delicate, flat-surfaced Federal style of Charles Bulfinch, Benjamin's mentor.

Benjamin created the somewhat similar Charles Street Meeting House. He also published a series of immensely influential architectural handbooks that helped establish first the Federal

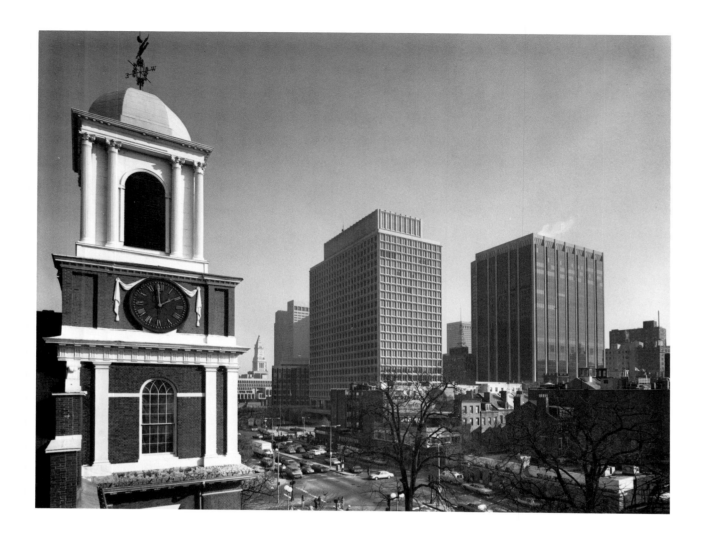

and then the Greek Revival styles throughout the United States. He was, in fact, indirectly responsible for much of the good architecture built in the United States from 1800 to 1830. In his *American Builder's Companion* of 1806, he describes Old West in a highly pragmatic manner:

> The size of the house is seventy-five feet square; porch twenty by forty-six feet; to contain one hundred and twelve pews on the lower floor. The gallery is supported by columns of the composite order. The ceiling has a low dome in the center, of forty-two feet in diameter, which rises six feet.

By the late nineteenth century, Boston's fashionables had moved away to the Back Bay and elsewhere. Old West Church closed in 1892, and the city converted it into a branch public library that long served the youth of the neighborhood, which had become a port of entry for immigrant populations. After the city brutally razed the West End in the late 1950s, a Methodist group reopened Old West as a church in 1964.

We hate the palpable design upon us.
— John Keats

1960

A Textbook Disaster

THE TRASHING OF THE WEST END has become a legend of bad urban renewal.

A densely populated, multiethnic neighborhood of brick tenements, the West End was declared blighted in the 1950s and taken by the city through eminent domain. Its residents received notice that the city was now their landlord and that they must vacate their homes. Little was done to help them relocate. When Marc Fried, a sociologist, later interviewed former West Enders, he found many of them suffering from sadness and alienation. They mourned a neighborhood that to outsiders had seemed a slum but that to its residents had been a closely knit, supportive community.

George Stephen, an architect with the National Park Service, made the earlier photograph in 1960 when the West End was being demolished. The more recent view shows what replaced this part of the neighborhood: the State Services Center complex, designed by the noted architect Paul Rudolph, part of the Government Center renewal project. Other parts of the West End became today's Charles River Park and Longfellow Towers.

Urban renewal, they called it. But it ruptured the human scale of Boston with sudden giantism. Old maps suggest there were not fewer than 130 separate properties occupying six tiny blocks on the site that became the single superblock of today's State Services Center. Rudolph conceived the new building as a craggy, Romantic, towered fortress, built of concrete that was deliberately roughened by beatings with hand-held hammers. As so often happens with grandiose projects, this one never was finished. The tower portion remains unbuilt, leaving a vast gap usually filled with parked cars.

66

Rudolph's design was a brilliantly theatrical concept, but it proved, in practice, inflexible to changes in use and intimidating to both occupants and passers-by. The photo shows one end of the building, fronting a plaza that is empty and frightening and ravaged by wind and glare. The plaza's edges fail to enliven it, either with the commerce of shops and restaurants or the human presence of residents. All this is a sharp contrast to the teeming street life of the old West End.

The new West End is a lesson in how not to make a city. Cities are made of streets and squares, not megalomaniac superblocks. The more streets, usually, the better. Thus Portland, Oregon, with its typical 200-foot-square block, is regarded as a gem of urban design, whereas Salt Lake City, with a 1200-foot block, is practically unworkable. A good rule for planners would be simply never to close a street. Such a rule would be a powerful weapon against overscaled development.

Good cities are made, too, of many uses mixed together in one place. Part of the astonishing deadness of the West End today is caused by the relentless sorting out of uses, as if apartments and shops and hospitals and hotels and government offices — all of which exist here — would somehow contaminate one another if they were allowed to make contact.

The new West End is the product of well-meaning but idiotic control freaks, playing in their offices with zoning maps instead of walking out into the world to observe how cities really work. It is the least urban neighborhood in Boston today. Its only virtue is that it has served for three decades, and will serve for many more, as a helpful textbook of mistakes to be avoided.

Babylon is fallen, is fallen, that great city.
— Revelations

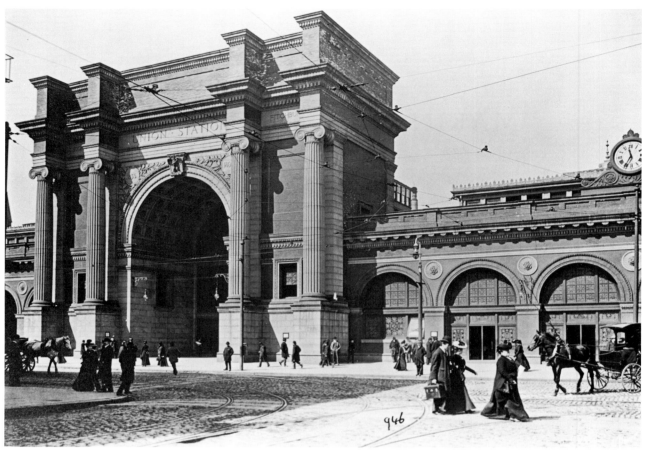

1905

From Unity to Dissonance at North Station

NO BUILDING EXPRESSES better than Union Station the sense of public grandeur — a false-fronted grandeur, often enough — that was sought by Bostonians in the decades after the Civil War.

The very name Union Station speaks of that era — of the patriotism of the War to Save the Union and of the belief, threatened by rising immigration, that the nation really was a cultural union expressing a WASP consensus. In these photos we see how the fragile dignity of that era — a dignity of both persons and buildings — has since been shattered by the pluralism and dissonance of our own time.

Union Station opened in 1893. It was torn down and replaced by the present North Station/Boston Garden complex in 1929. In the older view the people, like the architecture, are dressed up. All wear dark clothes, all wear hats, and all are leading busy and purposeful lives — or at

least would like to give that impression. The unity of dress and manner suggests a society that knows its values and wants to conform.

The five teenagers of today are equally concerned *not* to look dignified. Calculated disarray of dress and posture is their keynote. A different set of values is being expressed, those of uncertainty, pluralism, and inclusiveness. From left, the boys are Matthew Albrecht, Stephen Heywood, Duncan Moss, Andy Swett, and Jamie Heywood. They are from the suburb of Newton and have stopped for hamburgers during an excursion (by car, of course, not train) to the beach.

The architecture has changed as the people have changed, metamorphosing from a brave front of unity into something much less assured. Union Station, designed by Shepley, Rutan and Coolidge, the firm begun by H. H. Richardson, was, for all its grandeur, a sort of nonbuilding. It was little more than an enormous gateway and

arcade that linked two previously existing railroad stations. Its object wasn't so much practical use as the expression of civic dignity and permanence. But permanence was the one quality American cities were destined to lack. Today Union Station, which appeared to be built for the ages, like the Roman triumphal arches it mimicked, is long gone. Now there is talk of replacing its successor.

Union Station is one of the best Boston examples — the Museum of Fine Arts is another — of the architectural style known as Beaux-Arts, named after the École des Beaux-Arts (School of Fine Arts) in Paris, which many American students attended in the late nineteenth century. Another railroad monument, Grand Central in New York, is perhaps the best-known example of the style in the United States. Beaux-Arts tends to express the sense of an ordered,

hierarchical society by means of grandly symmetrical layouts and Roman imperial motifs.

The beer billboard above the Boston Garden and the mural on the Green Line MBTA bridge are reminders of our own very different, media-dominated age. They are part of a general visual polyphony, disorderly but not unpleasing, that is much like the dress and posture of the five boys. The mural, done in 1977 by Karen Moss (no relation to Duncan), is called "Leaves 'n Link" and depicts a luxuriance of growing plants, with perhaps also a hint of fluttering birds, all trapped behind a chain-link fence.

A city that invites ordering is better than an orderly city. — Kevin Lynch

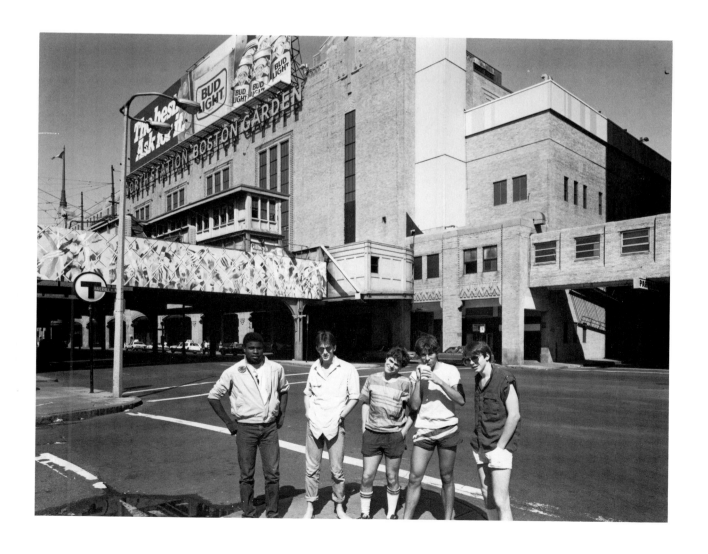

How to Fill a Corner

LIKE AN ENORMOUS STONE ocean liner
steaming toward downtown Boston, the
Statler Building with its curved prow is as
streamlined as the great Cunarders that were
among the visual icons of its era. The building is
everything, in fact, that its predecessor on the
site, the prickly Boston and Providence Railroad
Station, was not. Yet both, in their separate eras,
nobly anchored the prominent corner of Colum-
bus Avenue and Providence Street.

Sometimes the history of American cities
moves so fast it resembles a time-lapse anima-
tion. Already, by the time of the older photo, the
great rail terminal was in decline, having been
abandoned by its owner for the newer South Sta-

tion after only twenty-eight years of use. Its
various parts were soon converted into a roller
skating rink, a bicycle track, an exhibit hall, and
an automobile warehouse. Later it became a the-
ater. In 1925 it was finally demolished for the
Statler.

Peabody and Stearns, the architects for the
Boston and Providence Railroad, surely had
higher hopes. They designed the station in 1871
as one of the largest in the country, though it
served only the busy forty-four mile run to Provi-
dence. It is an engaging, cluttered heap of roofs
and gables and dormers, from which there shoots
skyward a 150-foot clock tower intended as a per-
manent Boston landmark — an ambition the
same architects were actually to achieve, decades
later, with their Custom House Tower. The style,
Ruskinian Gothic, is that of Harvard's Memorial
Hall. This multicolored, ornate version of Italian
medieval architecture was popularized in Victo-

rian times by the English author John Ruskin, who liked it because it offered so much leeway for craft and ornament. To compare this genial rat's nest of architectural motifs with the Union Station of twenty years later is to measure a sudden rise in national — and corporate — pomposity.

Today's Park Square is dominated by the Statler Building, a sleek shape, all business, that is neither genial nor pompous. Both an office building and a hotel (the Park Plaza, formerly the Statler), it was designed in 1925 by another famous architect, George B. Post of New York. It's a handsome, self-assured structure that powerfully embodies a lesson in city design. The lesson is that an acutely angled corner is better filled out with a building than left as open space. New York's Flatiron Building is the classic example.

To the Statler's right stands the bland Four Seasons Hotel, and to its left is a corner of the Motor Mart Garage, probably the ugliest building ever to win (in 1927) the Boston Society of Architects' annual Parker Medal as the most beautiful new work of architecture in greater Boston. The Motor Mart is a fitting backdrop for Thomas Ball's sentimental and condescending statue of Lincoln emancipating a slave, a copy of an original in Washington.

And instantly, an intolerable desire would awaken in me to go out in the streets. I would feel, with a feeling of wild longing, pain, and joy, that I was . . . allowing some superb happiness and good fortune to escape from me by staying in my room. . . . Some fulfillment of glory, wealth or love was waiting for me everywhere through the city. — Thomas Wolfe

Not Making a Great Public Square

A GHOST TROLLEY CAR, watched by a woman and a horse, speeds past Trinity Church in the older photograph of Copley Square.

Copley Square is an example of Americans' chronic inability to create successful public spaces like the great piazzas of Europe. At least once a decade, ever since the 1880s, someone has proposed a new design for Copley. Several were implemented. None has succeeded.

The trolley is on Huntington Avenue, which split the square diagonally until 1968. In that year a national competition was held to create a new design for Copley Square. The winning entry, by Sasaki Associates, proved to be — after some budget cuts, to be fair — all but universally disliked. It was a sunken square, hidden by concrete berms and paved in asphalt. A new national competition in the 1980s produced the Copley Square of today. It isn't sunken, and it's greener, but it lacks a memorable or even definable character.

Copley Square's problems are partly the fault of its site. When the Back Bay neighborhood was created in the late nineteenth century, this part was the farthest from the Charles River and the nearest to the railroad tracks. It was the least salable section of the development and so was devoted to public monuments like Trinity. It never was at the center of anything, but lay at the periphery of the Back Bay.

But Copley's more basic problem is indigenous to American culture. Except for eating brown bag lunches, we never seem to know quite what to do in a public square.

Besides the square itself, many other changes are visible. At the right in 1900 is the old Boston Museum of Fine Arts, designed in 1876 by Sturgis and Brigham in Ruskinian Gothic style. For all its pizzazz the museum building had a brief life, giving way in 1912 to the Copley Plaza Hotel, a tame example of the work of Henry Hardenbergh, the New York architect of the flamboyant Dakota apartments (where John Lennon lived and died, and where the movie *Rosemary's Baby* was made) and of New York's Plaza — now Trump Plaza —

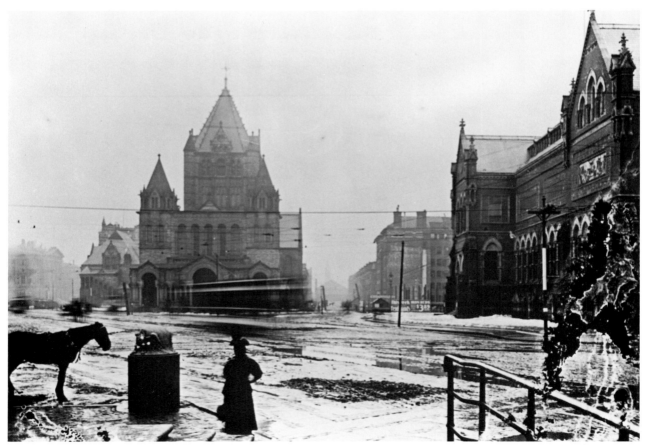

circa 1900

74

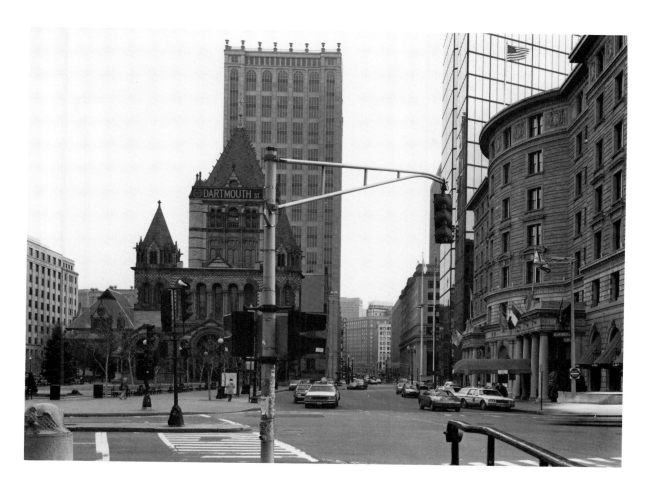

Hotel. Beyond the museum you can make out piles being driven for the construction of the old Westminster Chambers Hotel; beyond the Copley Plaza, you can see the glassy Hancock Tower, which replaced the Westminster in 1976.

The constant through the whole history of Copley Square is Trinity Church, one of the great Boston landmarks. Henry Hobson Richardson (1838–1886), its architect, grew up in New Orleans and studied at the École des Beaux-Arts in Paris. His name became forever linked with Boston when he moved to Brookline after being chosen to design Trinity in 1872. Richardson admired the Romanesque architecture of the French Middle Ages, a style of massive stone walls and deep-set round arches, and at Trinity he improvised freely on it. By no means flawless, Trinity is a building of boldly formed individual parts, sometimes awkwardly juxtaposed, that heap up into a great pyramid of enormous visual power.

Trinity dazzled American architects. Its style, known as Richardsonian Romanesque, was imitated in hundreds of city halls, libraries, and courthouses across the United States during the 1880s and 90s. Richardson went on to more mature works, but none more zestful. As recently as 1991, a national poll of architects ranked Trinity the ninth greatest building in U.S. history — and Richardson the third greatest American architect.

Trinity's great tower, alas, is no longer silhouetted like a giant against the sky. It is now dwarfed by an office building of the 1980s, 500 Boylston Street, a bland exercise in post-modernism by New York architects Philip Johnson and John Burgee.

Also a problem today is the deranged clutter of street furniture. At least fifteen traffic lights are visible, controlling cars and pedestrians at this one intersection, not to mention three *different* styles of streetlights. Because we've taught ourselves to be blind to such clutter in life, we're often surprised when we see it in photographs.

My idea of paradise is a perfect automobile going thirty miles an hour on a smooth road to a twelfth-century cathedral. — Henry Adams

Chopping Off the Top of the Westminster Hotel

L IKE A SERENE OLD SAGE, Trinity Church
has witnessed many changes in the world it
inhabits. None is more extraordinary than the
replacement of the late Victorian Westminster
Chambers Hotel by the late modern Hancock
Tower.

Trinity is on the left in both photographs.
Next to it, in the older one, is the underbelly of
the Westminster Hotel's octagonal corner bay,
richly endowed with decoration conceived in
kitsch and executed in terra cotta by a sculptor
named Max Bachman.

Bachman's lifeless pre-Raphaelite angels,
looking like drugged teenagers, hover above a fig-
ure of Neptune, who is holding hands with an
unseen lady friend around the corner. Beneath
Neptune we can read the end of an inelegantly
lettered Latin slogan, "Virtus non stemma char-

acter," which seems to mean something like
"Virtue, not pedigree." When did our buildings
stop preaching at us?

For all the richness of surface, for all the
humanity and charm, you can't avoid the sense at
the Westminster of a decorative tradition that has
reached its dead end. A tired artist is going
through the motions one more time.

The Westminster, completed in 1903, was
demolished in the 1960s and eventually replaced
in 1976 by the Hancock Tower, designed by
Henry N. Cobb of I. M. Pei & Partners (now Pei
Cobb Freed). The Hancock's minimalism — its
exterior is 10,244 pieces of glass framed in black
aluminum, nothing else — offers the ultimate
contrast to the Westminster's kitsch. Swept away
by the clean broom of modernism are the clutter
and confusion, but also the life and texture, of the

Westminster. They are replaced by a blank, aloof, and abstract — but very great — elegance, an elegance of understatement that seems to say, "I know I'm too big so I'm pretending I'm not here." The Hancock has the arrogance of the shy.

The Westminster and the Hancock are linked by one of the great ironic stories of America's architectural history. When built, the Westminster was discovered to exceed the height limit of ninety feet, which the legislature had established in 1898 for all buildings fronting Copley Square. The city sued the owners, and in 1903 the U.S. Supreme Court ruled against the Westminster in a decision that helped establish the right of governments to regulate the heights of buildings. And the ruling was enforced: the Westminster's owners were compelled to chop off the top six feet of their building, leaving it visibly shorn for

decades, until its demolition and replacement by the Hancock Tower — which exceeds the old height limit not by six feet, but by exactly seven hundred.

Between those two symbolic events — the chopping off of the Westminster in 1903 and the topping off of the Hancock in 1975 — there occurred, surely, a loss of nerve and consensus among Bostonians in deciding what our city should be.

For architecture is, after all, a representational art — an art of portraiture, if you will — and what is portrayed in it is precisely the multiform structure of desired relationships between human beings, their institutions, and the natural world. — Henry N. Cobb

A Neighborhood That Is a Masterpiece

1864

FOR MORE THAN THIRTY YEARS, starting in 1858, a train arrived from Needham about every forty-five minutes, day and night, with a load of gravel to fill the odorous tidal salt marsh known as the Back Bay.

One pales to imagine the screams of environmentalists should any such act be contemplated today. The filling of the Back Bay was an operation of city building on a scale that dwarfs the efforts of our own time. It created 450 acres of new land, including all of today's Back Bay neighborhood plus some of the South End, filled to an average depth of twenty feet. And it was only one of many such operations. Across the Charles River, in Cambridge, another 416 acres were created, intended as a residential community but instead the site today of Massachusetts Institute of Technology.

The Back Bay is surely the greatest of all *designed* American residential neighborhoods, as opposed to those, like Beacon Hill or Georgetown, that grew more slowly and organically. It was a joint venture, a grand public-private speculation, by the Commonwealth of Massachusetts,

the City of Boston, and commercial interests, all owning parts of the original marsh. After the filling, lots were sold for houses.

The remarkable street plan gathers around the great public boulevard of Commonwealth Avenue, a link in the so-called Emerald Necklace of parks conceived by pioneer landscape architect Frederick Law Olmsted. Commonwealth is a band of green that joins the Public Garden to the Fens. The logical, beautiful Back Bay plan, with its service alleys between the streets, was developed over many years through a great deal of discussion and negotiation and was firmly in place before the first buildings were built.

The old photo gives a sense of the raw, vacant, no-man's-land atmosphere of the landfill in its early years. Speculators sometimes held plots back from development, awaiting a rise in their value, creating a checkerboard pattern of growth. The prominent building is the museum of the Boston Society of Natural History, just one year old. Behind it, under construction, is the Rogers Building, home of the newly founded Massachusetts Institute of Technology. The year is

1864, the photographer the celebrated Josiah Hawes. Both buildings were designed by a young architect named William G. Preston, and they looked much alike. In 1947 the Natural History Museum moved over to the Charles River Dam to become today's Boston Museum of Science, and the clothing store Bonwit Teller moved into the former museum. In 1989 it was restored for another clothier, Louis of Boston.

William Gibbons Preston (1842–1910) was perhaps the archetypal Boston architect of the Victorian decades. Unconstrained by dogma, he didn't limit himself to the Renaissance Revival style, rooted in Palladio, that we see here. Like many Paris-trained architects of those years, he could give you just about anything you might want. Examples are his Hotel Vendome on Dartmouth Street, his First Corps of Cadets Armory in Park Square, his Chadwick Lead Works on High Street, and his Claflin Building on Beacon Hill — all different, each a gem. His ten thousand drawings fill forty-eight volumes in the Boston Public Library.

Preston's Rogers Building was demolished in 1939 — by then it had long been MIT's school of architecture — to make way for the New England Life Building, the ungainly block designed by Ralph Adams Cram that stands like a vertical punch card in the background of the new photo. Its vague, funereal classicism inspired a satire, shaped in the short, self-mocking verse form called a clerihew, by Harvard poet David McCord:

> Ralph Adams Cram
> One morning said damn,
> And designed the Urn Burial
> For a concern actuarial.

Ironically, as a young Turk forty years earlier, Cram had been among the loudest protestors when the Westminster Chambers Hotel broke the height limit in Copley Square.

I never saw . . . so many FINE-LOOKING GRAY HAIR'D WOMEN. — Walt Whitman ("The Boston of Today")

Designing by Deed Restrictions

ANOTHER JOSIAH HAWES photograph, dating from 1864, suggests the lonely isolation of the early Back Bay houses, built on newly filled land, their rear windows looking across the tidal basin to the little village of East Cambridge. The house is 234 Beacon Street, at the corner of Dartmouth. It stands on what people always called "the water side of Beacon," long one of the city's prestigious addresses.

In the 1860s the fashion in Boston was French. The boulevards of Paris were being created for Napoléon III, and the first Americans to study architecture at the École des Beaux-Arts were returning home. Boston's taste changed suddenly. The traditional brick bowfronts grouped around small patches of green space — the English model, followed on Beacon Hill and especially in the South End — began to feel cramped and provincial. There was a yearning for grander vistas like those of Paris, for sweeping boulevards in which the big public shape of the street space (with its suggestion of parades, especially those of fashion) would matter more than the private assertions of any one house or grouping of houses.

As historian Bainbridge Bunting writes in *Houses of Boston's Back Bay:* "The chief responsibility of each façade is to enhance the total street rather than divert attention to itself. A house front is merely one section of the long continuous wall that defines the street-corridor."

To enforce that continuity — yet also relieve it by variety — the Commissioners on Public Lands in the Back Bay imposed some amazingly sophisticated controls on all owners through the deeds to the land.

A house had to be at least a minimum height (the elevator hadn't been invented, so no one was worried about buildings getting too high), and it had to be set back twenty feet from the front property line. Here follows the real genius: a house could project forward as much as five feet from that twenty-foot line — thus violating the setback — for up to 70 percent of its width (not to exceed eighteen feet). But this projection had to remain within a trapezoid framed by sides angled at 45 degrees to the façade — in other words, the bay window as we see it in these photos.

By allowing bay windows to extend outside the normal zoning envelope, the commissioners guaranteed there would be no lack of them. The bay-windowed street frontage of today's Back Bay was imagined by the laws that created it. This was an astonishing act of city design.

The streets of the Back Bay embody a distinctively American kind of urbanism. Unlike the boulevards of Paris on which they are modeled, they're not made up of uniform frontages, with all the buildings alike. Uniform frontage implies a powerful central authority, controlling the lives of individuals — as indeed existed in Paris. Americans have never been comfortable with that kind of urbanism. In the Back Bay almost every house looks different. The neighborhood is an explosion of individuality and personal display. Yet because of the commissioners' wise controls, there is also a sense of public consensus.

A street in the Back Bay makes two statements. It says, "We are a community." But it also says, "We are free individuals." The Back Bay creates a public realm without stinting the right of personal self-expression. It's an architecture that expresses the best of America.

The photos tell of changes in the Back Bay over time. At some point the two houses in the newer one were stripped of ornament and converted into apartments. In one, stucco covers the original brownstone. The wealthy families who pioneered the Back Bay had largely deserted by 1950. Mansions became dormitories or lodging houses. In the early 1960s Mayor John Collins swore he would stem the neighborhood's decline by building high-rises on corner sites. But he was stymied by an emerging preservation ethic. In 1966 the Back Bay Architectural Commission was created to assure preservation of the neighborhood. In the 1970s and 80s the Back Bay changed radically once again, returning to affluence as many houses were converted to condominiums.

The houses lining the [Back Bay] streets are all individual expressions, which, due to the unifying effect of rhythm and scale and the use of brick and brownstone, become members of the same family. — Christian Norberg-Schultz

1864

Throwing Away a Resource

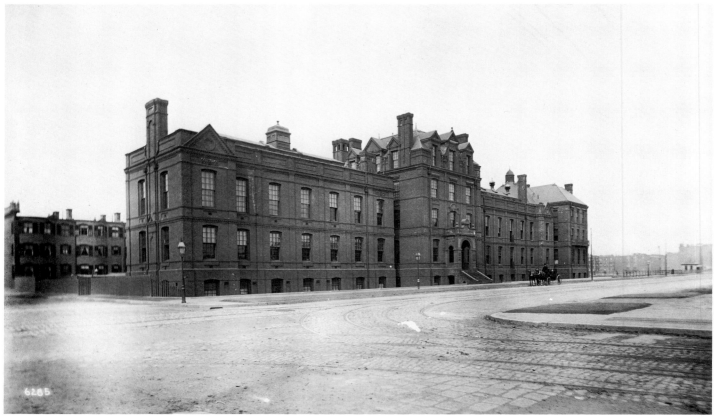

1893

H IGH VICTORIAN GRANDEUR shrivels to
twentieth-century efficiency on Hunting-
ton Avenue. The impressive old building that
looks like a vast Victorian British country seat is
Boston Children's Hospital, erected in stages
between 1881 and 1890. This was the first home
Children's built for itself. Previously, since its
founding in 1869, it had occupied converted town
houses at the corner of Rutland and Washington
streets in the South End.

Soundly constructed of red brick, generously
proportioned, the hospital deployed two wings,
with a total of ninety patient rooms, on each side
of a tall administration block. With ceiling
heights of up to seventeen feet, it must have been

flooded with sunlight and fresh air. It boasted a
huge playroom and — added after this photo — a
series of glass-enclosed sun balconies on the
south-facing Huntington façade.

Boston's history is filled with buildings
intended for all time yet doomed to last only a
generation. By 1914 Children's had outgrown its
handsome quarters and moved to the country —
that is, to Longwood Avenue near the border of
Brookline. It remains there today, although no
longer in the country, and is still in a constant
state of growth and change. By 1917 the grand red
brick pile on Huntington had been demolished.

In the 1920s the site was redeveloped as a
480-foot-long, two-story concrete box of commer-

cial space. It contained the Raymore and Playmore ballrooms, where nationally famous swing bands performed in the 1930s, when the neighborhood was dotted with jazz and dance clubs.

Also visible in the new photo, at far right, is Symphony Hall. It arrived in 1900 on the corner of Massachusetts Avenue, at the far end of this block. In the 1980s, in an era of depressed real estate values on Huntington, the Boston Symphony Orchestra bought a third of the 1920s commercial block, and in 1989 opened it as the Cohen Wing, with banquet rooms, office space, and a gift shop.

The short life and thoughtless demolition of Children's Hospital illustrates the changing ethic of a maturing nation. Casually discarding so valuable a built resource would be unthinkable today. The American belief in limitless resources, so long nourished by a vast and unexploited continent, is disappearing. The Boston Symphony gave more love and care to the renovation of its chunk of the concrete box than anyone ever thought of devoting, sixty years earlier, to Children's Hospital.

No American lives where he was born or believes what he was taught. — George Santayana

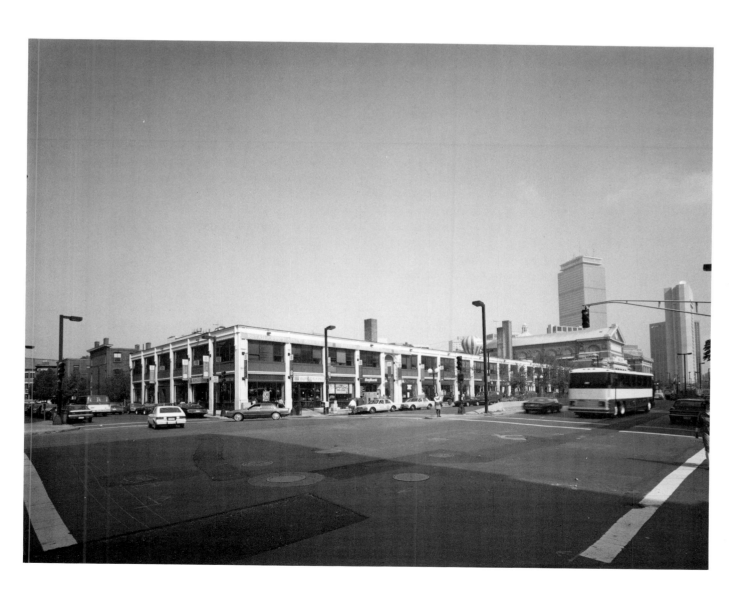

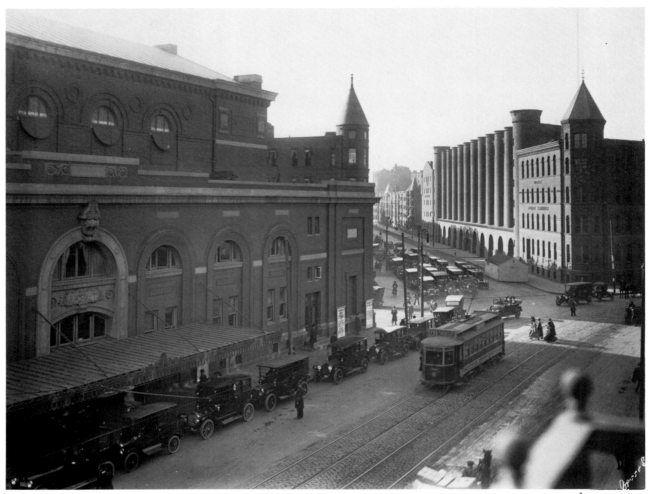

late 1920s

How to Ruin a Good Corner

WHAT IS IT, EXACTLY, that has transformed the intersection of Westland and Massachusetts avenues from well-shaped urban space into a mishmash?

Symphony Hall, on the left, hasn't changed much, although the recent photograph shows a less elegant canopy. But look at the rest of the old scene. Westland and Massachusetts meet at an acute angle, and the Boston Storage Warehouse, the building on the right-hand corner in the old photo, responds by angling along with the streets. It fills the corner and holds the edge and shape of both street spaces. At the same time, its octagonal tower punctuates the corner. It isn't an elegant building, but it's a very elegant piece of urban design.

There's another tower in the old photograph, poking up over the end of Symphony Hall, and this one also marks a corner, that of Westland

and St. Stephen Street — also an acute angle. Together the two towers, with their wizard hats, frame the opening into Westland, suggesting a gateway to this short, wide street, which is, in fact, a kind of boulevard leading to the Fenway beyond.

Thus can architectural forms work at shaping and marking urban space. And looking farther along Westland, next to the Boston Storage Warehouse, we see a remarkable building — another part of the warehouse — that is clearly intended to reassure customers by looking as impregnable as a fort. Its boldly shadowed rank of bays above and arches below make it, too, a strong — maybe even too strong — element in the street wall.

Now look at the corner today. Replacing the warehouse is Church Park Apartments, designed by the Architects Collaborative and finished in 1973. The rigidly right-angled orthodoxy of mod-

ernism does not allow this building to fold naturally, as it should, around the angled corner. It can align with one street or the other, but not both. Choosing to align with Massachusetts, the major street, it leaves silly little triangles of useless residual space along Westland. The spaces chip away at the shape of the street and the corner. And the aggressive, jutting upper floors of Church Park dominate Symphony Hall, which is the more important building, while failing to punctuate or turn the corner in any way. The round shape of the parking garage in the rear completes the chaos.

Even the cars and the trolley in the old picture have a humane appearance, looking like boxy rooms on wheels, unlike the sleek capsules of today. Cobblestones carpet the old street, domesticating it, where the bold painted stripes of today are visual static. In the old photo the cars parked in front of Symphony Hall make a kind of hedge that softens the street edge. They'd be illegal today.

Nothing in the recent picture is visually an improvement.

Charles Follen McKim (1847–1909), the architect of Symphony Hall, was a partner in the New York firm of McKim Mead & White, the most successful of its day. McKim and Stanford White had both been young draftsmen in the

office of H. H. Richardson. White was soon to achieve notoriety when he was murdered by socialite Harry K. Thaw, who was jealous of the architect's earlier affair with his wife, former showgirl Evelyn Nesbitt, known to gossip-column history as "the Girl in the Red Velvet Swing."

McKim handled most of the firm's Boston work, which includes his masterpiece, the Boston Public Library, and many buildings at Harvard, notably the stadium, the Freshman Union, Robinson Hall, and Johnson Gate in Harvard Yard. For these he developed a sober, dignified style drawn from a scholarly knowledge of Renaissance and Roman originals (which he employed for public buildings) as well as American Georgian and Federal (which he kept for clubs and houses). Symphony Hall was the first building ever to benefit from the services of an acoustician, Professor Wallace K. Sabine of Harvard, who invented the science. It has long been regarded as one of the best symphonic halls in the world.

The city is built
To music, therefore never built at all,
And therefore built for ever.
— Alfred, Lord Tennyson

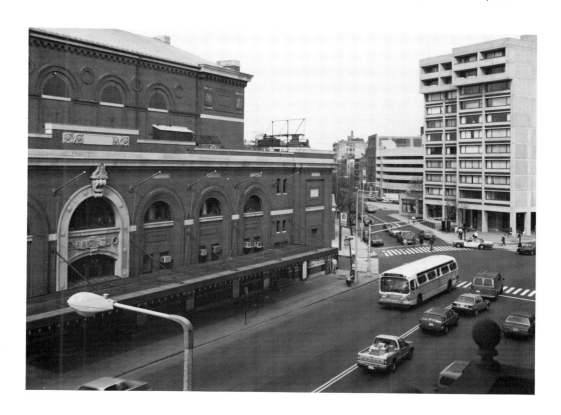

A Temple That Orders a Jumble

ORDER AND HIERARCHY and the architectural proclamation of an important public use give way to energetic visual static. The scene is the Longwood Medical Area, a secular Vatican within the city of Boston. Longwood is one of the engines of Boston's prosperity and a magnet for talent and money. Its 175 acres are devoted almost entirely to medical uses, and it includes seven hospitals, Harvard Medical School, the Harvard Schools of Public Health and Dental Medicine, and the Massachusetts College of Pharmacy. Now growing faster than ever, Longwood resembles a permanent construction site, as many of the institutions shoehorn new buildings into an already sclerotic context.

The situation was different in the first decade of this century. Then Longwood, as its name implies, was countryside. Harvard Medical School moved here in 1906, and its teaching hospital, the Peter Bent Brigham, opened in 1913. The original Brigham is the subject of the older photo, made when it was new. Peter Bent Brigham was a Vermonter who came to Boston in 1820 at age thirteen, prospered in the restaurant business, railroads, and real estate, and left more than a million dollars to found a hospital. Codman and Espadrille, the architects, also designed, when in a more festive mood, the fine Berkeley Building at Berkeley and Boylston streets, which looks like a cake iced with white frosting.

1913

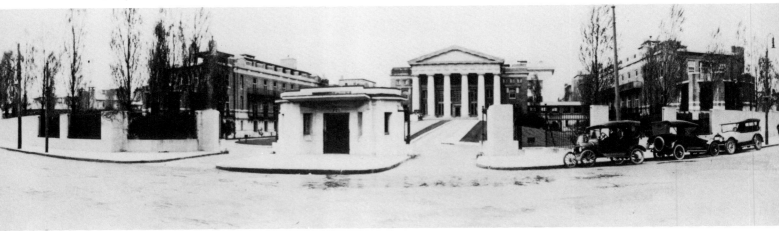

The Brigham exemplifies the formal, symmetrical planning taught at the École des Beaux-Arts. As so often happens when we Americans want our architecture to announce "secular, but still sacred" (for instance in our colleges, courthouses, and museums), the central element takes the form of a classical temple, with a chaste row of columns beneath a triangular pediment. This is the administration building, a link to the medical school behind it. Like its model, the Parthenon, it anchors what amounts to an acropolis of pavilions, spaced to permit the maximum in light, air, and view to the patients, most of whom also had easy access to outdoor lawns.

In the newer view the Peter Bent Brigham has become part of Brigham and Women's Hospital, thanks to a merger with two neighbors. New lab towers, drab as filing cabinets, hulk beyond it. The former entrance lodge, which looked a little too much like a tomb to be the ideal entrance for a hospital, has been replaced by an undignified box. Also gone forever is a precious metaphor of health: the ambiance of sunshine and trees. Hospitals today are factories for processing the sick, and they look it. But the power of Longwood's original organizing idea — the temple and the axis it commands — remains, still giving form to what would otherwise be chaos.

After the age of fifty, all change becomes a hateful symbol of the passing of time.
— Jorge Luis Borges

IV

STRUTTING OUR STUFF

SIDE BY SIDE with the public city, and helping to finance it, was a private capitalist city of ebullient pride, money, and growth, strutting its stuff in the Gilded Age. New styles of architecture — some French, like the Second Empire and Beaux-Arts and later the art deco, and some Victorian, with roots in Britain — offered architects a rich palette of shapes and colors. European culture and history seemed a costume shop to be raided at will. The Great Fire of 1872 created plenty of opportunities to build, and new inventions like the steel frame and the elevator helped buildings leap higher than ever before.

The landmass of Boston circa 1890

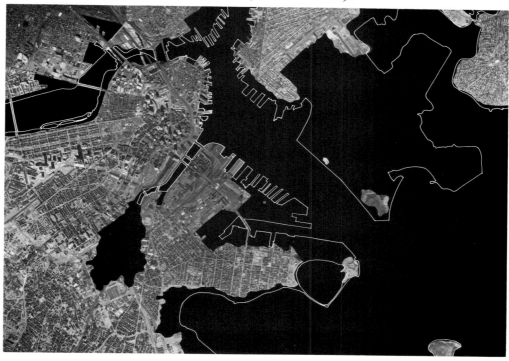

Stealing a Jewel from the Emerald Necklace

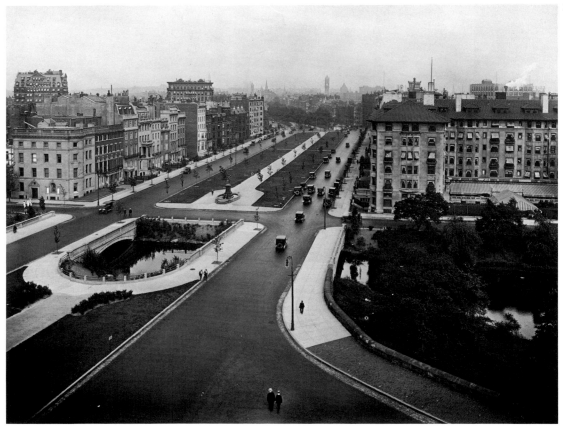

IT MAKES A POEM, a Walt Whitmanish catalogue poem:

> Sea lavender, goldenrod, asters, beach peas,
> beach plum, sea buckthorn, tamarix, Virginia
> rose, bayberry, sweet fern, dyer's greenwood,
> Oregon hilly grape . . .

It is part of a list of plants that were installed in 1884 in a tiny new park called the Beacon Entrance. The park covered only two and a half acres, but it was planted with 100,000 shrubs, vines, flowers, and trees. It was created by the great landscape architect Frederick Law Olmsted (1822–1903), who called it the Beacon Entrance because he thought of it as a narrow doorway into his much larger Back Bay Fens beyond. The park runs horizontally across the foreground of the photographs.

The Beacon Entrance hasn't been lucky. One wonders what would be the thoughts of the drivers of those speeding cars — oblivious, isolated, and encapsulated as they are — if they knew that someone, once upon a time, cared enough about the little patch of earth and water beneath the Park Drive overpass to place 100,000 plants there. No other part of Olmsted's Emerald Necklace, the chain of connected greenery that runs from Boston Common to Franklin Park, has been so devastated.

More has been lost than flora. The Emerald Necklace was part of the new public world that Bostonians were creating in the late nineteenth century. It provided places to which people of different classes, ages, and sexes could go from their private homes or offices. Here they could meet and mix, could see and be seen, in a new, engagingly theatrical awareness of their membership in a larger and more cosmopolitan community. For today's drivers, by contrast, the only shared public world is the media world — the cyberspace, as some now call it — of the car radio.

In the background we can see Commonwealth Avenue, the green spine of the Back Bay, carrying the Emerald Necklace on into the downtown. The tiny, toylike trees of 1924 have matured into green giants. Commonwealth at

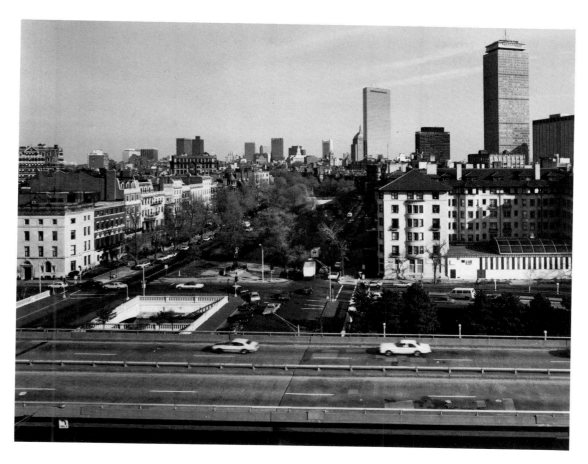

this end is lined with apartment houses and a few hotels; the building nearest on the right is the old Hotel Somerset, where Ted Williams once lived, now converted to condominiums.

In the Green Decade of the 1990s there is renewed interest in the work of Olmsted, who virtually founded the profession of landscape architecture, and whose works range from Boston to Yosemite. Superb restorations have enhanced New York's Central Park, by Olmsted and Calvert Vaux.

Olmsted believed in parks that seemed natural, like swatches of countryside that happened to survive by chance in the city. Most people probably believe his great parks are no more than just that. In fact, however, Olmsted's designs were brilliant feats of hydraulic engineering and artificial reconfiguration of the land. They completely transformed their settings, as the massive planting at Beacon Entrance suggests.

Olmsted lived most of his later life in Brookline, just a few hundred yards from the home and studio of his friend H. H. Richardson, with whom he often collaborated. His house there, Fairsted, is today open as a museum of his life and work. In his last years Olmsted became insane and was moved to McLean Hospital in Belmont, where he died. The lovely grounds of McLean, created decades earlier, were yet another Olmsted design: he made his bed, and eventually he lay down in it.

It's too late now for the Beacon Entrance. In his "Notes on the Plan of Franklin Park," Olmsted quoted the English critic and historian John Ruskin in words that can serve as a sad caption for these two views: "Let it not be for present delight, nor for present use alone; let it be such work as our descendants will thank us for and say, 'See! This our fathers did for us.'"

God the first garden made, and the first city Cain. — Abraham Cowley

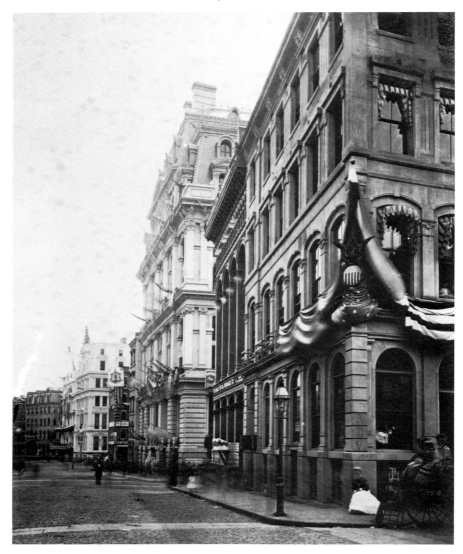

A Delicatessen of Styles

Iᴛ ɪꜱ 1876 in the old photo. The bunting on the building at the right front is the giveaway. Boston, along with the entire nation, is celebrating the American centennial. The country has donned its glad rags and is strutting its stuff. So is this architecture.

Everything here is brand-new because only four years earlier the Great Boston Fire had consumed 776 buildings, including the entire south side of Milk Street — the street we are looking at from the corner of Arch.

Probably there never was a more ornate display of Victorian grandeur in Boston than this row of buildings. The low block nearest to us is handsome, but fairly ordinary for the time. Beyond it, however, rises a lavish pale pile in the French style, decked out with pilasters and arches, and climbing to a spectacularly complicated mansard roof. This is the Equitable Building, designed by the prolific Arthur Gilman.

Not surprisingly, Gilman was also one of the architects of Old City Hall, another building in the Second Empire style. Napoléon III (the second emperor, uncle Napoléon having been the first) and his planner, Baron Haussmann, had recently created famous boulevards and monuments in Paris. The Paris Opera opened in 1875, just a year before this picture. Architecture *à la Française* was, briefly, all the vogue in Boston.

A bit farther down the street is what looks like a single white mansard-roofed building with a pointed tower. It's really two more insurance companies side by side: New York Mutual (which has the tower) and New England Mutual Life.

What we're seeing here is the pride and pleasure — plus a little pomposity — of these corporate owners who dressed their buildings with architectural ornament as they dressed themselves for balls and banquets. America was growing rich as it entered what Mark Twain

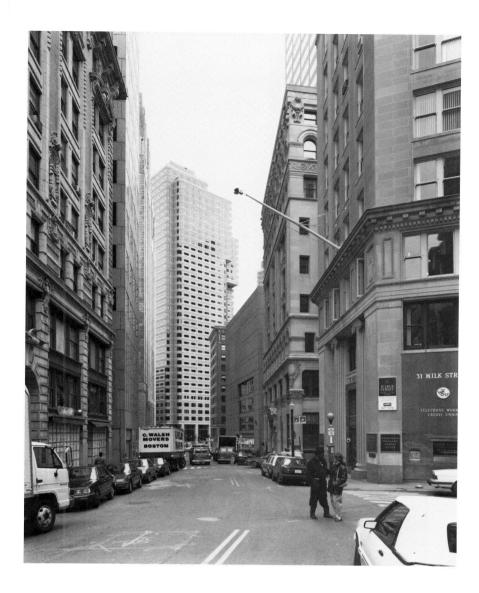

called "the Gilded Age." The term "robber barons" was coined for the Vanderbilts and Rockefellers now rising to eminence. Conspicuous consumption was perfectly all right, as in the Philadelphia Centennial Exposition of this same year, where 249 buildings constituted "a grandiose summation of the architectural styles of the period," in the words of one historian.

Americans felt themselves to be the young, legitimate heirs of European culture. Architectural history was viewed as a sort of delicatessen, from which Americans plucked whatever style they liked. William Randolph Hearst was soon to pack up European buildings and literally ship them home for reassembly.

These insurance companies, dressed to kill, prove that styles change but goals don't. In the 1960s and 70s, Boston insurance companies like Hancock and Prudential also knew how to demonstrate their importance, but by very different

means. They did it by the sheer height of their towers and by their consumption of the city's most valuable commodity — street-level real estate — by means of conspicuously useless plazas and lobbies. Still more recently, in the 1980s, the New England life insurance company chose a stagy version of post-modernism for its architectural self-assertion.

Every one of these Victorian commercial palaces, seemingly built for the ages, has disappeared in the new photo. Their replacements lack their zest. Dominating the view at the far end is One Post Office Square, an office high-rise with a few elegant interiors and a boxy exterior of flat precast concrete panels. It fails to make up in bulk for what it lacks in delight.

Good Americans, when they die, go to Paris.
— Thomas Appleton (nineteenth century)

Tombstones in a Cemetery

THE MOST TRAUMATIC EVENT in the history of Boston architecture — and Boston business — began at 7:24 P.M. on the evening of Saturday, November 9, 1872, in a four-story granite building at Summer and Kingston streets.

The 776 buildings destroyed by the Great Boston Fire were nearly all brick or stone. The fire virtually obliterated what was then the newer part of commercial Boston, leaving intact only the older area around State and Broad streets. Boston's tragedy occurred only a year after two even fiercer holocausts: the great Chicago fire, and a forest fire in Peshtigo, Wisconsin, that killed more people than any other in American history. Americans in the early 1870s must have wondered whether the Apocalypse was at hand.

One difficulty in fighting the conflagration was the odd fact that all but two of the city's ninety-plus fire horses were incapacitated, victims of a national horse epidemic. Another was the narrowness of streets, even major ones. After cleaning up the rubble, civic leaders seized the opportunity to straighten or widen many of them, including Washington, Federal, Franklin, Chauncy, Congress, Summer, and others. In both photos we are looking down Summer Street toward the waterfront, with the intersection of Arch and Chauncy in the foreground.

In the 1872 view the city resembles a cemetery. Chimneys and fragments of walls stick up like tombstones. A few horses and men are visible, wandering like ghosts among the ruins. It's hard to believe that within three years the district would be completely rebuilt, fancier than before, following strict new codes intended to make the buildings fireproof. The codes worked: there has

1872

never been another extensive fire in Boston. For some, the fire had a silver lining: it made the careers of a number of architects, just as the Great Fire of London fueled the career of Sir Christopher Wren.

Today's photo shows a Summer Street that can charitably be described as in transition. Ugly buildings — a blank little bank at lower left, the CVS pharmacy across from it, and the gigantic 100 Summer Street in the background — disrupt the human scale of the older Victorian streetscape. The CVS, though not a good piece of architecture, is a good example of some characteristics of the modernist style. Broken into thin, flat, seemingly weightless planes, like a house of cards, the building is intended to look as if it has been machined and assembled by industrial processes rather than by hand. And its clean, simple shape, like that of an ordinary carton, is a metaphor for one of its aspects: that of an easily

measured volume of leasable commercial space.

Plenty of other aspects of the building have been zealously left unexpressed. There's no suggestion that a human presence may exist inside the building, no play of light across the texture and color of recognizable materials, no expression of how the structure is held up and put together. We're reminded of the motto of the influential modern architect Mies van der Rohe, that "less is more." In Mies's own work, less was more elegant than this.

There's vitality here, as there always is in the burgeoning of new shapes among the old. But there is anxiety, too, caused by the party-crashing of faceless robotic hulks among the frilled and hatted relics of the past.

It is wiser to ask forgiveness than permission.
— A Boston developer

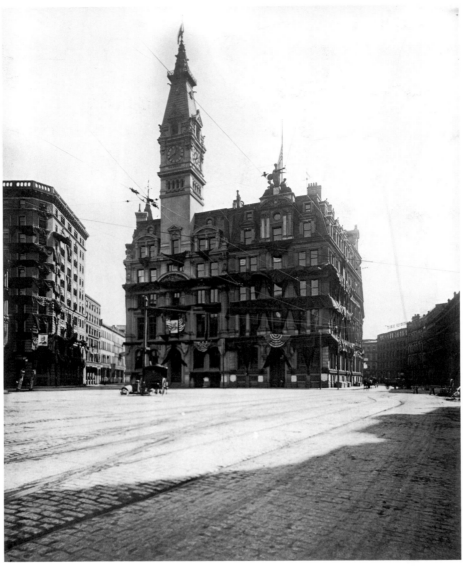

Buildings Picnic Around a Blanket

A CHUNK OF OPEN SPACE in the right place can magnetize a city, just as a chunk in the wrong place can erode and suburbanize it.

One way to give order to anything is to provide it with a center. The new Post Office Square Park does that for downtown Boston. Before the arrival of the park, downtown was a fascinatingly intricate but frustratingly incomprehensible maze of streets in which you were always discovering that you were walking at right angles to the direction you thought you were going in. Post Office Park now establishes a constant point of reference that helps make sense of everything else. The buildings seem now to be gathering around the park, as picnickers might gather at a blanket.

Post Office Square Park replaces an ugly city-owned garage (1976 photo). It sits atop seven new levels of parking that are buried underground — where parking belongs. Designed by the Halvorson Company, landscape architects, and Ellenzweig Associates, architects, the park is simple and memorable: a carpet of grass, a canopy of leaves, a single long trellis, a couple of small pavilions, a pair of water sculptures. Yet there are more than 125 species of trees, shrubs, ground covers, vines, and flowers, providing interest in every season: evergreens in winter, flowering shrubs in spring, perennials in summer, foliage in fall.

Local businesses, led by the Beacon Companies, took the initiative to create Post Office

Square Park during the 1980s, an era when private purses were much fuller than public ones.

The step-top building behind the park, in the center of the new photo, is the New England Telephone headquarters building, designed by Cram and Ferguson and built in 1947. It's a late example (in cautious Boston, all examples of architectural styles tend to be late ones) of art deco, that charming odd-couple marriage of modern and classical that drew its name from the Exposition des Arts-Decoratifs held in Paris in 1925. In the lobby is a 160-foot-long mural depicting scenes from telephone history — a history that began in Boston with Alexander Graham Bell.

The earliest photo, made in 1901, shows today's park site filled with two commercial palaces in the French Second Empire style, together forming a single block. They are the towered New York Mutual Life Insurance Building, by architects Peabody and Stearns, and the New England Mutual Life Building, by N. J. Bradlee. Both are draped in mourning for the death of President William McKinley.

True taste is for ever growing, learning, reading, worshipping, laying its hand upon its mouth because it is astonished, lamenting over itself, and testing itself by the way it fits things.
— John Ruskin

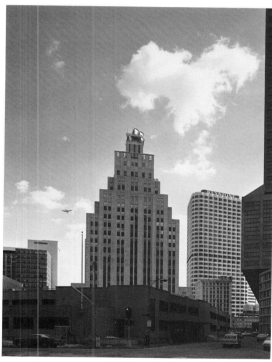

1976

Two Buildings Top by Bottom

A LOT OF LIFE accumulates in buildings as they grow and change over time. Often they become, like people, quirkier with age.

The handsome commercial block seen here stands at 151 Milk Street at the corner of Batterymarch. It was built in the middle 1860s, photographed in 1865, and damaged in the Great Boston Fire of 1872. No one today knows how bad that damage was. Perhaps the fire was the cause of the disappearance of the sloping mansard top story. The three new floors that replace it weren't added until the 1980s, a decade during which an expanding Boston economy collided with a growing architectural preservation movement. The result was compromise: fewer old buildings were demolished, but some grew taller.

The original building is Victorian Italianate in style, and the three-story top is post-modern

1865

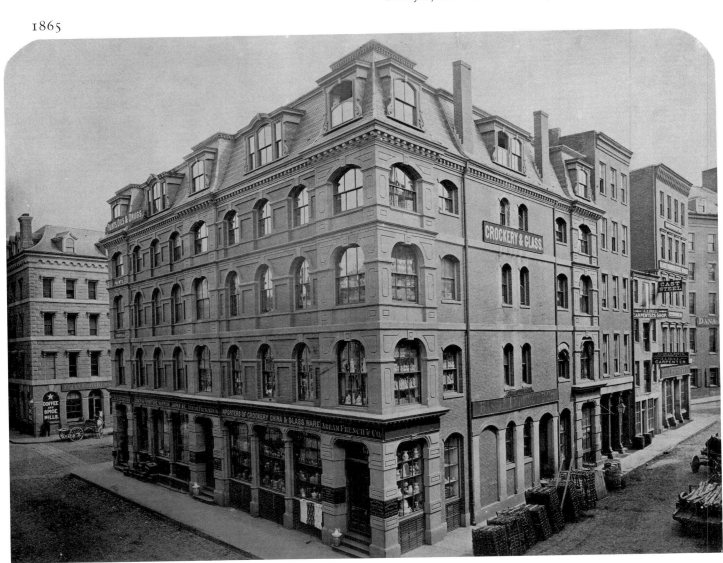

neo-Georgian. The two have nothing in common, yet they add up to the kind of pleasantly idiosyncratic mix that makes cities fascinating. If two different buildings can stand side by side, why can't they stand top by bottom?

In the old photo you can make out the names of some of the occupants, for example Abram French & Co., Importers of Crockery China & Glass Ware, a company that did business at this site as early as 1822.

To the left of 151 Milk in both photos, across the street at 50–54 Broad, is a gem that recently began a new lease on life. This five-story structure was built in 1862 of massive blocks of granite left deliberately rough for a massive, hand-hewn appearance. Used initially by Flint Brothers, coffee merchants, it survived the Great Fire and is now one of the best downtown examples of the so-called Boston Granite style of the mid-nineteenth century. In 1988 it was purchased — for the highest imaginable price, at the peak of the real estate boom — by the Boston Society of Architects and renovated as its headquarters.

I must study politics and war that my sons may have liberty to study mathematics and philosophy. My sons ought to study mathematics and philosophy, geography, natural history, naval architecture, navigation, commerce, and agriculture, in order to give their children a right to study painting, poetry, music, architecture, statuary, tapestry, and porcelain.
— John Adams (1780)

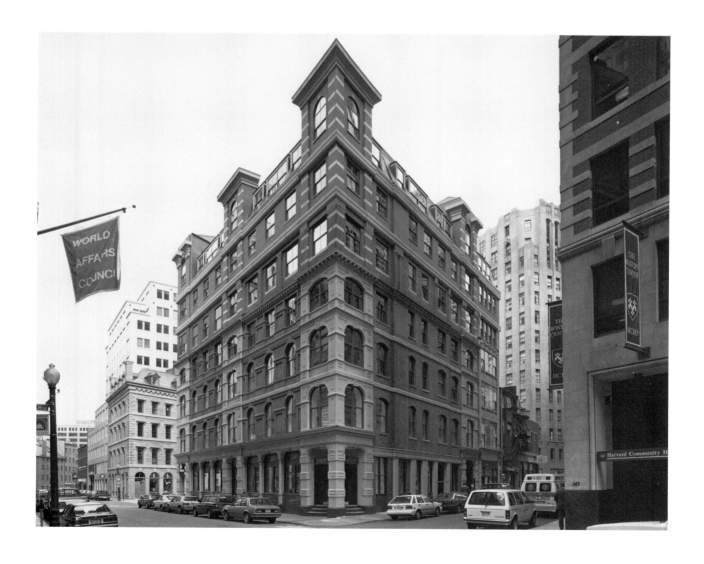

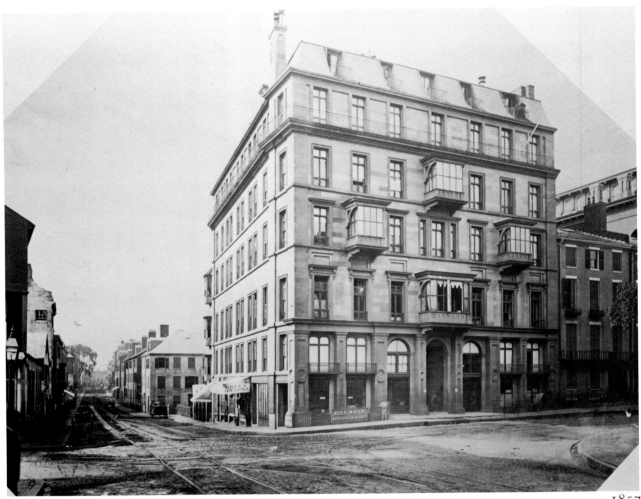

French Flats and Fake Shadows

I N CAMBRIDGE, ACROSS THE RIVER from Boston, there used to be a saying: "You'd better get up early, before the houses begin to move." Moving buildings was once far more common than it is in today's world of overhead telephone and power lines.

The older photo must date from before 1869, because that was the year in which — astonishing as it now seems — the heavy stone Hotel Pelham, at the corner of Tremont and Boylston, was jacked up and slid back fifteen feet (rightward, in the photo) to accommodate a street widening. We're looking here at the earlier, narrower version of Tremont.

Despite its name, the Pelham, by a Providence architect named Alfred Stone, wasn't a hotel for transients but a permanent dwelling. It's

often identified as the first apartment house in America. All the apartments were flats, a newfangled idea in the Boston of 1857. Bostonians, like Britishers, were used to living in vertical slices of space they called town houses. The French, by contrast, preferred horizontal slices, as they still do, and "French flats" is what people called these apartments at first.

Indeed, everything about the Pelham is Parisian, from the mansard roof to the shops at the street. The Paris of the new Second Empire was in vogue.

In the new photo everything in the old one has disappeared. In place of the Pelham stands the Little Building, a fine office block of 1926, designed by the firm headed by Clarence Blackall — he of Tremont Temple, the Wilbur Theater,

the Metropolitan (now the Wang Center), and the marvelous Winthrop Building on Washington Street.

Compared to the Pelham, the Little exemplifies the ever-growing scale of Boston buildings. But it's a lot subtler than it looks at first. The two lower floors are handsome, generous shops, and the third floor, just above them, recalls the old "bosses' floor." In the days before elevators, the floor just above the shops was the most prized and was usually occupied by management. That floor often received, as this does, a special architectural expression. The Little, of course, was built as an elevator building, and its "bosses' floor" is already a pleasant exercise in nostalgia.

Above, the Little's façade is a richly modeled surface of shallow bay windows alternating with white cast-stone shafts embellished with Gothic detail. The shafts contrast with the darker windows, and especially with the metal panels above and below the windows. That contrast gives an effect of light and shade to this north-facing wall, which in fact receives little or no sunshine. Inside, a two-story arcade overlooked by a mezzanine extends the shop-lined sidewalk into the building with genuine urbanity.

Attendant on things are people and their intimacies. — V. S. Pritchett

1934

A Century of Jewels

IN THE EVER-CHANGING CITY, there is reassurance in simple continuities. One in Boston is the so-called Jewelers Block, along the west side of Washington Street between Bromfield and Winter.

Not much has changed here — luckily so, because the changes we do see are all for the worse.

The once-handsome two-story building at right, for example, a Neisner's 5c to $1.00 Store in 1934, is now skinned with aluminum panels for a Wendy's restaurant that looks more like a glossy shoebox than a building. It has lost its face; you feel you can no longer make eye contact with it.

All up and down the street at the rooflines, projecting cornices and decorative crowns have been ruthlessly stripped off. Presumably the owners decided that these were in danger of falling and, consulting only their pocketbooks, decided that it would be cheaper to remove than to repair them.

The tallest building retains its cornice, though without the original lacy copper trim. This is the delightful Jewelers Building at 371–379 Washington Street, an early skyscraper dating from 1898.

The Jewelers is an example of the ornate Beaux-Arts style. Designed by the noted firm of Winslow and Wetherell, the building is frosted as richly as a cake with elaborate detail made of the hard cast clay known as terra cotta. Where the architecture of Wendy's suggests only efficient

speed-feeding, the gift-wrapped Jewelers promises surprises and delights within.

The Boston Landmarks Commission notes that the Jewelers Building has been "traditionally considered the jewelry center of Boston and New England." It is still so today.

Thanks be to the Lord: for he hath showed me marvellous great kindness in a strong city.
— The Book of Common Prayer

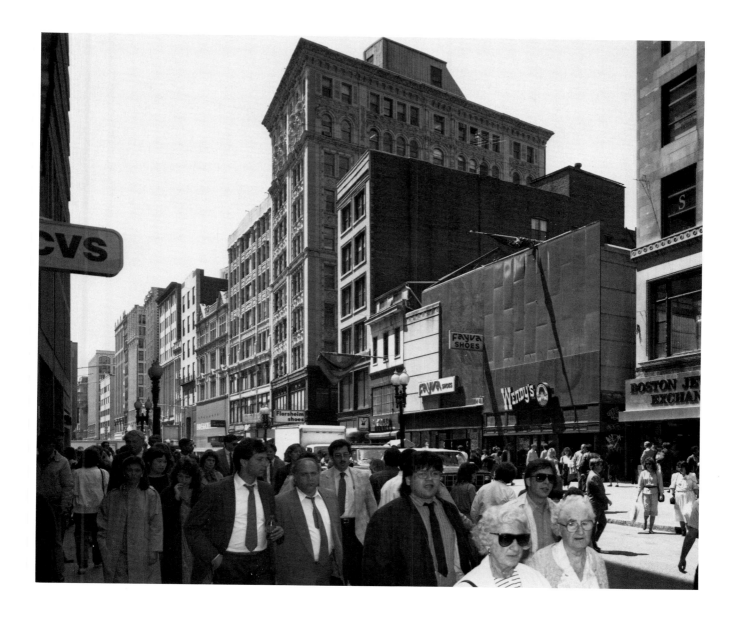

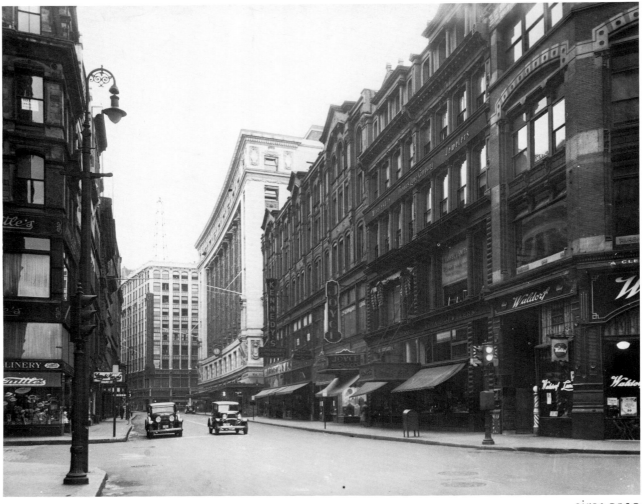

circa 1930

A Building That Floats

We're looking up Summer Street toward its intersection with Washington at what used to be known in real estate circles as the One Hundred Percent Corner — the locus of the top commercial rent — of Boston.

Here were clustered the major department stores of the city — Jordan Marsh, Kennedy's, and Filene's, still here, and R. H. White and Gilchrist's, now gone. Department stores came into existence in the late nineteenth century at about the same time as the first American world's fair, the Centennial Exposition of 1876. Department stores were smaller versions of the great Victorian expositions, those vast displays of consumer goods brought together under one roof. They were also institutions that for decades gave middle-

class women a means of interacting safely with the city's downtown, till then largely a male preserve.

The old photo shows a lushly detailed row of commercial buildings along Summer Street. The structures are bulky, but they're made to look domestic and friendly, almost homelike, by the clutter of windows, doors, and awnings along the sidewalk.

What's extraordinary about the new photo, which otherwise shows few changes, is the Erector Set framework of dark steel scaffolding that is holding aloft — literally in midair — the top forty feet of the brick front of the Kennedy's building. Kennedy's, a pleasant but unremarkable brick Victorian built in 1874, was to be torn down

for an office building in the 1980s. But a fierce battle by preservation groups led to the Solomon-like compromise we see here. All of Kennedy's was removed except the upper part of its façade, which remained suspended in air while a large new building was slipped in, so to speak, behind and beneath it.

"Façadism" is the contemptuous term sometimes applied to this kind of preservation, which uses a veneer from the past, like cosmetic gel, to disguise the reality of the present. But the real lesson of Kennedy's is a different one. Whatever else it was, Kennedy's was good streetscape. It's not great architecture — not a soloist — yet it contributes to the architectural choir that is Summer Street. Sometimes good manners and a regard for convention are more important than originality or distinction.

On the right of Kennedy's is 40–46 Summer Street of 1873, one of only two cast iron–fronted buildings still intact in the central business district. And to Kennedy's left is the curving shape of Filene's department store of 1911, the last work of the great Chicago architect Daniel Burnham, its olive and gray terra cotta façade more subdued than those of its earlier Victorian neighbors. Filene's originally was a social and economic experiment, a profit-sharing, employee-owned cooperative. When the store opened, it boasted a rooftop recreation field, an assembly hall, a library, and a hospital.

No city should be too large for a man to walk out of it in the morning. — Cyril Connolly

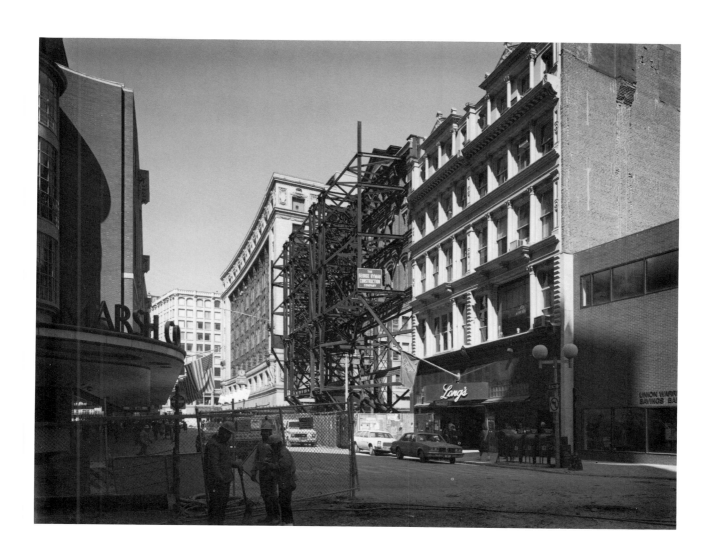

Fashions in Skin Care

"A LOOK AT TOMORROW TODAY...
Colorful, clean-lined First Federal
Savings Building is part of the New Boston plan,
symbolic of the faith this organization has placed
in Boston's growing future."

So gushed a newspaper supplement announc-
ing the opening, in 1957, of a renovated building
on Franklin Street. More graphic language came
from the building contractor: "We wanted to put
a little paint, powder, and rouge on the old girl."

Powder and rouge are fashionable in some
eras, less so in others. The rouged First Federal is
visible at the left in the second photo. The first
photo shows the building in the mid-1950s,
before the makeup job, and the last one shows it
as it is today. It looks much the same in both
because the makeup has been removed —
cleansed, you might say — and the old skin
restored. Taken together, these three photos are a
remarkable commentary on changing tastes in
architecture.

The original building dates from 1874 —
another post-fire job. Its architect isn't known.
The 1957 renovation was by Bastille Halsey Asso-
ciates. Robert Bastille recalls that the bank
"wanted to put the place on the map. They
wanted to make sure people would not fail to
see it."

Times change, and First Federal, now North-
east Savings, decided in the 1980s on a retro face-
lift. It pulled off the metal skin and restored the
old building. The result is handsome, although a
bit stiff at sidewalk level compared to the engag-
ing jumble of signs we see in the earliest photo.

Such knee-jerk "modernization" of older
buildings was a fad of the 1950s. Metal-and-glass
curtain walls vaguely resembled the work of
abstract modern painters like Piet Mondrian.
They felt fresh and contemporary and became a
rage, though few were as sporty as First Federal's,
with its splotches of red, orange, and blue. A gen-
eration later the idea of pasting such junk on a
fine old building is incomprehensible. Even
Bastille admits he's delighted his bright skin has
been stripped.

Also visible at the center of all three photos
is the step-top profile of 109–123 Franklin (once
the State Street Bank), Boston's most elaborate art
deco skyscraper, designed by Thomas M. James in
1929.

The graceful curve of Franklin Street, by the
way, traces the memory of an invisible master-
piece, another ghost from the past that continues
to shape the present. Here stood the lovely Ton-

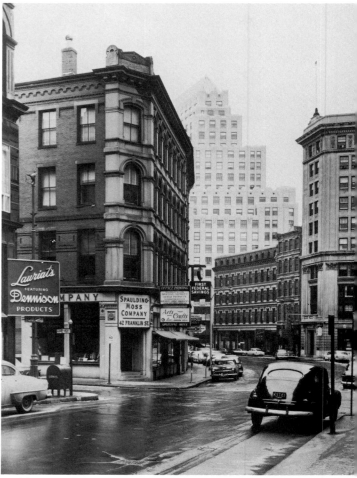

mid-1950s

tine Crescent, a sweep of sixteen Federal-style
row houses designed by Charles Bulfinch in the
1790s and demolished in 1858. The name derives
from the fact that the crescent was supposed to be
financed by a tontine — a group of investors who
agreed that as each one died, his share would pass
on to the others, until eventually the whole prop-
erty was owned by the last survivor. The tontine
failed to get itself incorporated, and the project
proved a disaster financially, bankrupting Bul-
finch. Old photos and drawings suggest that
Tontine Crescent, inspired by the crescents of
Bath, England, must have been one of the great
urban groups in Boston's history. A classical urn
that stood in a small enclosed garden in front of
the crescent now marks the Bulfinch grave in
Mount Auburn Cemetery.

*The figure of a city's streets, squares, gardens per-
petuates the existence of the hills, ponds, rivers,
woods, moats and roads which preceded its edifi-
cation.* — Pierre Schneider

1934

An Outdoor Park Becomes
an Indoor Atrium

The FOREGROUND OF BOTH these photos was once part of Fort Hill, one of the three hills — along with Beacon and Copps — that dominated the original topography of Boston.

Fort Hill was eighty feet high and fortified with cannons — the battery that gave its name to Batterymarch Street — commanding the inner harbor. It was cut down to level ground about 1870 in order to generate fill to extend the harbor shoreline nearby, creating the land for what is today Atlantic Avenue. Fort Hill, which as a hill had been a fashionable residential neighborhood and later a hive of Irish immigrants, became, as flatland, a commercial zone.

It was a very handsome one. The park in the 1934 photo, just planted with new trees, was known as Washington Square. Fronting it is a fine

row of buildings, most of which remain today. The best is the Chadwick Lead Works of 1887, with four large arches near the top and a tower in back. The tower was used for manufacturing lead shot; the molten balls were dropped its full height to shape and cool them. The Chadwick's architect was the versatile William Preston.

When Boston prostrated itself before the automobile in the 1950s, Washington Square gave way to a hideous Central Artery ramp and a city parking garage. Later, in prosperous 1987, a huge office development began to rise on part of the site. Known as International Place and designed by the New York partnership of John Burgee and Philip Johnson, the development now occupies the entire space that once was Fort Hill and later was Washington Square. In its middle a paved, glass-roofed atrium with a fountain provides an air-conditioned contemporary urban space — a privately controlled update of Washington Square, lacking weather and other surprises and inconveniences.

The other Hill hath a very strong Battery, built with whole Timber, and fill'd with earth.
— John Dunton (1686)

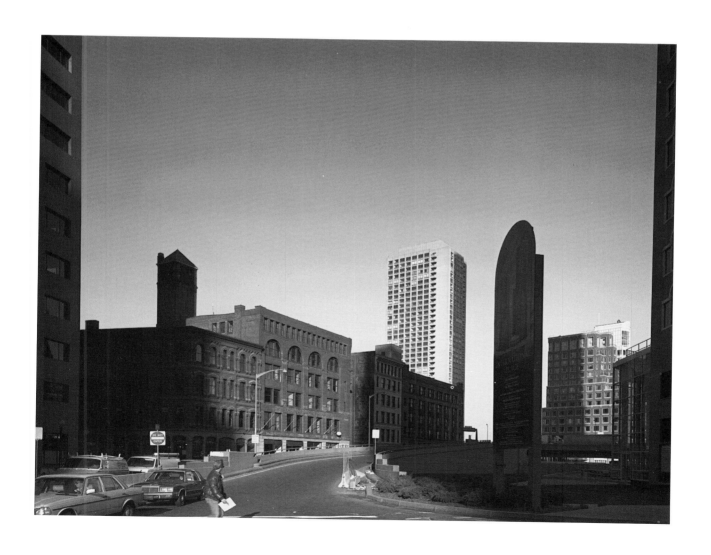

A Rowes Is a Rowes . . .

THE MORE THINGS CHANGE, the more they remain the same, as the French say. Here we see two Rowes Wharfs, the first about 1960, the second in 1988. The resemblances are striking. Both buildings are solid horizontal walls along Atlantic Avenue. Each has a grid of windows set in brick above whitish shopfronts. And each features an emphatic bold archway at the center.

The older Rowes was torn down by the Boston Redevelopment Authority soon after this photo was made. Its castellated Gothic architecture probably dates from the late nineteenth century. Adrian Smith of Skidmore, Owings and Merrill in Chicago, the designer of the new Rowes Wharf, says — amazingly — that he knew nothing about the old Rowes when he began his design. He first came across this photograph a year later.

The Rowes of today is already a Boston icon. The modest exterior of brick and cast stone is deceptive, since it's hung on an invisible steel frame, but it works: it looks humane and Bostonian without looking old. Also a virtue is the mix of different uses in one building; hotel rooms, condominiums, offices, restaurants, and underground parking all feed off one another, generating a truly urban buzz.

And few local experiences are more exhilarating or more often talked about than the water shuttle ride from the airport across the harbor to the dock on the ocean side of Rowes. When you disembark and walk into Boston through the great arch — the gateway to the city — you feel like an arriving monarch.

The water shuttle reminds us of a unique fact about Boston: the center of transportation at the end of the twentieth century, Logan Airport, is in exactly the same spot, the middle of the harbor, where the center of transportation has always been. No suburban airport is sucking Boston business out of the downtown.

The old Rowes was a functioning wharf too; you could take a boat to the Provincetown and Nantasket beaches. But it served a more blue-collar culture. In the photo we can see shops labeled Warren Drug, Atlantic Uniform, Hub Surplus, Continental Motor, Billy Vigor's Surplus, and Marine Hardware. The upper floors were warehouse space. The name Rowes Wharf was carved into the center of the arch.

circa 1960

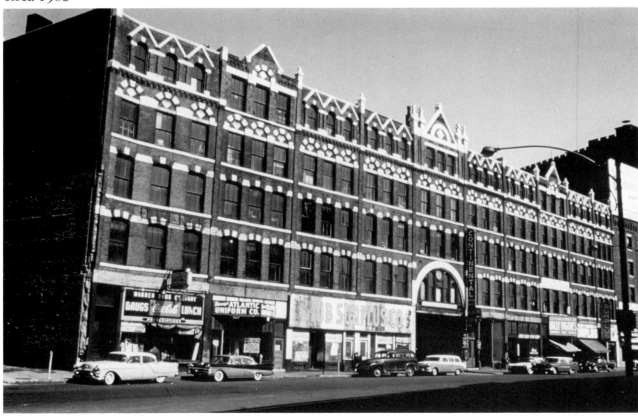

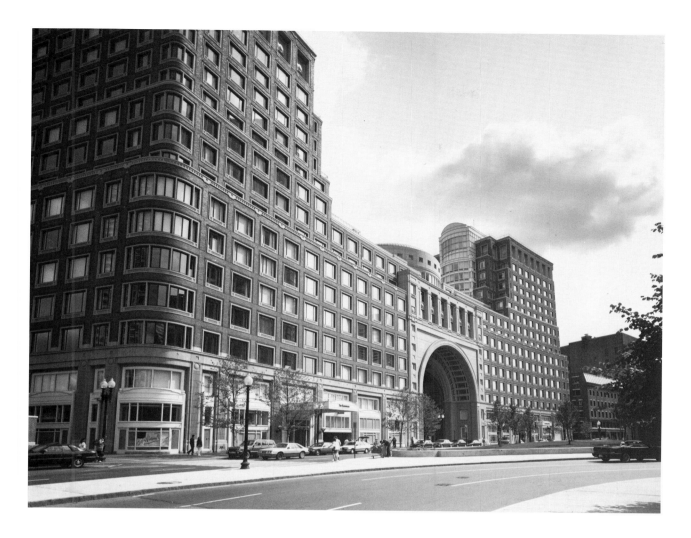

Vigor's still exists on Summer Street, and Mark Vigor remembers the old building. "We had the ocean behind and the Central Artery in front," he recalls. "On hot days we'd open the window in the back and get the sea breeze." He says the store was forced out in 1960 or 1961.

Both Rowes Wharfs, new and old, are street architecture. They link up in a row with other buildings to make a long firm wall that shapes and contains the space of the street.

If the new Rowes Wharf had been built in the 1960s or 70s, it surely would not have been a street-shaping building, but instead some kind of free-standing object in an empty plaza, like the Marriott Waterfront or Harbor Towers. We've come full circle from Rowes I to Rowes II. We've learned again that a city's most important outdoor spaces are not its parks or plazas, good though they may be, but its streets. Each Rowes is a handsomely paneled wall, with a symbolic door between the harbor and the city, in the urban corridor that is Atlantic Avenue. Ironically,

a generation after the Boston Redevelopment Authority demolished Rowes I, it was this same agency that did the most to influence the shape and character of Rowes II.

Critics have called the great new arch too pompous for a private commercial building. It should be in a civic monument, they say, if it's to be anywhere, like the Gateway Arch in St. Louis. It's true that much of what used to be public realm has fallen recently to private enterprise. Post Office Square Park, the new Copley Square, and the streets of Faneuil Hall Marketplace — all privately financed and managed, at least in part — are Boston examples. But it's also true that in the history of cities, private enterprise with public ambitions has created some of the best urban spaces.

To see is to forget the name of the thing one sees. — Paul Valéry

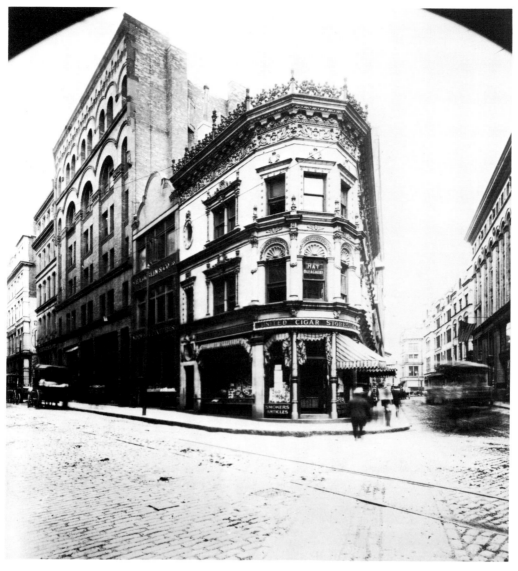

Small Wonder

THE PROCTOR BUILDING, at the corner of Kingston and Bedford streets, is many people's favorite small commercial building in Boston, despite the gruesome condition in which it has long moldered.

The old photo shows the Proctor as it was meant to be. The year is 1903 and the Proctor, just five years old, looks like a tiny jewel box. The developer was the estate of Thomas Proctor, a prominent lawyer; the architects were Winslow, Wetherell and Bigelow.

"When in doubt, leave it out," Mark Twain is supposed to have said of the comma. Many modern architects have felt the same way about ornament. The architects of the Proctor were clearly of an opposite persuasion. Little is left out

of its cream-colored architecture that could possibly have been slathered on.

We see brackets, pilasters, finials, and even scallop shells over some of the windows. Best of all is the stunning cornice, as intricate as a diamond tiara. The openwork crest at the very top, sprouting torches that glint in the sun, is copper, and the frieze beneath it is terra cotta. Notice the faces peering out at the corners.

It was the new technology of producing terra cotta that allowed the explosion of this kind of ornament in late Victorian architecture. Detail that previously was carved from stone by hand could now be cast in factories. Few buildings frolicked in the new technology as exuberantly as did the Proctor.

Today the Proctor is a relic, crowded by bigger buildings, its ground floor hideously defaced by brick walls. Designated by the Boston Landmarks Commission as a work of "major significance," the Proctor will at least survive. But it deserves a loving restoration as much as any building in the city.

Tomorrow night I appear before a Boston audience — 4,000 critics. — Mark Twain

An Alienating Horror

THIS PAIR OF PHOTOGRAPHS makes you want to cry. Nothing could be more expressive of the loss of ability to make good cities than the contrast between the humane streetscape of the older view and the alienating horror of the new. Every trace of life and interest has been ruthlessly stripped from this stretch of Huntington Avenue.

In both cases we're looking west from the corner of Dartmouth Street. The old photo shows, on both sides of Huntington, a pleasant array of buildings. They're typical city buildings, with private offices or apartments upstairs and shops at the sidewalk.

Nothing about these buildings is pretentious, but they engage your interest with a variety of detail — windows, cornices, storefronts, signs. They seem to reflect your presence by facing you with numerous elements that are about the size of a human being. Looking up at a bay window, for instance, you can easily imagine yourself standing inside it. As you walk along the sidewalk, each window and door invites your attention, perhaps even your entry.

The small shopfronts and signs are visibly the expression of many individual human initiatives. Their complexity can't be grasped or sorted in a single glance. They promise mystery and

1949

intrigue. You feel you could buy almost anything here. You feel drawn to walk, to linger, to fantasize.

By contrast, it's hard to imagine anyone walking willingly along this same sidewalk as we see it today. The whole block is now a single entity, the expression of collective corporate power and regimentation rather than of multiple personal initiative. Much of it is devoted to the auto drop-off for one of the hotels of Copley Place, a use that lines the sidewalk with a row of dark voids.

Even the street itself has been degraded. Gone is the rhythm of streetlights marching down the center, each resembling a human figure. Instead an uncrossable wall and moat — the ramp to the Massachusetts Turnpike — divide one side of the street from the other. As pedestrians, we feel this is no world for us.

There are lessons in these photos. The quality of city life depends on things as simple as the size of lots. If a whole block is one building lot, as it now is on the left, the chances for human interest and variety are lessened, regardless of the talents of the architect. And if there are no retail uses along the sidewalk on a commercial street like this, the sidewalk sickens.

Finally, if a street is conceived by its designers as nothing but a conduit for vehicles, rather than as a setting for life and human commerce, it is doomed.

The way to plan a street is not as a means of access to other things, but as an end in itself — a place that can be enjoyed for its own sake. — Roger Scruton

1915

A Good Street Wall

LITTLE SEEMS TO HAVE CHANGED in this row of buildings on Boylston Street near Exeter in the seventy-six years between these two photos. But a closer look reminds us of the flux that is the nature of a city, always evolving, like a field or forest.

The big building at the left of center with square windows is Boylston Chambers, a handsome commercial front of 1890. It suffered a fire in 1985 and was boarded up for a time, then restored with two new floors added under a curving copper roof.

At Boylston Chambers's right in the older view are two bay-windowed town houses of the 1890s that already had acquired extra top stories and been converted into shops on the street floor. Later, in 1927, the right-hand of the two houses was remodeled to match the one on the left, and the pair became the single office building we see today.

At the extreme right are more former town houses, which at some point, doubtless around 1960, acquired a banal metal-and-glass curtain wall.

In 1915, horse-drawn carts mix with early open-topped automobiles. A street sweeper pushes a broom over the cobblestones, probably cleaning up after the horses. Today the sanitary sealed cars slide noiselessly on smooth asphalt.

But more has remained than has changed. These buildings, with their varied heights, their expressive windows, and their interesting shopfronts, gather into a collective whole, into what urban designers call a street wall. They define the space of Boylston Street as the shelf-lined wall of a corridor in a house shapes a long and interesting space for living and moving.

But the goldfish bowl is no more natural to man than the cave; in so far as men live well, they must alternate between the two — between light and darkness, between society and solitude, between participation and withdrawal.
— Lewis Mumford

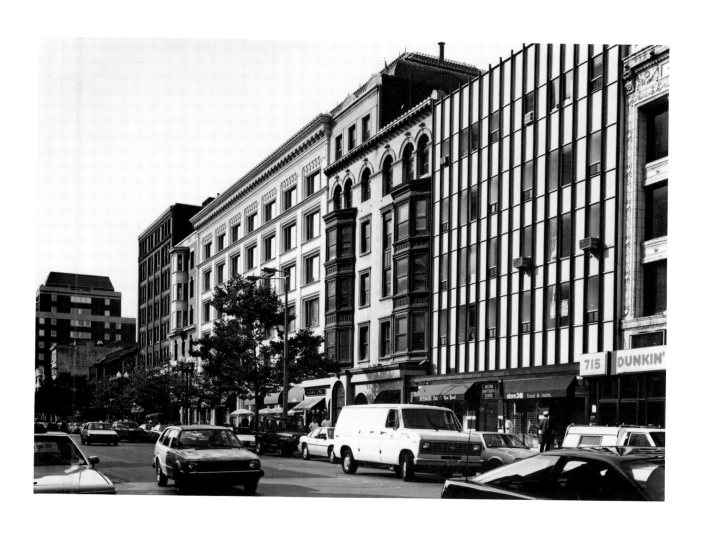

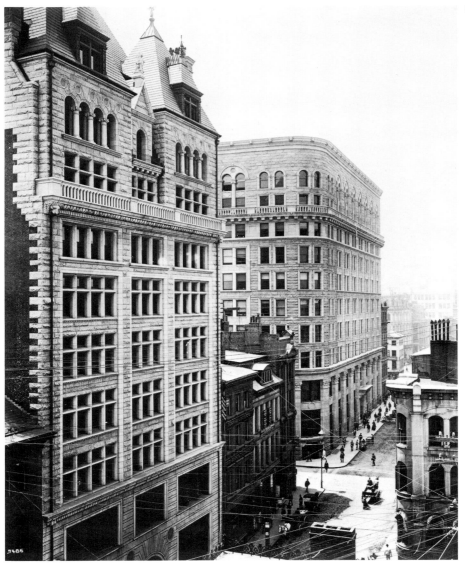

An Airborne Beach-Front Motel

THE TACKIEST RENOVATION EVER perpetrated on a major Boston building appears in the second of these three photographs. The first shows us the original building before it got trashed. In the third the whole mess has disappeared, replaced by a new shopping arcade and office tower.

The victim is the Fiske Building, designed in 1888 by the noted firm of Peabody and Stearns in the burly Boston Granite style.

The Fiske was an ornament of State Street until 1964, when its owner, Maurice Gordon, covered its granite facing with blue and black metal panels. Gordon didn't stop at that atrocity. He also chopped off the building's dramatic mansarded, chimneyed top to add five more floors of offices in the balconied style of a cut-rate beach-front motel. The result was, for its twenty-five-year life, the ugliest building in Boston.

Just beyond the defaced Fiske is another mistreated work by the unfortunate Peabody and Stearns. This is the former Boston Stock Exchange at 53 State, erected in 1891, just three years after the Fiske, which it resembles.

In 1979 developers proposed to demolish the Exchange for a high-rise tower. A vocal preservation lobby intervened, and eventually a Solomonic compromise, somewhat like that of the Kennedy's store, was reached. The rear of the Exchange was chopped off, to be replaced by the new tower, called Exchange Place, leaving the front of the old landmark a forlorn relic.

The demarcation line between old and new at Exchange Place, like a military front, is a pre-

cise measure of the relative power of the forces of development versus those of preservation at one moment in Boston history. The tower rears its forty stories of mirrored glass behind the gutted Exchange like a gleaming Niagara above a barnacled ferry boat.

To return to the Fiske Building: in 1989 the abused corpse of this onetime gem was decently removed and replaced with the modest five-story shopping arcade of 75 State Street. The arcade leads back to a new office tower designed by Graham Gund. This tower quickly became notorious for its jazzy gold neo-deco zigzag ornament,

yet it fits into Boston far better than Exchange Place. And it offers a small recompense to Peabody and Stearns by opening a view down State Street toward still another of that firm's contributions to the architecture of Boston: the Custom House Tower.

No city that is built by a free people will ever be a great work of art, for freedom allows the expression of bad taste as well as of good.
— Martin Meyerson and Edward C. Banfield

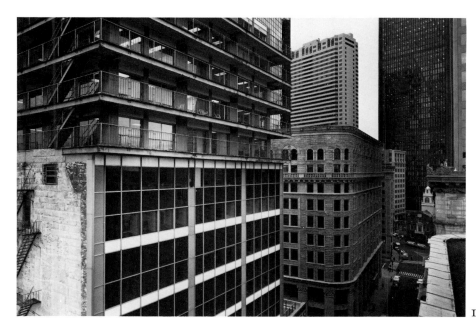

1984

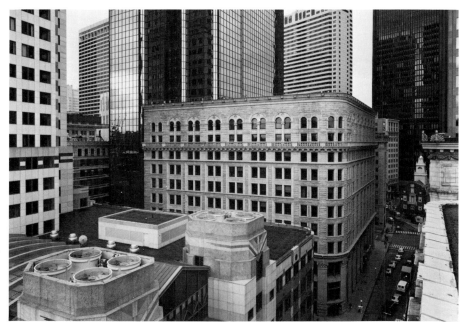

Historic, Modern, and Post-modern on Great, King, and State

LIKE A VENGEFUL GIANT in a nightmare, the office tower known as One Boston Place blots out the sky and seems about to stomp on the Old State House in the newer of these views of State Street — at one time King Street, at another Great Street, but at all times the spine of Boston's financial community.

One Boston Place looks like the box the real building came in. Utterly lacking in charm or interest, its architecture proclaims all too clearly what its architects and developers imagined it to be: a problem in structural engineering and economic analysis rather than one in human accommodation.

Nothing about the architecture of One Boston Place suggests that this is a workplace for human beings instead of, say, a widget ware-

house. The steel cage structure is clearly expressed, even to the diagonal bracing, but who or what may lie behind it apparently isn't worth architectural mention.

One Boston Place displays another peculiarity. It hovers behind the Old State House like a photographer's backdrop. The effect is fascinating. The Old State House seems to be posing for its portrait. It seems to be on display, to be proffered to us as a precious object, like an ornamental snuffbox in a museum. Stripped of most of its setting, it feels more historic but less real.

There are other changes. The old photo depicts a world of surface patterns. The carpet of paving stones, the façades with their rhythm of stonework and window, even the peppering of signs — all contribute to an astonishing textile

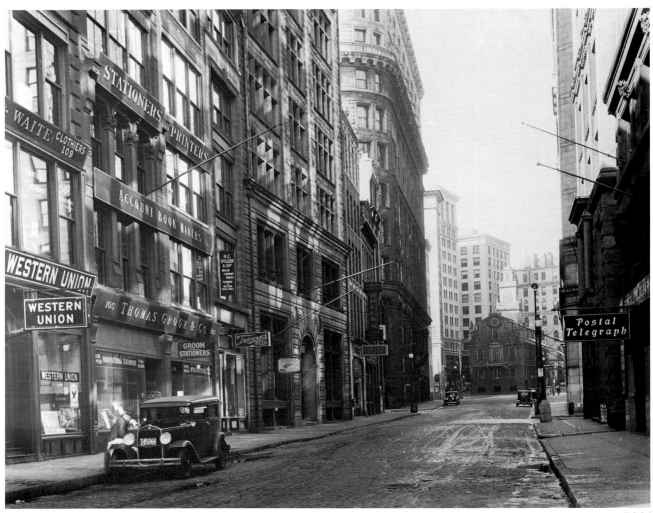

1933

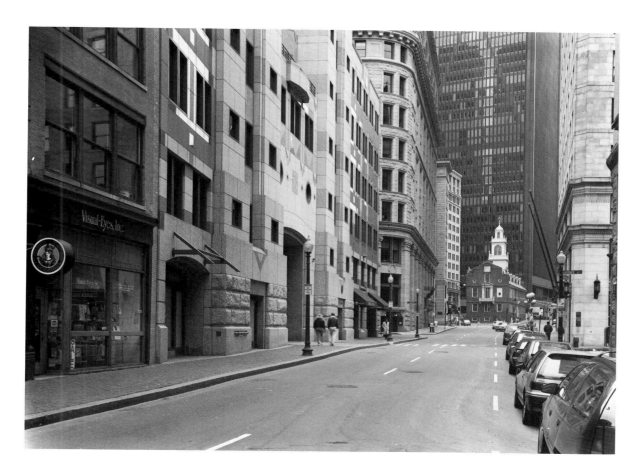

weave of elaborated surfaces. In the new photo the signs are nearly gone, the street is slick with asphalt, and the architecture is smooth.

Most of the left side of the new photo is filled with the frontage of 75 State Street. This shopping arcade and office tower was built some twenty years after One Boston Place and is, in many ways, a reaction to it. Designed by Graham Gund of Boston with Adrian Smith of Chicago (the designer of Rowes Wharf), it is known for its memorable gold-trimmed top, not visible here, and is a successful attempt to create an office tower that at least doesn't look like a packing crate. Burly stonework at the base evokes the past, and so do many of the materials, shapes, and colors. Yet 75 State is candidly a product of its own era. It is surfaced mostly in big, flat, smooth panels of granite, and we cannot fail to understand that these form a thin veneer of stone, placed in position by a modern crane and fastened to a steel skeleton beneath.

One Boston Place is a modern building; 75 State is post-modern. Modernism took its cue from the fact that we live in an industrial society, one in which products are manufactured serially and repetitively by machines, not crafted individ-ually by people. Most modern architecture seeks to discover a kind of beauty and order in the reality of repetition and modularity. One Boston Place does that badly, but the same job can be done with great elegance, as it is in Boston's Hancock Tower.

Seventy-five State is very different. It suppresses rather than expresses the modular, repetitive character that an office tower by its nature possesses. At the same time it is much too suave to want to look falsely historic. Instead it is a playful stage version of history — in this case, a version of the art deco of the late 1920s. The result is typical of the post-modern era of the 1970s and 80s: a festive, breezy, freely inventive variation on the past that makes ironic fun of its own staginess and usually looks, for better or worse, a little thin — a little like a travel poster of architecture, rather than the genuine article.

Modernism assumes that things can be only themselves, that you don't have to deal with resemblances. — Dmitri Porphyrios

The Skyline as Power Graph

THE SKYLINE OF A CITY is often a graph of
the power structure in that city. If a mon-
arch is in charge, a palace will probably be the
most prominent point; if the church, a cathedral;
if the corporation, a skyscraper. In a special case,
like that of the little town of San Gimignano in
Italy, ruled in the Middle Ages by an oligarchy of
wealthy families, it is the towers of their private
houses that reach toward the sky.

A century ago the skyline of Boston was
topped by the State House dome. Next highest
were the steeples of the churches, then the
offices, warehouses, and ship's masts of com-
merce, and finally the houses. The graph was
clear: a stable, hierarchical society, ruled by
elected Government, by Church, and by Com-
merce — in about that order.

The older photo shows that one-time Boston
hierarchy in a state of transition to the new
graph — a skyscraper graph — of today. Still
prickly with steeples, the sky is starting to fill in
with bulkier office towers. By the time of the
new photo we seem to see, rather than a row of

buildings, a row of upended packing crates.
Architectural form is rarely meaningless. The
new corporate towers look like cartons because
their owners and architects conceived them as
packages of leasable space.

Both photos were made from the vantage
point of Massachusetts Institute of Technology.
Boston is seen across the quiet water of the
Charles River Basin, with the houses of Beacon
Hill in the foreground. The city seems to have
assembled itself at the beach to pose for the
annual Fourth of July photograph of an ever-grow-
ing family of buildings, with the taller folks in
the background and the dogs and children in
front. Cities look best this way, with no bulky
buildings shouldering into the foreground, like
drunken uncles, to crowd out the others behind.
A city should be a quirky collective entity, like an
interesting family.

The new squarish towers look their best as
seen here, from a distance, like a continuous nat-
ural rock cliff or like a drop curtain behind
Beacon Hill that gives the hill, paradoxically,
more presence than it had before the towers

existed. The small red houses of the hill and the big boxy towers of the downtown are foils for each other, and the clash of different sizes, although disruptive, manifests the tension and vitality most real cities need and possess. The towers, too, change the scale of the Charles River Basin. They domesticate it, making it feel more like an urban water park, less like a natural lake or an arm of the ocean. The tiniest elements of all are the white triangles of the sailboats, navigating past the giant towers like delicate luminous moths.

Skyscrapers, whether royal or religious or commercial, serve other purposes than that of providing a graph of power. They visibly and symbolically mark the center of a city, the place where the energy is greatest and the identity most intense. They give the city a form in three dimensions. And in America, which invented the office skyscraper, they often carry an extra charge of meaning.

Early American art is filled with images of a person looking across a vast space at a high object in the distance — a rock, a ship, or a mountain.

When you move today across the great flat emptiness of the American desert or prairie toward, say, Denver or Dallas, the faraway towers afford a pale sense of what it must have been like for the westering pioneers to see, after weeks of travel, the first high forests and mountains rising above the horizon. In Houston they talk of the "Oz view" of the crystal towers of downtown — the magic city (of money, among other things). The clustered skyline of an American city is a multiple symbol — of landscape forms, like mesas or mountains; of civilization in the wilderness, like wagons drawn tightly in a circle against danger; and of ourselves, individual human beings standing tall and close together against the vastness of the North American continent — ourselves writ large enough to matter, in so big a place.

In architecture the pride of man, his triumph over gravitation, his will to power, assume a visible form. — Friedrich Nietzsche

A City Must Not Change.
A City Must Change

Mᴏʀᴇ ᴅᴜᴍʙ ᴘᴀᴄᴋɪɴɢ ᴄʀᴀᴛᴇꜱ. The background of the new photo looks like an urban warehouse of abandoned trunks.

Look closely at both these photos and you see something fascinating — something like the geological strata in a place like the Grand Canyon. On the canyon wall you can read the traces of eons of history on the horizontal layers of rock. In Boston you can read four periods of the city's growth in the layers of buildings of different heights.

The old photo is mostly the ten-to-twelve-story Boston built right after the Great Fire of 1872. You see a field of roofs as uniform in height as a cornfield or a table top. The elevator existed by then, but a zoning law held heights to a certain limit.

Farther back are two exceptions — two party-hatted towers that poke up above the table top. They're the United Shoe Machinery Building (left) and the former State Street Bank at 75 Federal Street (right). Both are landmarks of the art-deco period of the late 1920s when the height restriction began to ease. Both display the typical step-pyramid tops of that style.

Moving to the new photo you see at the top another horizontal line, another table top, this one at about forty stories. It's formed by the crew-cut flat-tops of those crate buildings, the products of the boom of the 1960s and 70s when a forty-story cap was informally enforced by the city's planners.

Lastly, come down one notch from those crates to the two newest buildings, side by side at the left of the photo. Both are about twenty-five stories. In the 1980s still-booming downtown Boston was beginning to feel overbuilt. It was becoming dark, windy, and overbearing. Planners responded by squashing new buildings down to this new lower height, chosen because it was the

circa 1930

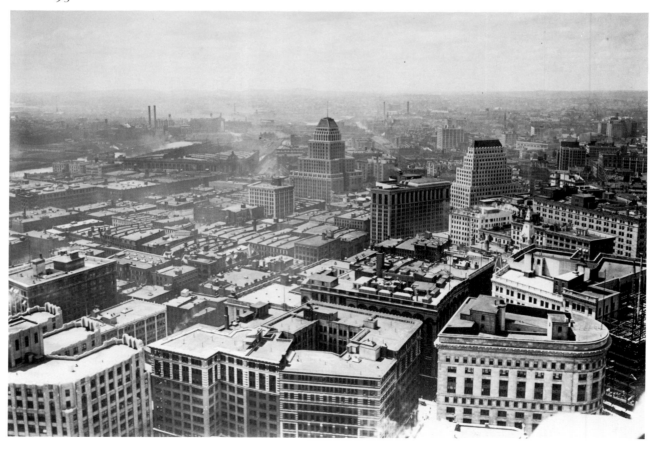

height of the art-deco era, another of whose step-top monuments, the New England Telephone Building, is visible in the center of the new photo.

Confusing? Wait. There's one more geological stratum of Boston architecture, not visible here and lower than any of these. This is the first Boston, made entirely of walk-up buildings no more than five or so floors.

The crowded jostling of old against new and of tall against short gives today's Boston its sense of life and thrust. Still, there's a consensus that the Age of Crates brought too much change too fast. A spurt of high-tech growth in the suburbs created a need for lots of service purveyors — bankers, lawyers, brokers, insurers. Instead of moving out to the circumferential Route 128 to join their clients, in the kind of exodus that has ruined many American cities, these service professionals chose to stay downtown, where they could be near the airport, near government, near the courts, and near one another.

As these people proliferated, they sustained a busy, compact, walkable downtown. But the new office towers in which they worked soon threatened downtown's access to sun and view and its freedom from architecturally induced gales. They threatened, too, to overwhelm the city's delicate balance between memory and invention, between past and future.

A city is a paradox. It mustn't change, because it must always reassure us of the continuity of life and remind us where we came from and who we are. Yet it must change, because it must always offer the pleasure of novelty and the promise of a better future. A city isn't only a museum of culture and history, although it's certainly that. It's also the exciting place where we go to get rich and famous. Crates or no, Boston steers its course among such contradictions better than most.

Tall buildings are vicious and immoral.
— Leon Krier

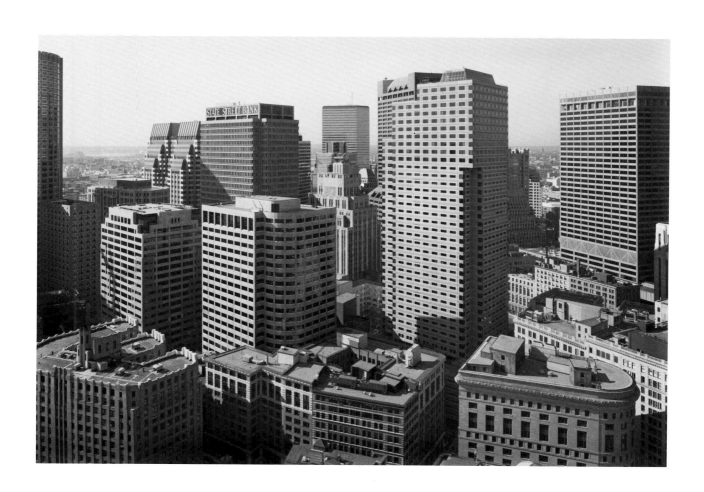

V

THE CITY AS THEATER

T oward the end of the nineteenth century, Boston, flooded with refugees first from Ireland and later from Italy and Eastern Europe, began its long, slow transformation from a WASP city into a city of pluralism. Many of the old families fled to the suburbs as the Irish took over the city's politics. Theater flourished in every conceivable form, from vaudeville to baseball, and served among other things to introduce the city's multiple cultures to one another.

The landmass of Boston circa 1910

1906

As STUNNING AS ANY CHORUS LINE is the handsome row of buildings in the old view. It's the west side of Washington Street between West and Boylston.

Sunshine dapples the façades — they are mostly theaters and theater hotels — with a pattern of light and shade. The rows of awnings and deep-set windows, following the curve of the street, resemble the tiers of boxes in an opera house. They seem to contain an audience, one that is looking down in anticipation of a good performance of the daily festival of street life. Not only is this a street of theaters: it is a street in which the city itself is understood as theater.

The only building remaining today is 545 Washington, just to the right of the Paramount Theater. Disfigured by clumsy changes at street level, 545 nevertheless still looks good. It is now on the National Register of Historic Places.

You could write a short history of the American theater around these buildings. The former Savoy Theater, originally called the Keith Memorial and more recently the Boston Opera House, is at the extreme right in the new photo. One of the most lavish of all vaudeville and film palaces, it opened in 1928. It was built on the foundations of an earlier theater, the Boston, barely visible in the old photo. Here Edwin Booth appeared on the night his less talented brother upstaged him by shooting Abraham Lincoln in a box seat in Washington; here Enrico Caruso, Gustav Mahler, Ignace Paderewski, and Sarah Bernhardt performed; and here Helen Keller declaimed Longfellow on the occasion of her graduation from the Perkins School for the Blind.

Another famous theater, B. F. Keith's, was located behind 545 Washington, which was serving as its entrance at the time of the old photo.

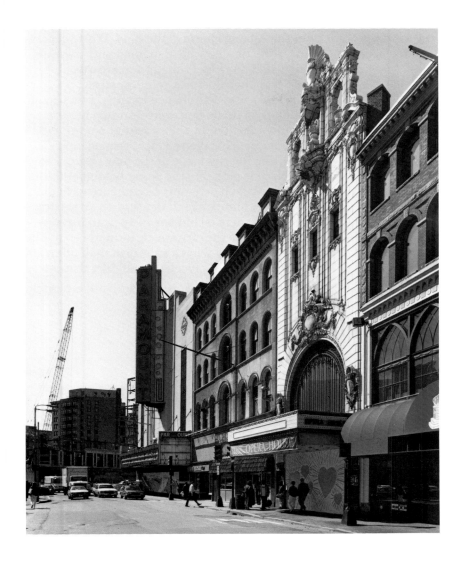

Keith's, built in 1894, became known as the birthplace of American vaudeville. Before the arrival of Keith's, 545 housed the Lion Theater (1835), a minstrel hall (1859), the Gaiety Theater (1878), and a "museum of curiosities." Amazingly enough, at different times there were yet two more theaters, the Bijou and the Modern (now the Mayflower), flanking the Savoy.

Still another theater is the Paramount, probably Boston's most elaborate example of the art-deco style of the 1920s and 30s. It has long been dark, and its gaudy marquee is in disrepair, but its sleek interiors of ebony, walnut, aluminum, and gold remain. A designated Boston landmark, it awaits a long-promised restoration.

The explosion of theaters in Boston from the end of the nineteenth century through the Great Depression coincided with the arrival of large waves of non-English-speaking immigrants from Italy and eastern Europe. Like other institutions of the era — baseball, for instance, which is after all another kind of theater — the plays and vaudeville acts, rich in racial and ethnic humor (both kind and unkind), helped acclimate the new arrivals to American life and lingo — and vice versa. In the same period another new institution, the great department store, was offering a different group of "new arrivals" — middle-class women — entrée into city life.

The privilege of the great is to see catastrophe from a terrace. — Jean Giradoux

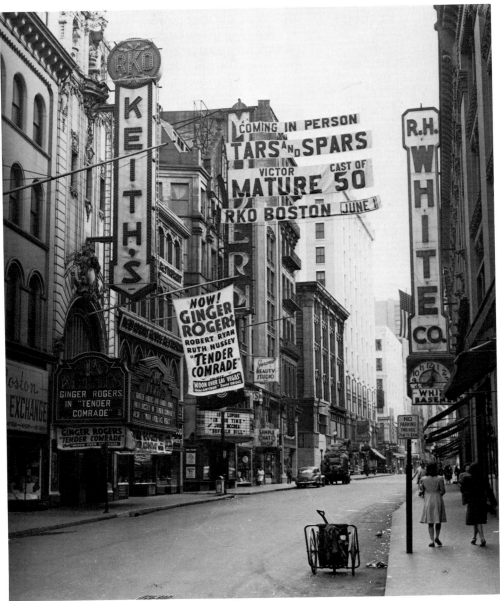

How Much Mess Is Enough?

CLUTTER AND MESS bring vitality to a city
street. Vivid, bold signs, each trying to be
bigger and louder than the next, proclaim a place
where things are happening, where exciting
events are vying for attention.

At what point does liveliness turn into
chaos? It's hard to say. In the old view of Washing-
ton Street, department store and movie signs

pretty much block any view of the architecture.
The architecture — much of it the façades of
marvelous old theaters — deserves better. Still,
it's hard to object very strongly to the gaudy vigor
of this scene.

We're looking at Washington Street in 1944.
The film titles and stars' names evoke the mood
of the wartime years with poignance: Ginger
Rogers, Robert Ryan, and Ruth Hussey in *Tender
Comrade*, Ida Lupino in *In Our Time*, Joel
McCrea in *Buffalo Bill*, David Bruce in *Moon
over Las Vegas*. Few remember these movies now,
yet how easily the names stir, in those old

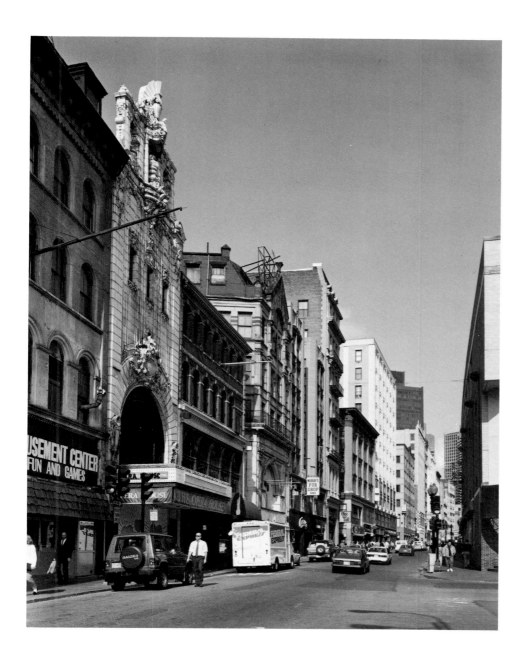

enough, a reminiscence of the atmosphere of the time. Most evocative of all is the banner for a stage show called *Tars and Spars.*

Bloodless, by comparison, is the scene of today. The blank and pitiless Lafayette Place has replaced the vigorous R. H. White store, and the theater façades have been scrubbed clean of their signs. The theaters look better as architecture, but it is painfully clear that nothing is now going on inside them.

Order that is being challenged, order that is barely able to contain the vital, jubilant forces that are making for disorder — that kind of ten-

sion is best for the appearance of a commercial street like this. Someone once said of Charles Dickens that he was always inventing elaborate plots from which his characters were always escaping. There could be no better definition of the perfect relationship between order and freedom in a good city. Such an ideal falls somewhere between the chaos of the old photo and the tedium of the new.

A street without windows is blind and frightening. — Christopher Alexander

A Theatrical Revival

THE RAVAGED HULK of the once grand Majestic Theater dominates the photo of 1978, a year that perhaps marked the nadir of the Boston theater district. We are looking along Tremont Street toward the corner of Stuart.

Twenty years earlier the Sachs chain bought the Majestic and converted it from stage to film, renaming it the Saxon — thus perpetuating a Hollywood tradition of Anglicizing (or Saxonizing?) a Jewish name. The Saxon displays a ground floor that has been "renovated" to a level of chaos and ugliness so grotesque you almost wish it could be preserved as a marvel of its kind.

For a time in the 1950s and 60s, the renovated Saxon was Boston's cinema showcase, home to *Exodus*, *Ben-Hur*, *My Fair Lady*, and *Around the World in 80 Days*. This was the era of experiment with wide-screen technology, when major films usually played in only one large, custom-fitted theater per city, rather than in numerous mini-cinemas as they do today. With changing technology and economics, the Saxon's fare declined to cheapies. The lascivious title of one of the latter is visible on the marquee.

High above all this decay, the noble Roman arches and pilasters of the original theater remained intact. In the old photo they seem to be trying to ignore the indignity beneath them, as a man in a dinner jacket might ignore the fact that his pants had fallen down.

The new photo shows the theater in happier days. Emerson College bought the Saxon in 1983 as a home for its theater program, and in 1989 reopened it as a legitimate playhouse. Today it's called the Emerson Majestic — although if a generous donor should appear, it will surely acquire yet another name.

1978

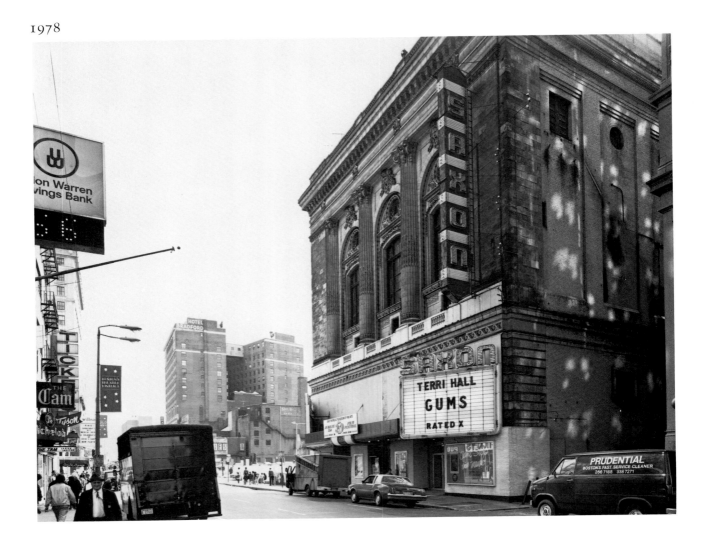

The scaffolding supports technicians who are examining the façade, which is made entirely of terra cotta. Their work is the tiny beginning of what Emerson hopes will be a complete restoration of the theater, inside and out, at a cost of several millions.

It's hard to believe in our present age of home entertainment, but throughout the first third of this century, a major new theater or concert hall opened, on average, every eighteen months in downtown Boston. And that's not counting dozens of smaller houses. The Majestic arrived in 1903, designed by John Galen Howard and J. M. Wood in the lavish Beaux-Arts style. Howard, trained at MIT, soon went west to design the campus of the University of California at Berkeley. Eben Jordan, founder of Jordan Marsh, paid for the Majestic.

The Majestic's auditorium is a lavish domed fantasy of painted and gilded ornament, as rich in architectural calories as any interior in Boston.

Especially notable is the inventive use of electric light, then a novelty: tungsten globes are set into garlanded arches that soar above the auditorium.

Beyond the Majestic a vacant lot in the old photo has been filled, in the new, by a state office structure, the Transportation Building. Its ground floor is filled with shops, restaurants, and performance space. An example of the wisdom of mixing uses in a city, the Transportation Building has infused life into the theater district and helped it achieve its present state of precarious health.

No one ever went broke underestimating the taste of the American people. — H. L. Mencken

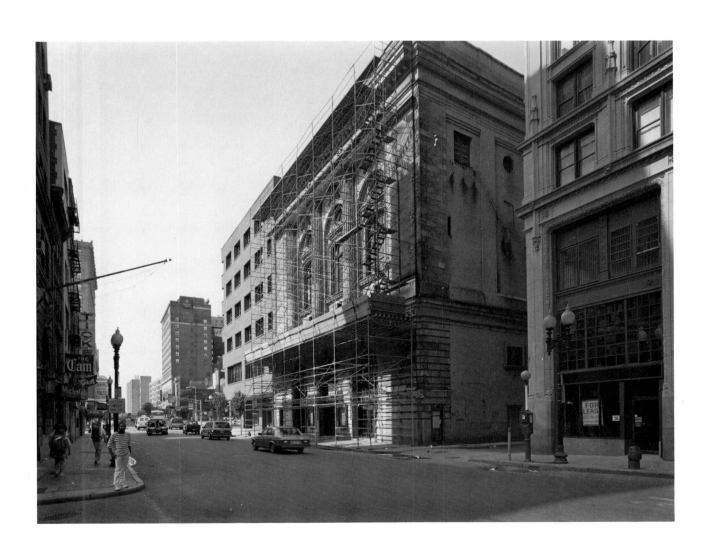

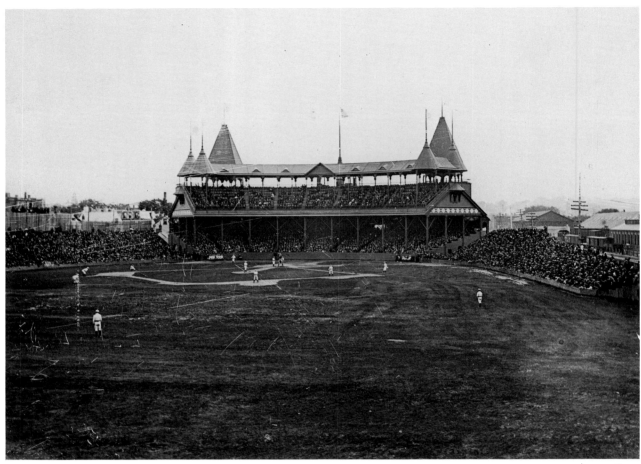

Two Ways to Bring People Together

Two good buildings of two very different eras stand on almost exactly the same spot in these photos.

The building in the old photo is the Walpole Street Grounds, sometimes called the South End Grounds, the baseball park of a professional team called variously the Red Caps, Bean-Eaters, Doves, and Rustlers — and later known as the National League's Boston Braves.

The many-hatted old grandstand is an engaging building. Its architecture, playful and even silly, is well suited to a place where grown men chase balls on summer afternoons. Boston's only double-decked ballpark ever, it burned in 1894. The fire began in the right-field bleachers during a game and went on to consume the whole park and 177 other buildings in what is sometimes called the Great Roxbury Fire. The Grounds was rebuilt and used until the middle of the 1915 season, when the Braves decamped to the new

Braves Field on Commonwealth Avenue. Meanwhile, in 1901, the rival Pilgrims of the new American League built another park, on Huntington Avenue just across the railroad tracks at the right of this photo.

Baseball parks like the Walpole Street Grounds began to appear in the late nineteenth century and were more important than they seem. Baseball — that unique pastoral dance of white-clad figures on a green lawn — served American culture in many ways.

Baseball was one of the institutions by which an increasingly pluralistic society could introduce its members to one another and give them a common language. Everybody — at least, everybody male — could talk baseball. And the game was a way to indoctrinate new immigrants into American mores, such as the value of competition and of playing by voluntary rules (or at least appearing to). Baseball provided us with some of

our earliest celebrities, those phony media friends whom we all "know," about whom we gossip, and whose existence allows a vast, fragmented nation to feel something of the oneness of a small community. After Christy Mathewson there would be Jack Benny and Bill Cosby and Madonna.

Baseball also both celebrated and softened that scary new phenomenon, the big industrial city. The teams belonged to the cities and took their names. They were among the cities' proudest icons and emblems, helping to define the whole concept of the great metropolis as it began to emerge in these years of the Industrial Revolution.

All that is changing now, as the growth of suburbs blurs the image of "major league" cities like Boston. Pro teams now often take vague regional names — New England Patriots, Texas Rangers. Less and less do Americans define themselves by their proximity to any center.

Lost, too, is baseball's myth of rusticity. The game's "parks" and "fields" were like Frederick Law Olmsted's great urban landscapes, created at the same moment: little green allegories of country life, placed, as foils, in an urban world. Today we watch the game no longer in park or field but in a stadium — or astrodome.

In the new view we see Ruggles Station on the Orange Line, designed by Stull & Lee. We're looking at a side view of the station, a view that doesn't do it justice. Approached from either end, as it normally is, Ruggles is a handsome building of bold arches that proclaim — as did the hats of the Walpole Street Grounds — a place of civic prominence. Its long, barrel-vaulted concourse is a pedestrian bridge over a railroad/highway line that divides two neighborhoods: the Fenway (largely white) and Roxbury (largely black). Ruggles thus links two groups of Boston citizens that have long been sundered. As baseball did, it introduces us to one another.

The axis of the earth sticks out visibly through the center of each and every town or city.
— Oliver Wendell Holmes

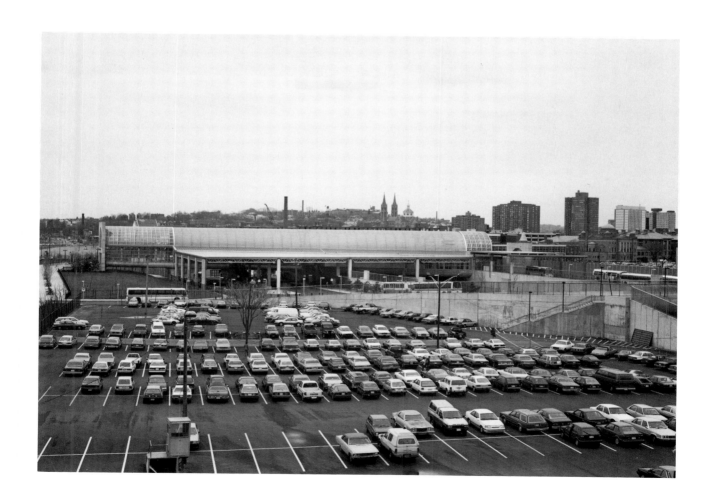

The Pilgrims' Progress

W E ARE WATCHING the first World Series ever played. The Boston Pilgrims (later to become the Red Sox) of the newly formed American League met the Pittsburgh Pirates of the National, here in the Huntington Avenue Baseball Grounds on October 1, 1903. Boston won, five games to three, in the best-of-nine series, collecting the first of five world championships it would win during a sixteen-year period that ended in 1918. As all Bostonians know, in the same intimate way in which they know their own sins, the team was never to be world champion again — at least not in the succeeding seventy-three years up to the writing of this book. Faith in the annual crash of the Sox is now so

deep and secure that a championship might prove difficult, psychologically, for many Bostonians.

The photo does not show the game actually in progress, although unruly crowds were commonplace in the old days of baseball, and spectators often stood on the playing field itself, restrained only by a rope. Instead, fans are watching infield practice just before the call of "Play ball." In a few moments the legendary Cy Young will begin pitching and losing for Boston. The photo must certainly have been made from a balloon.

This part of Boston is radically changed. Northeastern University, founded in 1898, came to Huntington Avenue in 1913 as a tenant of the

1903

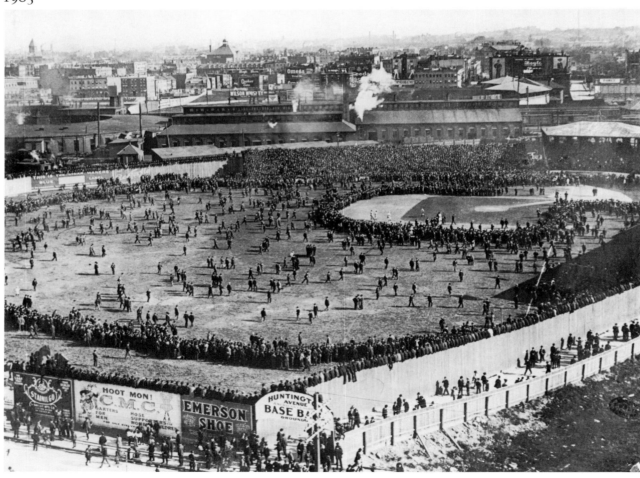

then-new YMCA building (it's the farthest building on the left in the new photo) and eventually grew to occupy the whole of the old Huntington Baseball Grounds site. (The Sox split for the new Fenway Park after the 1911 season.) Appropriately enough, the Cabot Physical Education Center ("gym" in English), built in 1954, occupies the center of the old ballpark. The rest of Northeastern's fifty-acre campus stretches beyond it.

Although it's hard to spot, there's a second baseball park in the old photo. Just beyond Huntington Grounds, on the far side of the Boston and Providence railroad tracks at the corner of Columbus Avenue and Walpole Street, is the Walpole Street Grounds of the National League team that became the Braves. You can just make out its grandstand roof, rebuilt after the 1894 fire, behind the right end of the train shed at the upper right of the photo.

Serious sport has nothing to do with fair play. It is bound up with hatred, jealousy, boastfulness, disregard of all rules and sadistic pleasure in witnessing violence: in other words, it is war minus the shooting. — George Orwell

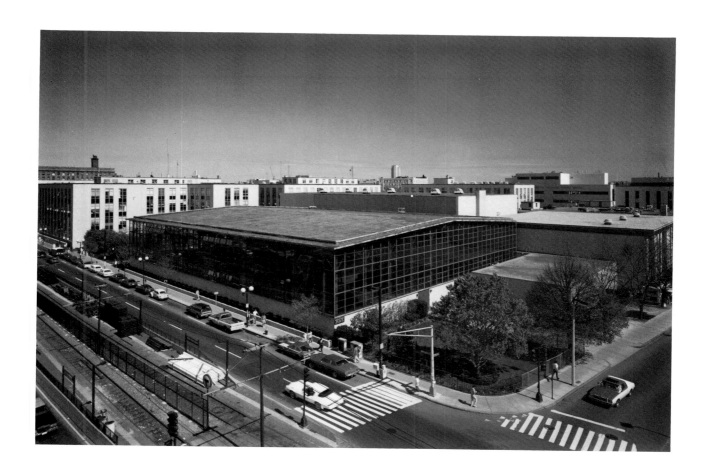

1901

The Green and the Gray

ELEPHANTS MARCH in one direction, Celtics motor in the other. Herd and team — one famed for bulk, one for height — are both on Boylston Street beside Boston Common, always a good place for a parade.

The circus elephants promenaded in 1901. The Boston Celtics are seen in a motorcade on June 14, 1986, honoring the team's fifteenth National Basketball Association championship in a period of twenty-eight years — easily the most remarkable record in the history of American professional team sports.

Like the baseball clubs of a century earlier, the Celtics nurture the unity and identity of the metropolis by symbolically integrating its many elements — especially, in this case, black and white — in a precarious but triumphant equilibrium.

A flourish of music stores along this stretch of Boylston has long given it the title of Piano Row. The 1901 photo already shows at least one piano shop. The vacant lot is the site of the old Boston Public Library, and the crane on it belongs to Norcross Brothers, building contractors. Norcross is at work on the new Colonial Building, which will contain the Colonial Theater.

The Colonial's architect was Clarence H. Blackall (1857–1942). Blackall, often working with collaborators, designed at least twelve Boston theaters, including the Wilbur and the Metropolitan (now the Wang Center for the Performing Arts). He also created two other masterpieces that are among Boston's best small buildings. They are the flamboyant Tremont Temple on Tremont Street, whose multicolored façade resembles a pool of water dappled with

sunlight, and the exquisite Winthrop Building at Washington and Water, a gem in buff brick and burnt sienna terra cotta.

The Colonial Building still stands. Its lavishly decorated theater is now the city's oldest to have survived intact. Next to it on the left in the new photo is the 1916 Little Building, replacing the mansard-roofed Pelham Hotel. The Little too is by Blackall, who this time imitated the Gothic style of the 1913 Woolworth Building in New York.

The two Blackall-designed buildings make good twins, alike in height and scale but very different in style and quite opposite in tone. One is vertical stripes, the other horizontal; one is white on black, the other black on white.

A virtue revealed by the older photo is the orderliness of the city. From any high window in Boston then you could see, as you do here, church steeples rising dark against the gray ring of hills in the distance. In the foreground the buildings fronting Boylston are drawn up like a row of somewhat unruly troops at attention, making a kind of informal honor guard for the parade. In the nineteenth century, city buildings resembled the human form. They were narrow and vertical, with some treatment at the top and bottom that always suggested hats and boots. And their windows were eyelike orifices behind which, you can't help imagining, creatures like you may be watching.

Not much has changed on Piano Row, still a good and characteristic chunk of Boston.

A critic is a man who knows the way but can't drive the car. — Kenneth Tynan

A Cathedral Trapped Behind an Iron Fence

ANOTHER PARADE, this one more solemn. For many Bostonians, the funeral of a cardinal is among the memorable public events of a lifetime.

The older photo depicts the funeral of Cardinal William Henry O'Connell, archbishop of Boston, held in April 1944 at the Cathedral of the Holy Cross on Washington Street in the South End. The new photo shows an opposite event, the ordination of a new priest. Both occasions take their place in an endless cycle of death and rebirth, like that of the city itself.

In that spirit we might caption this pair "Noel Noel Noel." There is indeed no el: the Washington Street elevated railway has been replaced by the underground Orange Line, on a somewhat different alignment. No longer does

the cathedral seem trapped, like a lion at the zoo, behind a huge iron fence — although the wooden rail and ramp in the new foreground, clumsily providing access for the disabled, seem almost intended to evoke a memory of the old el.

Holy Cross Cathedral is a sad story architecturally. It was designed by Patrick C. Keely in the Gothic style of the great medieval cathedrals of Europe and opened in 1875. It was enormously ambitious, as big as Westminster Abbey in London, intended not only to serve the Irish of Boston but to mark their civic significance at a time when this emerging group was just nine years shy of electing its first mayor, Hugh O'Brien. In the 1870s the Irish and the WASPs were employing architecture to dramatize a rivalry that would soon split the city politically.

1944

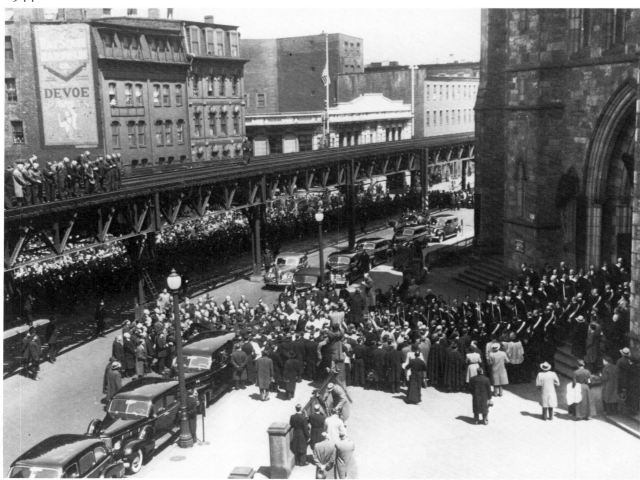

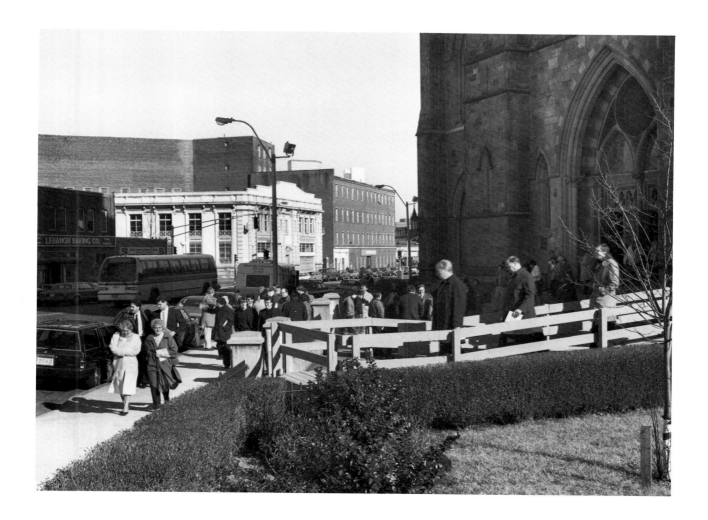

In Copley Square the Episcopalians were erecting Trinity Church — a comparable monument — during the same years Holy Cross was going up in the South End.

The WASPS proved smarter at site selection. Holy Cross stood in a South End that failed to boom. Soon the cathedral, intended as a central Boston monument, found itself stranded in a rooming-house backwater of the city. Its spires were never finished, its interior was never fully decorated. Its unbroken, unmodulated coat of dark Roxbury puddingstone looks, on so large a building, quite grim. For most Boston Catholics of today, the cathedral is an afterthought at best.

But cathedrals live a long time. With the even bigger Cathedral of St. John the Divine in New York now finally on the way to completion, perhaps Holy Cross, too, will someday be brightened and finished.

The stone shall cry out of the wall, and the beam out of the timber shall answer it. — Habakkuk

A Street for Pedestrians

THE SIGNS TELL THE STORY of a Boston that is changing while remaining recognizable. Doughnuts for the masses give way to trinkets for the cosmopolites, as Chockfull o' Nuts is replaced by Au Bon Pain, Edwin Case Shoe by Foot Locker, corsets by barbecue. Perhaps the taste police of our own time have slightly overedited the vulgar, agreeable chaos of the old commercial signs. Compare, for instance, the generous, messy, cartoonish Chockfull o' Nuts sign with the handsome but tensely self-conscious graphic of Au Bon Pain, which seems to proclaim "Good Design Here." Like the rest of America in these years, Winter Street has experienced a sort of grunge exchange. The shoppers have grown much more casual in dress, while the signs have grown more formal.

Other things have changed. Homer's Jewelers is "Going Out of Business." But a fair amount of the older Winter Street of jewels, furs, shoes, and

the 1950s

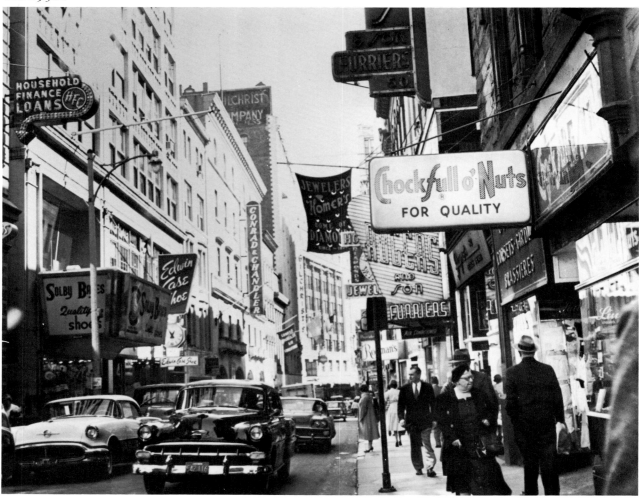

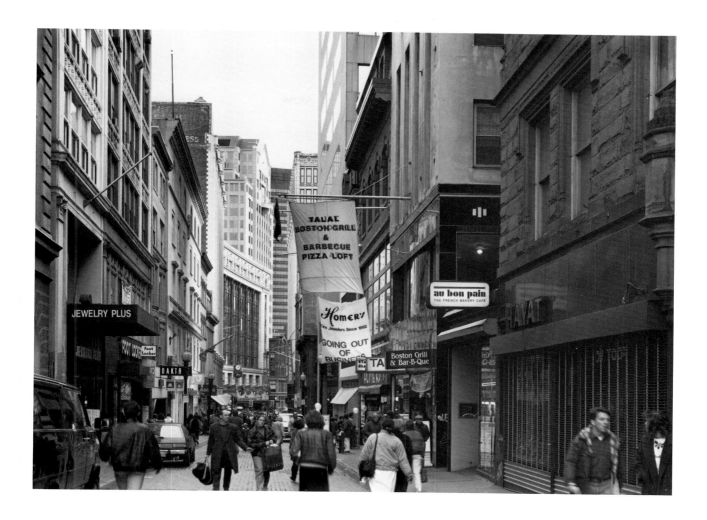

haberdashery remains, side by side with the new. No buildings have yet been demolished. Rarely noticed, most are fine examples of Boston commercial architecture: for example, the Thomas Building (architect John A. Fox, 1887) on the extreme right, with its heavy Richardsonian stonework, and the Homer and Reynolds Building (Parker, Thomas, and Rice, 1922) on the left, housing Jewelry Plus (another uptight graphic).

The biggest change is the disappearance of cars. Today's shoppers walk down the middle of the street on slate and cobblestone. Pedestrianizing streets became a fad in the 1960s because American downtowns were dying from the competition of suburban malls. The hope was to imitate the success of the car-free malls. But the result was usually disaster. Removing the colorful moving cars from American streets was like stripping the bright rotating toys from a baby's crib. Sensory deprivation ensued, and the streets died faster than ever. Planners had forgotten that congestion is a virtue, not a vice, of cities, and that most American downtowns have too little of it, not too much.

In many ways Winter Street is an exception: a pedestrian street that isn't dead. It's situated in the midst of enough life to keep it filled with activity, despite the departure of cars. And yet it somehow hasn't acquired the look of a true pedestrian street, of the European kind it's trying to emulate. It needs a livelier cast, a better set: outdoor stalls of fruits and flowers and newspapers, hawkers and vendors and dogs and babies and mysterious persons — who may or may not be famous authors or spies — conducting trysts at sidewalk cafes.

In art the best is good enough.
— Johann Wolfgang von Goethe

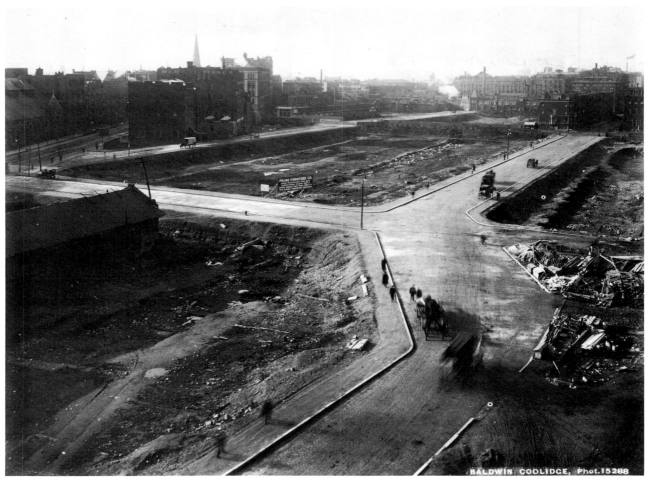

BALDWIN COOLIDGE, Phot.15288

1914

An Early Shopping Mall

WE TEND TO THINK of Boston as an old city. Park Square, for instance, with its traditional, carefully detailed buildings of brick and stone, its elegant street lamps, its trees and benches, feels rather Old World to most of us. But that feeling is a delusion.

We're looking along Providence Street toward its crossing with Arlington. The photos prove that, like most of Boston and most of America, Park Square is the product of ceaseless, restless change. No building whatever existed on this site as recently as 1914, a date within the memory of many living Bostonians.

Back in the nineteenth century, Park Square was home to the vast Boston and Providence station and its yards. After the railroad departed for South Station at the turn of the century, the land remained vacant. It soon eerily resembled the

shell-shocked no man's lands of World War I. That war began in August 1914, the same year the Paine Furniture Company planted a sign, visible at left center in the old photo, in this bare earth. It looks like a flag of surrender but it is actually one of promise: "PAINE FURNITURE CO. HAVE PURCHASED THIS SITE CONTAINING 25,000 SQUARE FEET UPON WHICH THEY WILL ERECT A TEN STORY FIREPROOF BUILDING."

The Paine Building still houses the furniture store. It stands behind the American flag in the new photo. That flag hangs from the Park Plaza Hotel, formerly the Statler, which came along in 1927. In the center of the photo is the Park Square Building of 1923. On the far right is the Heritage, a mix of shops, condos, and offices that arrived as recently as 1988.

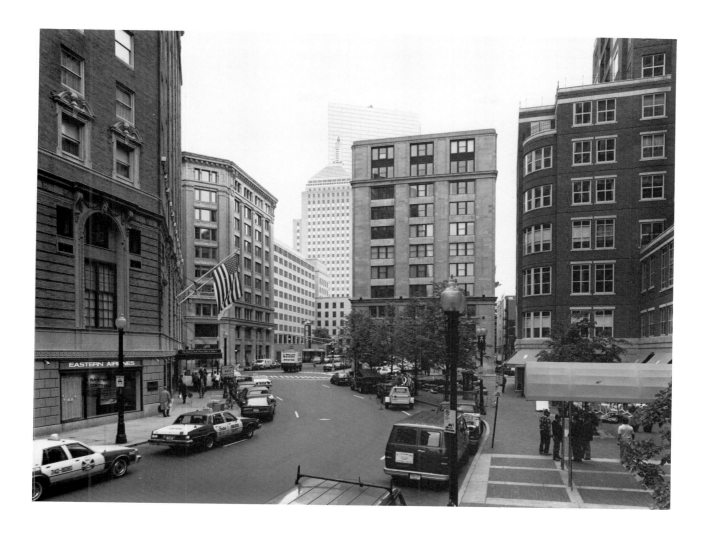

Seldom can you say this, but it's true here: every one of these buildings, new and old, is excellent — simple, elegant, rational, unpretentious. Each, like a well-dressed person, displays just enough ornament to look trimmed and cared for but never so much as to be ostentatious.

Perhaps the best is the Park Square Building, designed by the little-known firm of Densmore, LeClear & Robbins (which, as Densmore & LeClear, did the Paine too). This is an early example of a shopping mall, organized rather like Quincy Market, split down the middle by a block-long indoor arcade. The arcade is more than 650 feet long — just about two football fields — handsomely detailed in bronze and lined with shops on both sides.

Retail stores in cities do better when they're out on the sidewalk, meeting and greeting the public, than when they're hidden away in arcades, and business is often less than brisk at the Park Square arcade. Maybe it will pick up now, with the completion and occupation of the vast 222 Berkeley complex, right opposite the arcade's far end.

Today's Park Square is an outdoor room — a room with an interesting shape, a ceiling of sky, and walls paneled by the façades of the buildings. It is one of the pleasanter urban spaces in Boston.

Marriage . . . is a damnably serious business, particularly around Boston. — John P. Marquand (*The Late George Apley*)

*A Striptease
Palace Named
Howard*

BILLY BARNUM, in the new photo, is demon-
strating the former location of the Old
Howard's front door. Barnum, who lives around
the corner on Beacon Hill, once worked at the
Howard.

The Old Howard was surely the most cele-
brated burlesque house in American history. It
wasn't named, as one might wish to believe, for a
devoted elderly fan but instead for a street that
has disappeared. And its fame probably had more
to do with its location in puritanical Boston than
with any special sizzle in its performers.

Many Bostonians still fondly recall the How-
ard — "beloved," as historian Walter Muir
Whitehill so deftly put it, "by generations of
bums, sailors, and Harvard undergraduates." The
theater's beginnings were bizarre. Its story dates
to 1843, when a fundamentalist preacher named
William Miller and his followers built a wooden
tabernacle here, a place where Miller could
preach. His message was that the Second Coming
would occur between March 1843 and March
1844.

When the great event failed to happen, the
Millerites drifted on to other enthusiasms, and
their tabernacle became a theater called the How-
ard Athenaeum. To quote Whitehill again: "A
lingering Puritan prejudice against the supposed
wickedness of the stage caused Boston theater
operators to choose names that implied intellec-
tual elevation."

The original Howard Athenaeum burned in

1846. It was replaced by a Gothic stone structure designed by Isaiah Rogers, the architect of Commercial Wharf. The Howard almost justified its name in the early years, when its stage was home to operas by Verdi and Mozart. But it soon slipped downhill into a showcase for jugglers and performing monkeys and eventually into a legendary striptease palace. It was demolished after a fire in 1961.

Now wholly erased, Howard Street was a rich clutter of texture and inviting detail. Its buildings came right to the edge of the sidewalk with no setbacks, intimately offering you access with their signs and steps and doors and windows.

The new photo shows a much altered scene. Howard Street has been exchanged for what is fondly called open space, which in this case is the residual wasteland left over when city planners stuck square government buildings down on odd-shaped lots. SLOP, you might call it, in an appropriately bureaucratic acronym: Space Left Over after Planning. It is of no use to anyone, but it's typical of recent American downtown redevelopment, which often seems bent on abolishing city streets in imitation of suburban office parks — although such places are perhaps the dullest environments yet created by humanity.

If a thing is worth doing well, it's worth doing very slowly. — Mae West

A Skyscraper Lying Down

THE CENTER PLAZA office building is undoubtedly one of the best, most humanly scaled of the many buildings that rose in and around Boston's Government Center during the urban renewal era of the 1960s. It is a skyscraper lying on its side, and its long, slow horizontal curve pleasingly outlines the base of Beacon Hill, while its red brick and precast concrete recall the brick and limestone of older buildings.

But its blank giantism, its endless repetition of identical windows — so poignantly expressing the punch-card interchangeability of those who must work behind them — still fares badly in comparison with the extraordinary eloquence of the former scene. So completely has this part of

Boston disappeared that it is hard to believe both views were made from exactly the same point — or that as recently as 1960 old Scollay Square, though badly deteriorated, was essentially intact.

Scollay Square looked as much like a stage set as any Boston place ever has. You expect to find strolling minstrels, soapbox orators, furtive assassins in a setting like this. Two pavilions furnish the square as a room might be furnished by a chimneypiece or settee. The pavilion in the center is surely modeled on the Roman temple of Vesta, goddess of the hearth, at Tivoli. The one at the right with the clocks looks more like the tower of a Victorian town hall that has been sliced off and re-erected. Both pavilions are subway entrances. They remind us that in periods of civic pride, even Boston's sewage pumping stations were often magnificent.

circa 1920

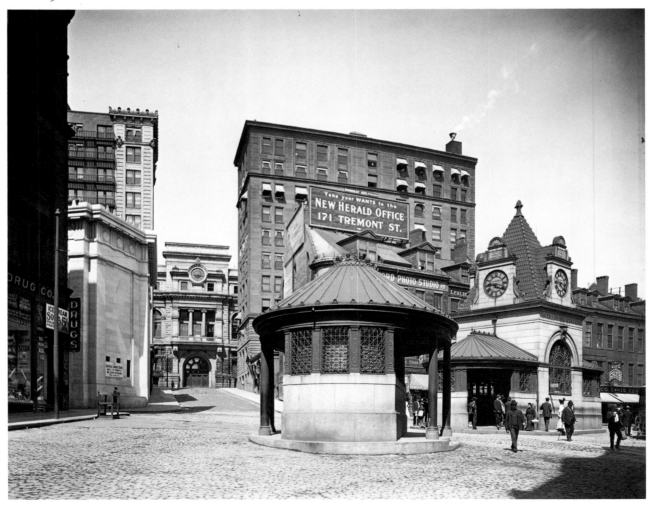

A single detail measures the difference between two eras. About a third of the way from the left, in the background of the older view, you can see another façade with a clock. At its bottom is an arched door. The door was the main entrance to the Suffolk County Courthouse. For decades, streams of people passed almost continuously through this door, using the courthouse lobby as a grand public arcade linking the Massachusetts State House to the financial district.

This courthouse "street" is still a good shortcut, and the doorway is still reachable through the wide square opening in the Center Plaza building. But the courthouse has long been closed to the public for no better reason than a nearly forgotten bomb incident. Bored guards at ramshackle tables, armed with metal detectors, mock the civic welcome and trust once offered by the great arched door beneath its clock.

Center Plaza proves again that the larger the plot of land on which any redevelopment takes place, the more difficult it is to preserve variety and human scale. A street of many owners, all building on small lots, has a better chance of success than a single gargantuan gesture like Center Plaza, no matter how sensitively designed.

A building cannot be a human building unless it is a complex of still smaller buildings or smaller parts which manifest its own internal social facts. — Christopher Alexander

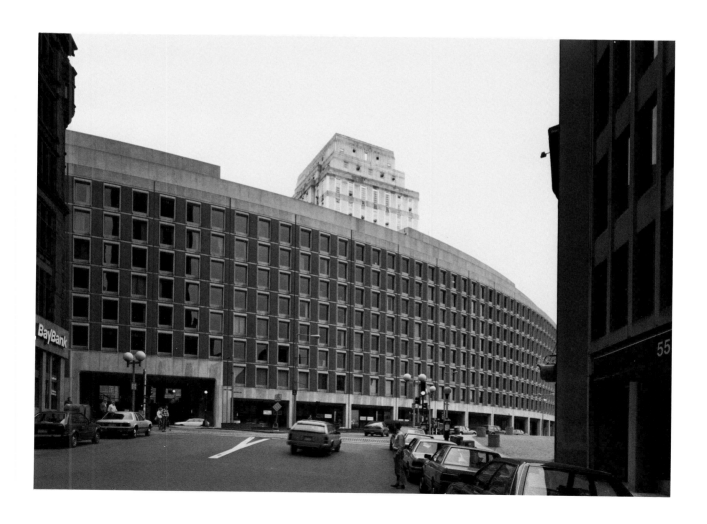

A Street that Beckons Us Mysteriously Forward

THEY CALLED IT "the New Boston." At the beginning of the 1960s, it was a vision of dramatic change and renewal that gripped the city and its leaders.

An alignment of the political planets appeared in the sky in those years. President John Kennedy was a Bostonian, and so was Speaker of the House John McCormack, and a Massachusetts senator, Edward Kennedy, was the president's own brother.

Boston's new mayor, John Collins, and his savvy city planner, Edward J. Logue, knew how to read such stars. Hundreds of millions of federal urban-renewal dollars rained on the city. The immediate result was Government Center — the replacement of old Scollay Square by a new Boston City Hall and much else.

In the older photo we see a corner of Scollay Square thirty years earlier. The signs proclaim the character of the neighborhood: pawn shop, passport photo shop, barber, locksmith, liquor store. A canopy at the corner shields a vanished subway entrance. Two taxi cabs stand at the curb.

Scollay Square had reached its final incarnation, as the Combat Zone of its day. It was a sleazy quarter, catering largely to sailors from the commercial docks and the Boston Naval Shipyard. There were burlesque houses like the famed Old Howard and tattoo parlors and all-night movies that doubled as cheap shelters for street people. But Scollay was always more than that: a busy urban melting pot, filled with students, shoppers, bankers, trolley riders, all passing purposefully through it.

There are hints, in the 1934 photo, of an earlier, more respectable Scollay Square. The clock

1934

tower at the left marks the Quincy House, a hotel for commercial travelers, one of several in the neighborhood. At the upper right — just above and to the right of the word CASH — is a strip of all-glass wall that lit photographers' studios, which occupied this building as far back as the 1880s.

Virtually everything has been demolished in the new photo. Revealed is the full length of the building with the former glass studio wall, now remodeled as Sears Crescent. Cornhill Street, onto which Sears Crescent once faced, has vanished into the yawning Bermuda Triangle that is today's City Hall Plaza.

Without mourning every aspect of Scollay Square, we may still regret the loss of the fascinating close-grained texture of the old photo. An especially poignant loss is the tight, curving street space of Brattle Street, at the left of the old photo, the kind of cityscape that seems to beckon us toward unimaginable mysteries just around the corner.

Slums may well be the breeding-grounds of crime, but middle-class suburbs are incubators of apathy and delirium. — Cyril Connolly

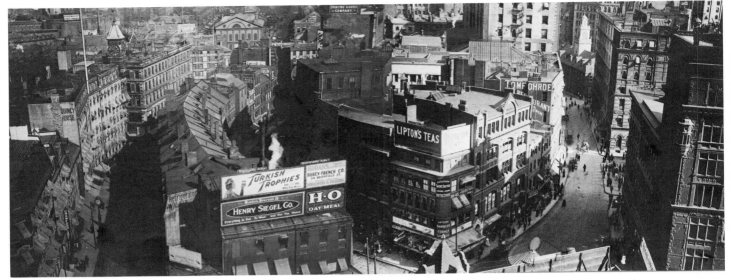

Barbarians Strip the Palace

THE RUGGED FORTRESS with the flags in front, shoving its way aggressively in from the left side of the new photo, is Boston City Hall. City Hall and its plaza swept away the delicate European swirl of small streets we see at the left of the old photo.

Little remains except a curve. The curve is the arc of Cornhill Street, an elegant crescent once lined with booksellers. Cornhill itself has vanished into City Hall Plaza. But its shape remains in the building on the right, still curled up like a sleeping spouse on a bed from which a partner has departed. Called the Sears Crescent, it was built in 1816 and remodeled in 1860 with fine details in the Italianate style. Beyond City Hall you can make out the peaked gable of Faneuil Hall. Not much else is left.

Planners of the "New Boston" of the 1960s needed a demonstration project to prove their mettle. They picked Government Center because much of the property was already publicly owned and so could be demolished and rebuilt with a minimum of interference.

With the help of Henry Cobb of I. M. Pei and Partners, the city created a master plan that erased the little streets in favor of a new plaza. But City Hall Plaza turned out to be so vast and shapeless as to be useless. Only the grandest of regimental troop maneuvers could justify this limitless expanse of empty brick. Or a throng gathered to celebrate a Red Sox championship: can this be what the visionaries anticipated?

The jewel of the new Government Center was to be a city hall. And herein lies a legend of architectural history. Like any legend, it has small beginnings. Two little-known teachers of architecture at Columbia University, Gerhard Kallmann and Michael McKinnell — one originally German, one British — go for a walk in New York in 1960. During their walk they decide to start a firm together. Both have worked for others, but neither has ever designed a building independently, and McKinnell is only twenty-five. They have few contacts in America, so they figure they'll seek work by entering architectural competitions — open contests in which architects anonymously submit designs for a proposed building, and a jury picks the winner.

Competitions are rare in the United States. Yet almost immediately one is announced for a new city hall in Boston. Kallmann and McKinnell enter. So do 250 other architects. Astonishingly, the unknown New Yorkers win.

Perhaps never in history have designers so untested been given a building so significant. To see it through construction, they move to Boston. Both teach at Harvard and, as Kallmann, McKinnell and Wood, they become perhaps the leading firm in the city. Among their works are the Hynes Convention Center, Back Bay Station, Shad Hall at Harvard, and Newton Public Library.

And Boston City Hall.

In a poll of historians and architects, sponsored by the American Institute of Architects in the bicentennial year of 1976, Boston City Hall was voted the sixth greatest building in American history — the highest ranking achieved by any work of a living architect. Tastes do change.

Today, this powerful but grim chunk of concrete, maintained in a Kafkaesque state of suspended decay by the government to which it is home, wouldn't make the charts.

The best way to understand, and perhaps to admire, the architecture of City Hall is to invent another saga. Once upon a time, let us imagine, there was a great palace. Its walls sparkled with precious mosaics and gold leaf and were hung with dramatic paintings and tapestries. Its great halls were filled with torchlight and music and ceremony, with princes and minstrels and clowns. But then came a time of troubles. Barbarians invaded. The palace was shelled. Great chunks were blasted away. Vandals stripped the ornament. Afterward, the surviving people of the kingdom, using the rubble of war, built their brick huts in the shelter of the ruined old palace.

That's Boston City Hall. Wounded and gutted but still trumpeting, it is an elephant at bay. Few have called it user-friendly. But it possesses the dignity of having somehow suffered and endured.

Kallmann and McKinnell offer a different metaphor for their building. They say it is a sandwich with three layers. The top, with its rows of identical punch-card windows, is like an office tower lying on its side, filled with anonymous, flexible space for the bureaucratic departments of government. The bottom, where you find those brick hutlike mounds, belongs to the old red-brick, low-rise Boston, which flows unbroken through and beneath the building. Handy to pedestrians, the brick bottom houses the services, such as marriage licenses, used by the public.

And the meat of the sandwich, where we see big boxy shapes spilling outward? This is the realm of the elected officials — the mayor and the city council — who mediate between the bureaucrats above and the public below. Powerful and independent, these officials are symbolized by aggressive architectural elements.

The trouble with this logical explanation, alas, is that it has never occurred to anyone who didn't hear it first from the architects.

Still another interpretation was once offered to Kallmann by a taxi driver who drove past City Hall, not knowing his passenger was the architect. "You want to know where they got the idea for that building?" said the cabbie, pointing at City Hall. "Yes," admitted Kallmann. And the driver held up the reverse side of a penny, with the image of the Lincoln Memorial turned upside down. (Try it.)

The wealth of possible readings makes City Hall fascinating. Perhaps it could even be lovable if someone would take a loving interest in it. Kallmann and McKinnell hoped to put a beer hall in the basement, like those in German city halls. How about a coffee shop, too, at the top of the great useless lobby stairs? A tapestry competition? How about a city hall that is also a museum of Boston, gradually crusting up over time with trophies and memorabilia like a family castle? How about filling the plaza with vendors, like a European market square? Maybe even shelters for the homeless?

Most Bostonians would settle for less. Replacing dead light bulbs would be a start.

Make no little plans: they have no magic to stir men's blood. — Developer James Rouse, quoting Daniel Burnham

I'm not sure that big plans ever did have the magic to stir women's *blood.* — Jane Jacobs — Exchange at a forum in Faneuil Hall, 1976

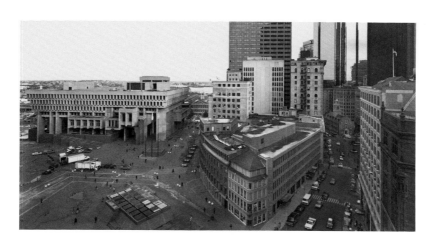

A Literate Streetscape

MILLARD FILLMORE was president and the Civil War was still nine years in the future when the Music Hall — now the Orpheum Theater — opened at the end of little Hamilton Place in 1852. Today, in the age of rock and roll, it continues to serve its original purpose.

An architect named George Snell designed the Orpheum — its front door was originally around the corner — and it quickly embarked on a fabulous career. Here the New England Con-

servatory began its life, here the Boston Symphony Orchestra played its debut concert in 1881, here Tchaikovsky's First Piano Concerto received its world premiere. Booker T. Washington lectured. So did Ralph Waldo Emerson. In later years the Orpheum — renovated several times — hosted vaudeville, movies, and the Opera Company of Boston. At the date of the older photo, a quarter bought a lot of fun: a feature film and short subjects, five traveling

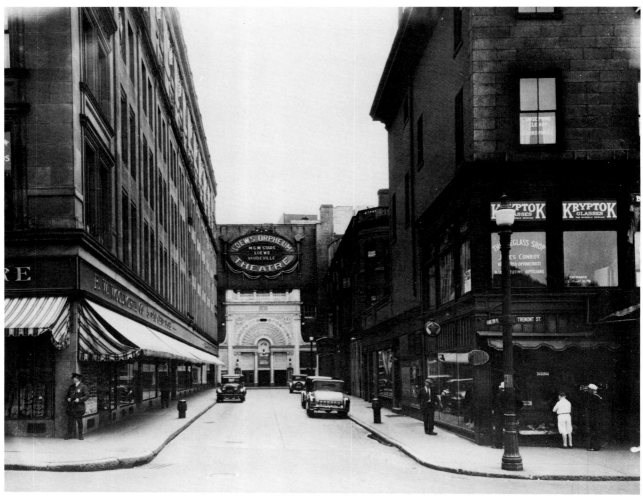

1934

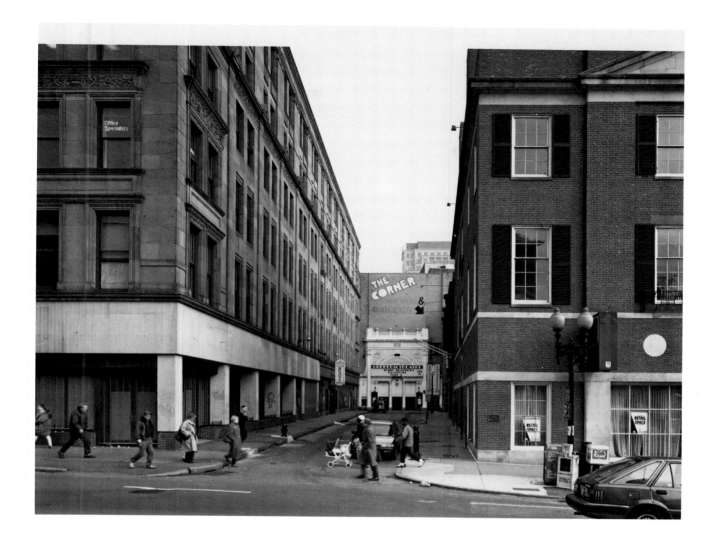

vaudeville acts, and a resident emcee named Art Spaulding, who led the audience in a sing-along. Today the Orpheum is often dark, booking only an occasional rock concert.

Almost as old as the Orpheum is the building at left, the Phillips Building of 1883, a simple but handsome structure for dry goods merchants. Nearly unchanged, except at the ground floor, the Phillips in 1989 was named a landmark by the Boston Landmarks Commission, but Mayor Raymond Flynn vetoed the designation to clear the way for a proposal — since abandoned — to replace it with a 155-foot tower.

In the old photo we see again the sociable patter of signage that enlivened so many street-scapes in the past, making them agreeably communicative, almost chatty. Today's view shows the architecture of an era that is, literally, less literate.

Not going to the theater is like dressing without a mirror. — Arthur Schopenhauer

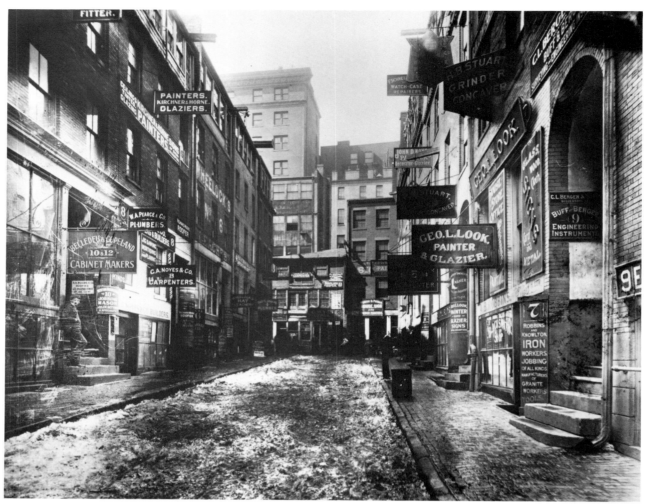

1900

A Warehouse for Automobiles

IT'S EASY TO SPOT the change at the end of little Province Court. Several small buildings, intended for people, have been replaced by one big building, intended for cars.

In the old buildings, small windows, each about the width and height of a human being, express the potential presence of human beings behind these walls. With equal accuracy, the horizontal stripes of steel, concrete, and shadow in the new photo look much like highway bridges and signal the presence of automobiles. "Form follows function" — provided, at least, that the proper function of cities is the warehousing of cars.

Province Court today is a dead street of blank walls and back doors, a mere service alley. But it was once alive with activity. The commercial signs, as so often is true, are the things you notice first in the old photo. With few outlets for advertising, merchants in the past relied on signs to attract attention. Most of the ones here speak of the construction business. On this one block we can make out painters, glaziers, cabinetmakers, plumbers, ironworkers, surveyors, sign makers, carpenters, decorators, roofers, and masons. Province Court was one-stop shopping, an outdoor department store of the building trades. These businesses came here after the fire of 1872, which leveled the downtown to within a block of here. They helped rebuild the city, and their signs helped enliven it.

An especially good piece of architecture is the building at the left in the newer view, the one with the tall arched window. It's the elegant

Hutchinson Building of 1924, which parades a row of no fewer than fourteen equally huge windows around the corner on Province Street. The Hutchinson was designed by a versatile architect named Ralph Harrington Doane, who also created Rindge Technical High School in Cambridge and the Motor Mart Garage in Park Square. The Motor Mart, which looks like an architect's attempt to entomb automobiles in a Roman mausoleum, stands at the opposite pole of garage aesthetic from the one we see here.

This car warehouse is the faceless Metropolitan Garage (1956), which may soon be demolished if a proposed redevelopment goes forward. Regardless of whether it lives or dies, the Metropolitan's lesson is clear. Garages in the city are useful, but they shouldn't be allowed to kill the life of the street by occupying, as this one does, large areas along the sidewalk. Walking past so much dead frontage is like crossing a no man's

land. It is empty, risky, and dull. Garages on commercial streets should be tucked out of sight beneath, above, or behind a continuous sidewalk frontage of other uses with interesting windows and doors, the architectural metaphors of human presence. Garages should also be designed with flat floors and enough ceiling room to enable them to be convertible — like other buildings — to different uses in the future.

To our grandparents, a "house," a "well," a familiar steeple . . . meant infinitely more, were infinitely more intimate — almost everything a vessel in which they found something human already there, and added to its human store. Now there are intruding, from America, empty indifferent things, sham things, DUMMIES OF LIFE.
— Rainer Maria Rilke (letter of 1925)

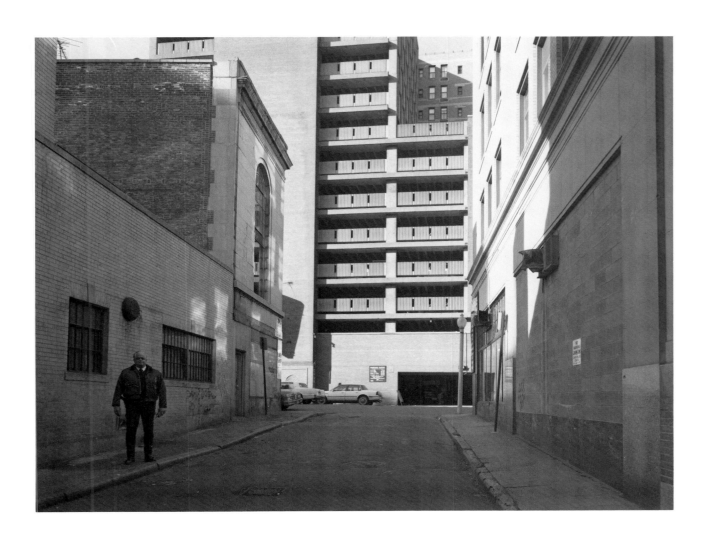

New Wine in an Old Bottle

R ECYCLING OLD SPACES for new uses has been a major industry in Boston in recent years. A police station becomes an art institute, a naval shipyard becomes a residential neighborhood. Apartments are made from garages, schools, factories, and churches. Shopping arcades now occupy what were once a meat market, a railroad station, an arsenal, and a Ford assembly plant.

Grill 23 and Bar, a restaurant in the Back Bay, is one such recycled space. It occupies the former office floor of the Salada Tea Company on Stuart Street at Berkeley. The Salada Building, designed by the firm of Densmore, LeClear & Robbins in 1916, is famous for something that doesn't show here: its exterior doors, which are cast in bronze and depict scenes from the tea trade, including some memorable elephants.

Clerks, brokering tea shipments from all over the world, fill the old photo. The architecture is Beaux-Arts, with fat Roman Corinthian columns, but the decor is Chinese, reminding us where most of the tea — and much of Boston's wealth — came from. We see a sculptured dragon, lacquered cabinets, Oriental carpets and tapestries. The employees bend to their tasks with seemly concentration, probably in awareness of the photographer.

In the new photo the floor in the foreground has been raised to create a mezzanine, and a wall

1920

25217

has been removed, but the space is much the same. Even the old office chairs have been meticulously replicated for the restaurant.

Recyclings embody a paradox. They work best when the new use doesn't fit the old container too neatly. The slight misfit between old and new — the incongruity of eating your dinner in a brokerage hall — gives such places their special edge and drama.

Recyclings raise another issue about architecture. The modern movement was based largely on the principle that "form follows function." But when a radically different function like dining can be contained so pleasantly in a form intended as a brokerage hall, that principle begins to seem a little silly.

The truth is that form shouldn't follow function too closely, for the simple reason that a building's functions usually change during its life. The best buildings are not those that are cut, like a tailored suit, to fit only one set of functions, but rather those that are strong enough to retain their character as they accommodate different functions over time.

Architecture is inhabited sculpture.
— Constantin Brancusi

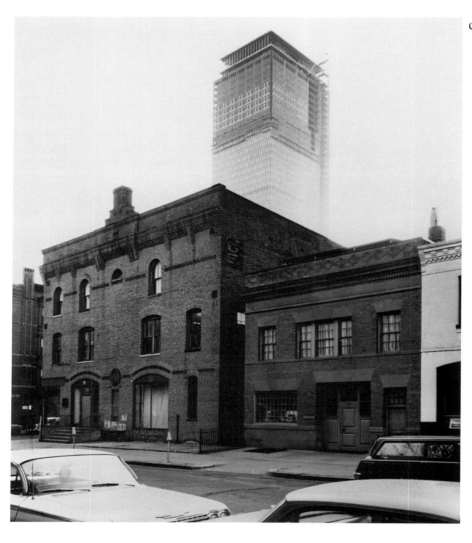

*An Architectural
Slide Show*

T HE BOSTON ARCHITECTURAL CENTER is
the schizoid marriage of two kinds of archi-
tecture. It's America's single most provocative
expression of the transition, during the 1970s,
from modern to post-modern architecture.

The BAC, at Newbury and Hereford streets
in the Back Bay, is a night school of architecture
that began life in 1889 as a tiny atelier in which
members of the Boston Architectural Club gave
drawing lessons to what in those days were called
deserving youth. It's now an accredited school
with more than seven hundred students, most of
whom work days and study nights.

The BAC building, seen in the new photo,
opened in 1967. Designed by the architectural
firm of Ashley, Myer (now called Arrowstreet), it
is an example of a modernist style known to his-
torians as Brutalism, of which the most notable

example in Boston is the City Hall of 1968. Influ-
enced by the rough, massive architecture of the
French master Le Corbusier, Brutalism enjoyed a
vogue in the 1960s and left a legacy of boldly
sculpted buildings constructed, usually, of solid
concrete. Brutalist architects sought a kind of
rugged blue-collar honesty. They tried to express
the true nature of concrete as a poured, molded
material. They liked to cast it in free shapes, leav-
ing on its surface the visible imprint of the
wooden molds into which it had been poured.

A remarkable transformation of the BAC
occurred only a decade after it was built. The
building's west wall had originally been left blank
and windowless because it was on a property line.
It was now enlivened by a mural painted by the
New York artist Richard Haas at the instigation
of the BAC's director, Peter Blake. The mural is a

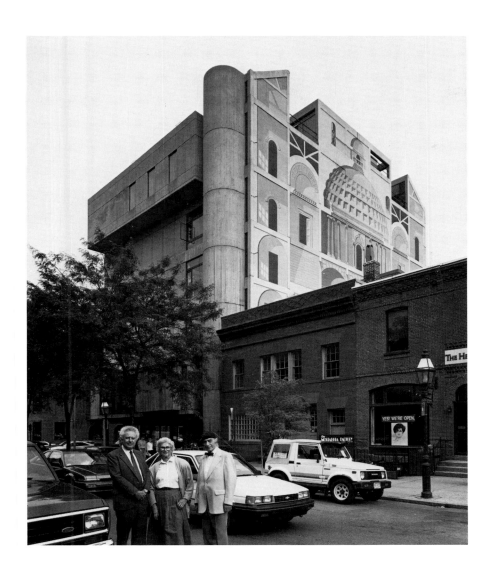

bold advertisement that shouts "Architecture!" It is a fantasy cartoon of motifs drawn from architectural history — a description that applies equally to the so-called post-modern buildings that were beginning to appear all over the United States at that very moment, such as the Portland Building in Oregon by Michael Graves.

The Haas mural is like a slide in an art history class, projected onto the wall of the BAC. If in the past Boston's architecture shaped the city into an outdoor theater, here the city is rather an outdoor slide show, as the media images of today replace the solid artifacts of yesterday. The mural made the BAC a Boston landmark.

The older view can be dated to 1964 because the Prudential Tower, rising in the background, is still under construction. The tower, one of Boston's least-loved buildings, looks much more

interesting here than in its finished state. In the left foreground is an old carriage house, which once housed the horses, carriages, and grooms of Back Bay households. It was demolished to make room for the BAC.

Standing in front of the BAC in the new view are some of its leaders: Bernard P. Spring (left), president, and Elsie Hurst (center), director of administration, both now retired, and Archangelo Cascieri (right), who graduated from the BAC in 1926 and has been the school's dean for more than half its entire century-plus life.

Architect, n. One who drafts a plan of your house, and plans a draft of your money.
— Ambrose Bierce

A Deconstructed Corner

THE CORNER OF CAUSEWAY and Canal streets has been a transit interchange for a century. These photographs show it growing more chaotic — some would say more interesting — over time.

In the old view we see two orderly rows of buildings, along Haverhill Street on the left and Canal on the right. The photographer, we surmise, was standing on the roof of Union Station, later replaced by North Station. Tracks for an elevated train, the old Boston Elevated Railway Company line to Forest Hills, are visible at the left. A wood fence encloses a construction site,

probably for a ramp serving the line known today as the Green Line as it climbs to North Station.

Yet a further transportation line — the expressway known as the Central Artery — has been added to the others in the new photo. For it, all the buildings along Haverhill Street were demolished. The Green Line has replaced the older elevated. And another transportation facility, the Government Center Garage, closes the far end of Canal Street.

The city's master plan for this area calls for the Green Line eventually to be placed underground. And the Central Artery, too, is to be submerged. If those things happen, this scene may regain the serenity it so long has lacked.

Not everyone will be pleased if that happens. American architects, especially younger ones, are often fans of scenes like the one in the new

1908

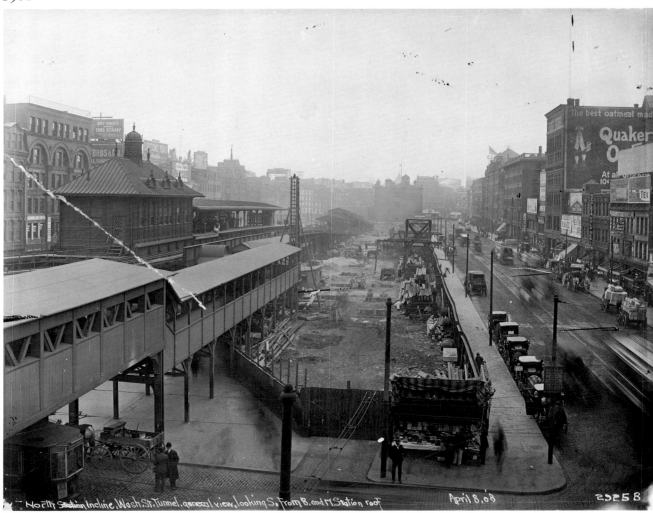

photo. They respond to the gritty sculptural power of such constructions — the big shapes, the visible tensions, the taut planes and lines, the explosive colliding angles. As the industrial age slips into history, its imagery grows in appeal.

Talented architects are now trying to create architecture of a similar abstract energy, calling it Deconstruction, a name that puns on both the Russian revolutionary "constructivist" artists of the 1920s and the French-inspired "deconstructionist" literary theorists of recent years. Deconstructionist architecture seeks to express the potential disorder that is thought to be inherent in any system of order, as well as the pluralism and fragmentation of today's culture. The jargon that promotes it can be silly and self-serving — so what else is new in architecture? — but the movement is serious. Few examples exist in conservative Boston; 360 Newbury Street, home to Tower Records, with its over-scaled angular struts and lead-coated copper walls, is the best. Its architects were Frank O. Gehry of Los Angeles and Schwartz & Silver of Boston.

It exemplifies conceptualistic innuendo pyramided upon spatial forebearance and altogether tokenish of tactile cosmological luminous volumentality. — Description of the Carpenter Center at Harvard in a tourist pamphlet

When the mind dies it exudes rich critical prose. — John Berryman

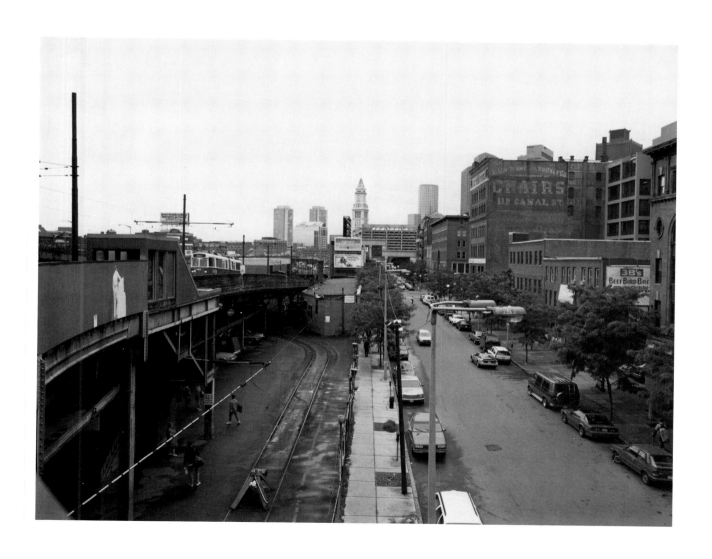

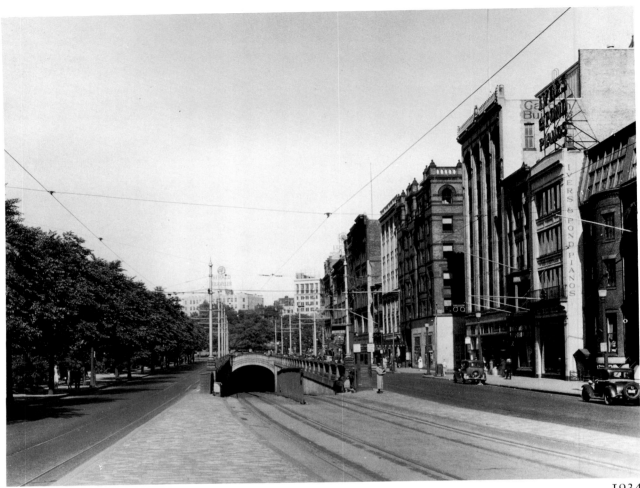

1934

The City of Ghosts

PART OF WHAT MAKES CITIES wonderful is their ghosts, things that once were present but are no longer. And things that might have been present but never were.

When you look at a city, you really see three cities. One is the actual city of today. Another is the city of the past, which, if you know it, seems still to be limned, ghostlike, in the air. A third is the city of dreams, of visions and proposals that never were realized. These, too, are ghosts, present though invisible, sobbing almost audibly, as ghosts do, at their lack of substance. The three cities overlie one another like scrims in a theater, or like the layers of pentimento in an old painting.

Here we see such a ghost from the past. It is an old trolley ramp that still exists, in part, beneath Boylston Street near the corner of Arlington. Arborway trolley cars came downtown along Boylston on the surface, then dove underground

into this tunnel, which opened in 1914 and closed in 1941 when the subway was extended out to what today are the Symphony and Prudential stops. The remains of the tunnel entrance and ramp now lie hidden between the inbound and outbound subway tracks near Arlington station.

On the left in both photos is the Public Garden. On the right, in 1934, are buildings of the early twentieth century, catering largely to the music industry (nearby were most of the theaters and nightclubs). Almost all are now gone. The buildings of 1990 look similar, yet were built as recently as the 1980s.

If we're in the know, we also perceive the ghost of an unrealized vision. In the early 1970s this stretch of Boylston, from the corner of Arlington all the way back to the corner of Charles Street, was the proposed site of a vast redevelopment project called Park Plaza. Backed by city planners, Park Plaza was to be a gargan-

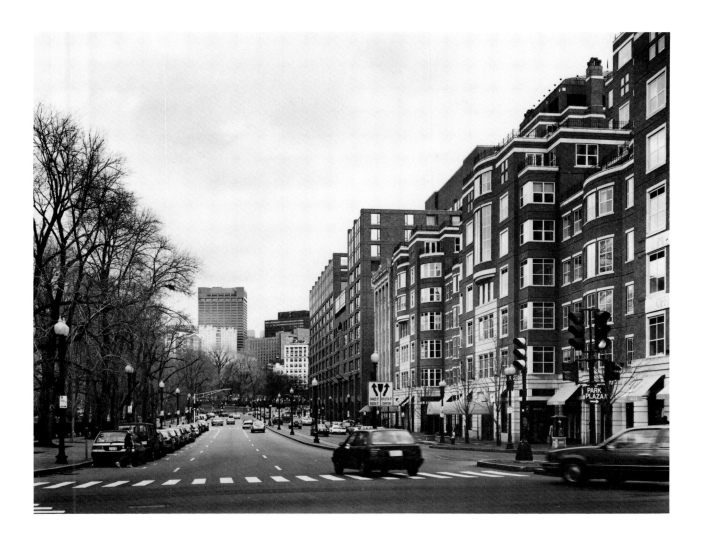

tuan array of six towers, each about forty stories — about the height of the Bank of Boston tower visible in the far distance of the new photo.

Park Plaza was shot down by a fierce alliance of private neighborhood and preservation groups. The result was the more modest redevelopment seen here, consisting of the Heritage in the foreground and the Four Seasons beyond. The Heritage, designed by the Architects Collaborative of Cambridge, is a handsome mix of shops, offices, and condominiums. The Four Seasons, less elegant, is a hotel.

Both buildings obey rules governing their materials, uses, and heights, and the rate at which they step back from the street as they grow taller. These rules were negotiated between the citizens and the city after the demise of Park Plaza. The Park Plaza crisis opened a new chapter in the history of planning and redevelopment in Boston, a chapter in which neighborhood associa-

tions, preservation lobbies, and other citizens' groups have much to say about what is and isn't allowed to happen.

So there really are two ghosts in the new photo, a forgotten ramp beneath the ground and an unbuilt megalopolis above.

There is even a third ghost. It is Church Street, a narrow thoroughfare that in 1934 entered Boylston halfway down the block on the right. Church Street still exists, but it has been renamed Hadassah Way — one of those gentle ironies that make good cities as rich in ambiguity as good poems.

If you would be known, and not know, vegetate in a village; if you would know, and not be known, live in a city. — Charles Caleb Colton

Homeless Men and the Visions of Planners

CROSS STREET doesn't cross much anymore. The bold visions of one generation are often erased by the next, leaving behind as evidence only a mysterious scar or twist in the city fabric.

Back when the older of these photos was made, in 1933, Cross Street was being widened. It became a gash through the solidly built mass of the North End, brutally lopping off whole chunks of solid warehouses. Cross Street began at the corner of Commercial, at the bottom of the photo. As construction continued, the new street drove onward past Hanover, at the photo's top, as

Washington Street and the bridge into Charlestown.

Cross Street relieved congestion in two ways: by providing a shortcut from downtown to the northern suburbs (there was no Mystic River Bridge then) and by providing access to the new Sumner Tunnel, which was already under construction out of sight behind those truncated warehouses on the right of the photo.

The once-great gash of Cross Street is today no more than a minor dislocation. A bigger cross street than Cross Street — the Central Artery —

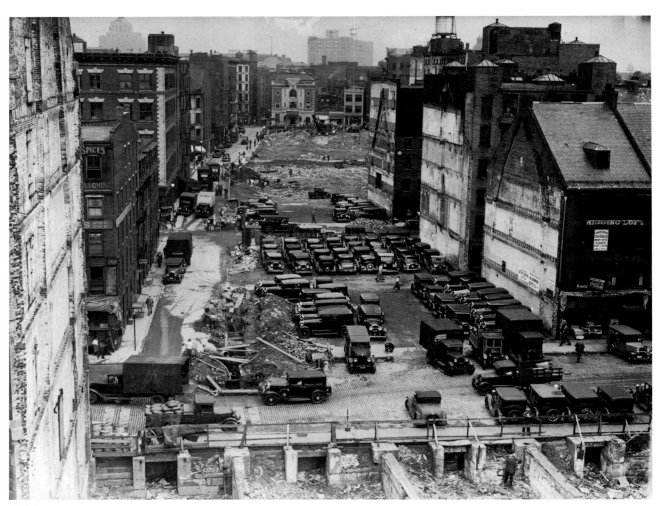

1933

arrived in the 1950s. It is just out of sight at the left of the new photo. At the right the old warehouses have metamorphosed into upscale condominiums.

The Artery reduced much of Cross Street to a mere scrap of disheveled cityscape. Today it is blocked by a ramp that peels off the Artery into the tunnel. In its curve, the ramp embraces a neglected swatch of grass and trees that in recent times has been the campsite of homeless men. They live no farther than a golfer's easy wedge shot across the Artery from the bustling Faneuil Hall Marketplace, in a rustic retreat that is the unintended by-product of the grand visions of two generations of Boston planners.

Architecture, the most visible and unignorable human performance, is the place where people most publicly derive their understanding of themselves. — Paul Fussell

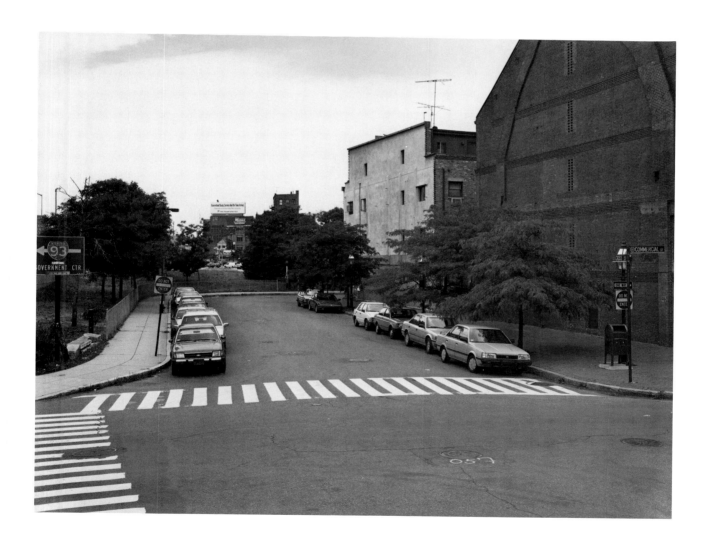

1934

Marauder Expressways

SINCE WORLD WAR II, American cities have been trashed by the invasion of marauding expressways that roar into town and slice up neighborhoods like raucous vandals.

In the new photo we might as well be in bombed-out postwar Berlin. In fact we are in the very heart of Boston, in Haymarket Square. The photo accurately depicts the chaos and emptiness of this ragged intersection of nine streets just north of what is now City Hall.

To the left is the dark edge of the vast Government Center parking garage. To the right is the Central Artery. In the foreground is a sea of asphalt. In the distance is a tangle of ramps and elevated rapid transit lines. The shopper in the foreground, like Mother Courage and her children, seems to be scavenging a shell-torn battlefield.

The older photo shows a more humane scene. The handsome brick building that looks

like a Harvard clubhouse is the Boston City Hospital Relief Station, an outpatient clinic for the North and West End neighborhoods. Designed in the Georgian Revival style, popular in the first third of this century for its air of Anglophilia, the Relief Station reminds us that our forebears fashioned such utilitarian public structures far better than we do, though we are much richer.

Just about everything is about to change again in this dismal scene, thanks to the plan for putting the Artery underground. One hopes that the disruptive Artery will be replaced by good streets and buildings that will knit up the torn fabric of the city — buildings perhaps similar in scale, pride, and richness of detail to those that have been thrown away.

That's what I want to cure myself of: the disease that has me wondering, when I finish a walk, how it would have been up there in the woods, in the rain, if I'd only been paying attention.
— John Jerome

VI

SATELLITE CITIES

FROM THE MID-NINETEENTH CENTURY on, Boston spawned a solar system of satellite downtowns, some in outlying city neighborhoods, some in separate suburbs. The streetcar and commuter train nurtured a new pattern of life: now father could coin the family fortune downtown while mother raised the children in the unspoiled havens of Dorchester or Roxbury or Newton or Jamaica Plain. After World War II, when the car replaced the railroad, the forces tending to disperse the city became ever stronger. The major site of physical growth was now Logan Airport in Boston Harbor: after more than three hundred years, Boston was still filling in its edges.

The landmass of Boston circa 1985

A Streetcar Suburb

CENTRE STREET in Jamaica Plain remains today what it has been for a century. It's the Main Street of a self-contained, identifiable neighborhood in a city that is a patchwork of such neighborhoods.

Coming toward us in the older photograph is the No. 212 streetcar. It will eventually swing onto Huntington Avenue on its way into downtown Boston. Jamaica Plain is a "streetcar suburb," to use the term coined by historian Sam Bass Warner in his classic 1962 book of that title.

Streetcar suburbs were the growth ring of the urban tree in Victorian times. Between 1850 and 1900 Boston's circle of one-time farm villages metamorphosed into commuter neighborhoods and grew from fewer than 75,000 to more than 440,000 people.

Centre Street's car tracks and overhead wires remain in today's photo, but the streetcars are gone, replaced, as in most cities, by diesel buses. In recent years there's been a movement to get the streetcars back. In the 1950s when everybody began to have cars, it was exciting to abandon the screechy, slow, sociable old electric streetcar — and, sometimes, to abandon the old corner merchant as well — and instead drive to the new supermarket or the mall. Forty years later some residents of Jamaica Plain have fallen out of love with the car, noticing how it tends to disperse a community, and have fallen out of love too with traffic jams, parking woes, and smelly diesel engines.

The year 1950 marked the census in which Boston's population peaked. It is no coincidence that 1950 is also the year often cited as a high-water mark of community life in Boston. The car

circa 1912

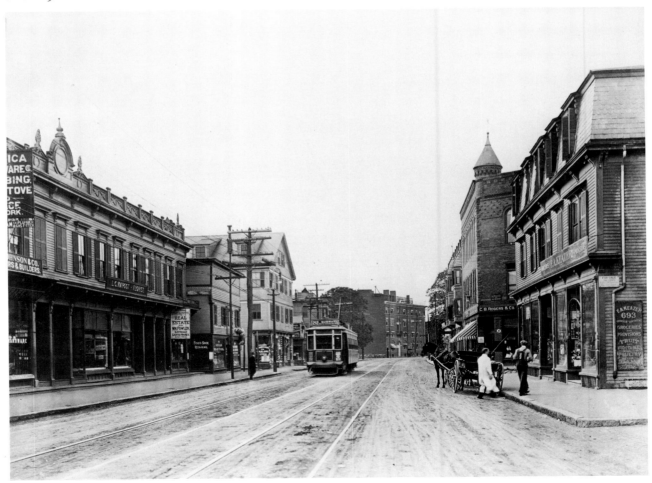

was one of a series of changes in technology, in the new postwar prosperity, that began to undermine communities. People bought television sets and stayed home to watch them instead of going out to the tavern or the bingo parlor or the social in the church basement. They air-conditioned their bedrooms and lost the urge to sit out on the stoop in the cool of the evening. With the new home washers and dryers, they no longer chatted over the back fence while pinning up or taking down the laundry from the line.

Luckily, despite the cars, Centre Street's continuous wall of storefronts isn't broken by too many of those vacant bomb sites we are kind enough to call parking lots. The street wall is lower now because second-story uses on Main Street don't do well in a car culture. But Centre Street's smile of welcome has few gap teeth.

Like any Main Street, Centre Street is a system, which means that its parts may be replaced but its shape and pattern remain. Basic useful services — bank, hardware, florist, food, clothing, shoe repair, real estate, tailor, jeweler — predominate in the new photo as in the old. Both convey the sense of a public place, a place where you can step out of your private world and engage your neighbors. Ethnic groups appear on Centre Street, flourish, and then, often, move on. Cubans have been prominent here for a couple of decades. Change occurs in the way one wants it to, bringing not rupture but rejuvenation.

Underneath the new Paris, the old Paris is distinct, like the old text between the lines of the new. — Victor Hugo

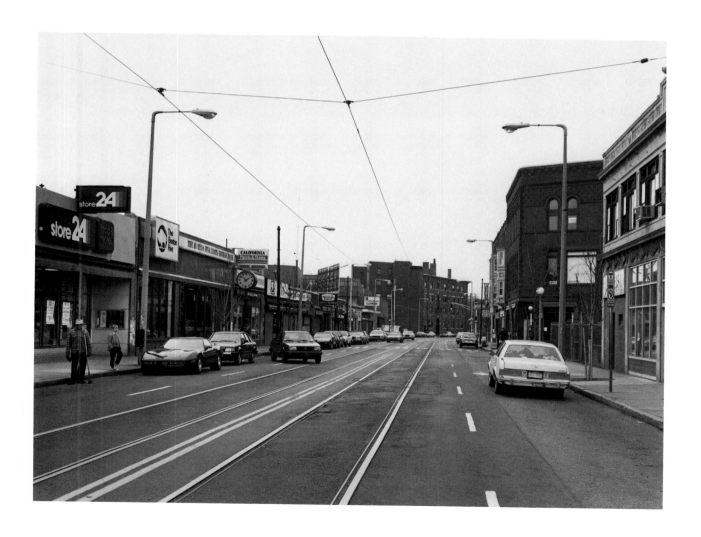

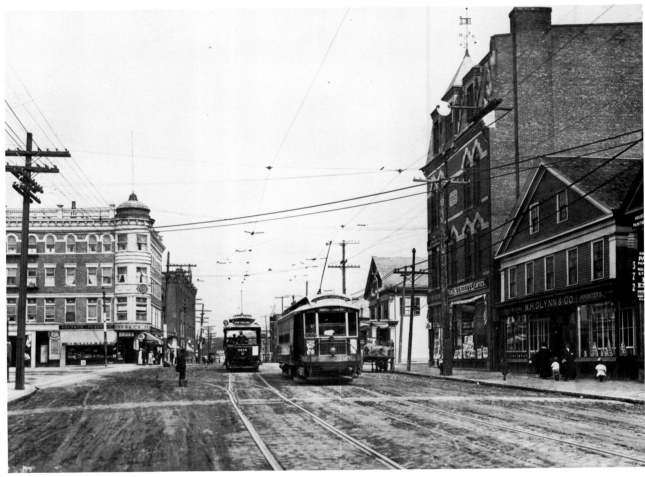

circa 1912

A Bus Lost in Trolleyland

STREETCAR POWER LINES still cross the sky, streetcar tracks still score the street. But today there are no streetcars. Instead, an incongruous diesel bus floats along in an air of lost connections, unattached to either the lines or the tracks.

The vision of a misplaced bus in trolleyland has the dreamlike aura of a tale by Kafka. As it turns out, the explanation is indeed Kafkaesque. The trolleys were "temporarily" replaced by buses in 1969, and now, twenty-odd years later, the bus service is still officially "on trial." The tracks and wires are carefully maintained, because they are the only path for moving sick trolleys from downtown Boston to a repair yard in Watertown that is gradually being phased out.

Except for the bus, not much has changed in these views of Washington Street in Brighton

Center. In the old photo the ground floor of the handsome building at left with the corner turret is occupied by Rourke's Drug Store, which is still there today. The Rourke's building is a typical design of 1898 in the modish Queen Anne style. It has lost its elaborate parapet railing and its flagpole, but it still looks good.

Other buildings remain too, including the Greek Revival house with a peaked roof just behind the bus. It dates from perhaps the 1840s and was moved here from nearby Agricultural Hill in 1900, when Americans were still busily moving buildings. The oddest survivor is the tall brick party wall, or common wall, at the far right in both views. The building it once walled is gone, destroyed by fire and replaced by a new one, but the wall and its chimney remain, shorter now by one story, a ghost from the urban past.

St. Elizabeth's Hospital now looms in the background like the local nobleman's castle. There are other changes. The ugly overhead telephone lines and their treelike poles are gone. But despite the differences, what is striking about these two photographs is how much the sense of place remains the same in Brighton Center. It is still a pleasant and busy neighborhood commercial main street — even with buses running loose.

Alas! poor Shelley! how he would have laughed had he lived, and how we used to laugh now and then, at various things, which are grave in the Suburbs! — Lord Byron

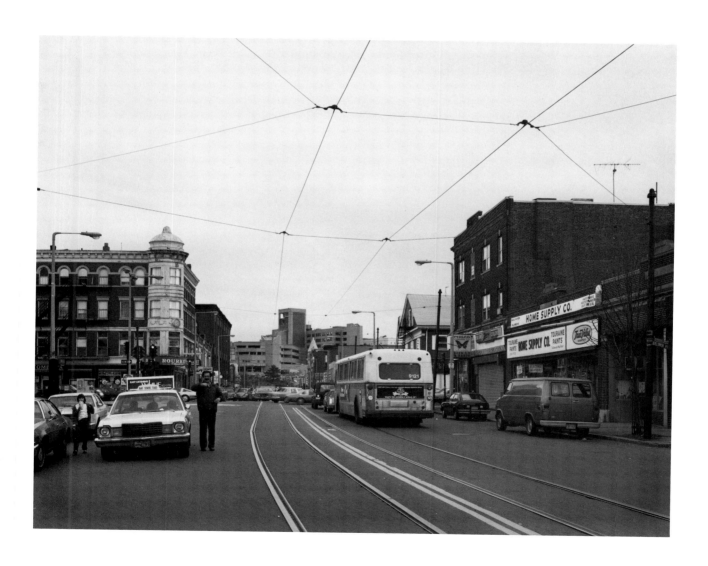

Destroying a Neighborhood in Order to Save It

FOR A LONG TIME, planners seemed bent on converting the entire historic neighborhood of Charlestown into a gigantic traffic interchange. Like traitors, they opened the gates of the city to an enemy army of automobiles.

Here we see the results in City Square, undoubtedly the single Boston site most grotesquely trashed by cars in the years after World War II.

The older view shows the square in its lovely heyday. It is commanded by Charlestown City Hall, the big domed building in the center, built in 1868 in the French Second Empire mansard style — a style that said "civic monument" in that era, a style employed also for Boston's Old City Hall. Charlestown's City Hall was built only six years before the town had the bad luck of being annexed to Boston.

City Square has the formality of a genuine civic space. It possesses the kind of physical order that is a metaphor for an orderly, hierarchical society and government. The square is paternalistic. City Hall sits at its head with the majesty of a balding Victorian father at the head of his table. But at the same time City Square has a human, democratic scale, thanks to the little round green

with the fountain, and the clusters of small buildings that bend back from City Hall along Rutherford on the left and Main on the right.

The City Square of recent memory was a sad contrast. An elevated rapid transit line long blighted the square. After it came down, the grim steel slash of an overhead expressway still hung like a guillotine over the scene, as shown in the second photo. The expressway hardly even served Charlestown, instead speeding North Shore commuters like flights of angels over a dying neighborhood. Most of the old buildings had gone from City Square, and there were only a couple of new ones, standing in lonely isolation. "What's going on around here?" a billboard wondered, only too aptly.

But Charlestown didn't die, and today Charlestown Square is regaining some of its former dignity. Handsome new housing developments are filling the vacant lots behind it. And in the third photo the overhead expressway has disappeared and is in the process of being buried in a tunnel, as the planners of today seek to recapture the city from the motorized hordes and return it to its rightful human inhabitants.

The lesson of these photos is that while there

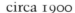

circa 1900

is certainly a place in the city for the automobile, the city should never be reconfigured in such a way as to give the automobile primacy over the pedestrian. To do that is to destroy the city in order to save it.

Such, such were the joys
When we all, girls and boys,
In our youth time were seen
On the Echoing Green.
— William Blake

1975

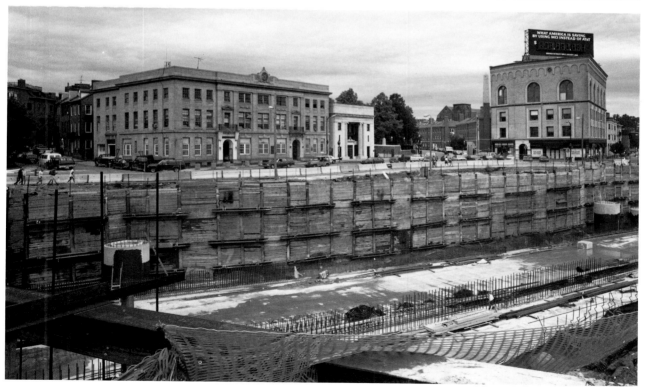

Zero Harvard Square

Harvard square is the biggest little downtown in America. Into its few blocks it packs more life than most whole cities.

The numbers are boggling. Bookstores: Harvard Square has seventeen, all selling actual printed books, not beer mugs or T-shirts. There are probably entire states in this country that can't count seventeen real bookstores. Restaurants: depending on how you figure, there are at least fifty, none of them a McDonald's or Roy Rogers.

The Square works because Harvard trusts it. Harvard has never had a separate student union or university bookstore. Instead, like its European counterparts, like the Sorbonne in France or Oxford in England, it reaches out to engage the ordinary commercial life of the city. You can't quite tell where Cambridge ends and Harvard begins. Often that fact has caused friction. Always it has energized both town and gown.

The photos depict the hub of Harvard Square in 1912 and today. Bucking a national trend, the Square traded in its cars for pedestrians. In the 1970s, when the Square was torn up for a reconstruction of the underground Red Line station, Cambridge grabbed the chance to reroute traffic and free up space for walkers. Pedestrian districts are usually dreary failures in the United States, because our culture just doesn't generate enough pedestrians. Thanks to students, there's no problem in Harvard Square.

A circular brick subway entrance occupies the foreground of the older view. Its life was brief. It was dangerously close to the traffic and it soon gave way to the copper-vaulted kiosk we can see behind the tour bus in the new photo. The copper kiosk is still there — in fact, it's a beloved landmark — but it isn't a subway entrance any more. It's now the home of the legendary Out of Town Newspapers (address: Zero Harvard Square), purveyor of magazines and papers from all over the world. Today's subway entrance — really just a

1912

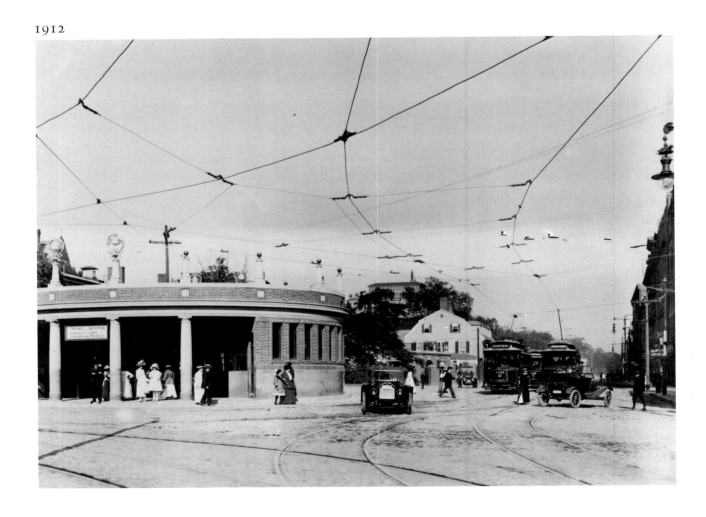

dark cellar stairway into the ground — dates from 1980. It's visible between those two strange cylinders (the one on the left, which appears to be King Arthur's jousting tent, is an information booth, and the one on the right, which looks like a fuel tank, is a subway elevator).

Behind all this confusion looms Harvard's Lehman Hall (1925), once the bursar's office, now a dining hall. It was designed by the successor firm to H. H. Richardson, Coolidge, Shepley, Bulfinch & Abbott, which (under slightly varying firm names) did most of Harvard's architecture for decades, including all the undergraduate houses. Lehman is typical of Harvard in its unabashed staginess. Its eight fancy white pilasters seem to be stuck, like patches of rouge or false noses, onto the face of an otherwise forgettable building. But the white columns do their job. They give modest Lehman a big public scale, billboarding the university to the world. And they successfully evoke the older Georgian and Federal landmarks that embody the architectural essence of Harvard.

On weekend evenings young people by the thousands flock to Harvard Square as they do to other outposts of urbanity, like M Street in Washington's Georgetown or Westwood Village in Los Angeles. They seem to be seeking the unpredictable mix of possibilities that has ever been the gift of a true city.

Harvard Square now faces the danger of death by success. It has become so attractive that national and international chains are moving in, gobbling up many of the old low-rent, family-run operations that make the Square unique. Harvard Square may soon become one more parade of the same stores and restaurants you already find in any upscale mall.

When a university is built up as a campus, separated by a hard boundary from the town, it tends to isolate its students from the townspeople, and in a subtle way takes on the character of a glorified high school. — Christopher Alexander

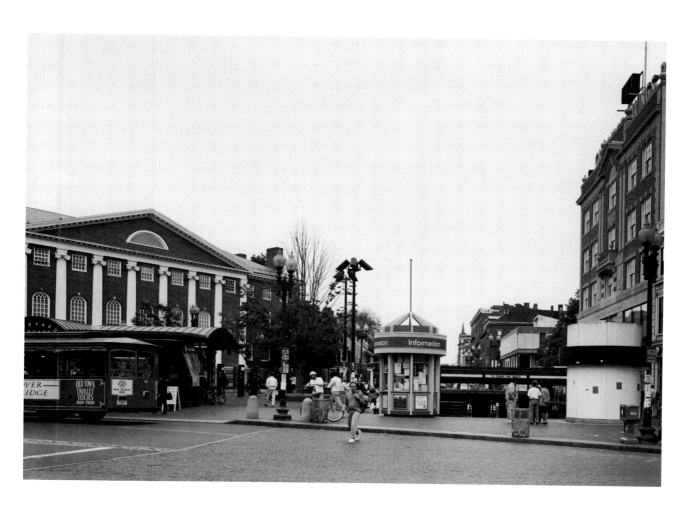

A Village in the City

THE VANISHED THREE-DECKER at a corner of Inman Square in Cambridge wasn't posh, nor was it distinguished architecture. But it was very, very good cityscape. It suffered from crude aluminum residing and a crummy street-level renovation. But the dramatic rippling curve of bay windows swept powerfully around the sharp bend like a ship's prow, giving the space of Inman Square a focus and a shape.

After a fire destroyed the building in the 1970s, neighborhood activists pressed the city to purchase the site for a park. With the help of a long-time Cambridge city councilor and former mayor, Alfred E. Vellucci, they prevailed. Vellucci Plaza was dedicated in 1980. Designed by the city with neighborhood input, it is unpretentious, containing only a grove of honey locusts, a few modest benches, and some decorative brick and granite paving.

Which is better, the park or the prow? The prow, probably. Inman Square has gained greenery but lost interest. Even the people who lobbied for the park don't use it. It serves only an occasional luncher or retiree in sunny weather.

A narrow, prow-shaped site like this, between two arterial streets, here Cambridge and Hampshire, isn't usually the best place for a park. People tend to feel at risk in such places, with traffic slicing closely by. And in the case of Vellucci Plaza, the removal of the corner three-decker has had the unfortunate effect of exposing the sides of two other three-deckers, which now seem to be facing away from each other, like a couple not on speaking terms.

Cities can be gutted by too much openness, in which case they turn into suburbs. Suburbs are fine, of course, but cities are something different, and worthwhile in their own right. They are places where a lot happens in a small area. They're packed full. If you open them up by removing too much of their substance, they die.

You wouldn't want to see any further erosion of the urban tissue of Inman Square.

Vellucci Plaza's sole accent is the pine tree at the corner. This used to be decorated at Christmas by volunteers, but it soon grew too big and now gets its Yuletide finery from the city. The volunteers came from a block-long thoroughfare called Antrim Street, which runs out of Inman Square and is one of those villages-in-the-city more often imagined than actually found. The inhabitants of Antrim Street's seventy-six houses have thrown a block party every spring since 1977.

The person walking toward us from the plaza in the new photo is Robert Campbell, who took the old photo, lives on Antrim Street, and wrote this book.

*I saw in my dream
the great lost cities, Machu
Picchu, Cambridge Mass., Angkor.*
— John Berryman

The God of Kenmore Square

DIAGONAL CROSSINGS of major streets in cities tend to become entertainment centers, perhaps because the prow-shaped corners of such intersections are ideal locations for billboards.

On the grand scale, Times Square is the classic case. Inman Square in Cambridge, with its jazz and comedy clubs, is a tiny version. Kenmore Square in Boston, seen here, ranks somewhere in between.

Except for the CITGO sign in the heavens and a mob of Boston Marathoners on earth, not much has changed in these two views. Kenmore Square is still a critical junction box in the street plan of Boston.

Three arteries meet here — Beacon Street (right foreground), Commonwealth Avenue (left foreground), and Brookline Avenue (disappearing to the right and leading to Fenway Park). For anyone journeying into town from the west — from Brookline, Brighton, or Newton — Kenmore Square is the place where the real Boston begins, especially since it has long been the point at which the subway plunges underground.

Most of today's buildings are already visible in 1914. The most interesting is the one with big windows that holds up the CITGO sign. It's the Peerless Motor Car Building of 1911, showroom of an automaker and one of the first in an "automobile row" that eventually stretched from Kenmore Square to what was called Packard's Corner (Brighton and Commonwealth) in Brighton. Today the old Peerless is the bookstore of nearby Boston University.

1914

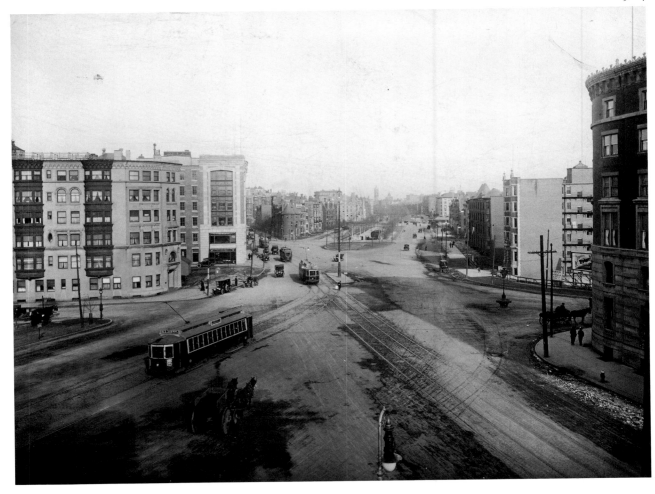

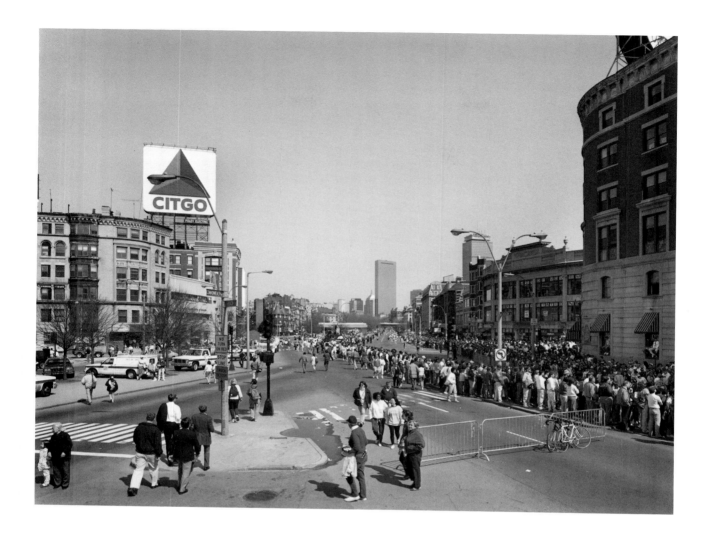

The resident god of Kenmore Square is the huge neon CITGO sign. It is visible up and down the Charles River, on which its blue and red colors are reflected at night, and inside Fenway Park, where it appears as a sort of crazy triangular moon. It was supposed to be scrapped in 1983 in token acknowledgment of an energy crisis. But a group of citizens petitioned the Boston Landmarks Commission to save it. The commission praised the sign but failed to declare it a landmark, in part because the Peerless Building isn't of landmark quality and thus poses the dilemma of how you would preserve the sign if the building were removed. All the publicity led the advertiser to save and restore the sign anyway.

Still less than thirty years old, the CITGO is now regarded as an important relic of America's fading industrial heyday.

Kenmore Square has been so named only since 1932. Before that it was Governor's Square, and still earlier it was Sewall's Point. In ever-changing Boston, Sewall's Point was once the only solid land in a tidal salt marsh that became, when filled, the neighborhood we now call the Back Bay.

A rose-red city half as old as time.
— John William Burgon ("Petra," 1845)

A Gift from the Sea

Beach street in Chinatown takes its name from the fact that it once marked the water's edge of the original Boston peninsula. In his 1972 book, *What Time Is This Place?*, urbanist Kevin Lynch claims that on this street, "If you look closely at the ground, you can trace the outline of the former shore."

It would be wonderful to have a photograph of Beach Street as it looked when it was indeed a beach, prior to the South Cove landfill of the 1830s. Unfortunately, photography hadn't been invented. But the two photos reproduced here depict a change almost as great. Hard as it is to believe, both are made from the same place looking in the same direction.

We're looking west along Beach. On the right in the old view is the Atlantic Avenue elevated line, which opened in 1901, closed in 1938, and

was demolished in 1942 for wartime steel scrap. There's no visual evidence of Chinese inhabitants, although there must have been many nearby.

The new photo looks across Surface Road above the Central Artery, for which all the old buildings came down starting in 1954. Chinese merchants and residents "bitterly opposed" the demolitions, according to one contemporary news account. Many families and businesses were displaced. Now the Chinese community is again expanding, and Chinatown's presence as a special quarter of the city is symbolized by the Chinese Gate, a gift from the government of the Republic of China (Taiwan), erected in 1982.

A work of art that contains theories is like an object on which the price tag has been left.
— Marcel Proust

Martians Land in Mattapan

THE INHABITANTS of Mattapan Square in the newer view appear to be the gracefully winged light fixtures, as if a squadron of flying Martians were just touching down on the site. This is the kind of sad anti-city we've created for the automobile, a treeless plain of asphalt, planted with a manmade forest: streetlights, traffic signals, billboards, and signs.

The elm trees and trolley cars of the old Mattapan Square suggest a slower way of life, though one also organized around transportation. At the right is the Old Colony Railroad Station, probably built in 1890 and moved to this site a few years later. Amazingly, the station survives, very recognizably, as the present Papa Gino's. The handsome building in the middle of the old photo is the Burt Block, erected in the early 1890s by a family of carpenters and builders named Burt. The trolleys survived in Mattapan Square until the 1950s, the railroad only until the late 1930s.

Mattapan has undergone as much change as any place in Boston. Originally a tiny village, it became part of the city in 1870, but for years

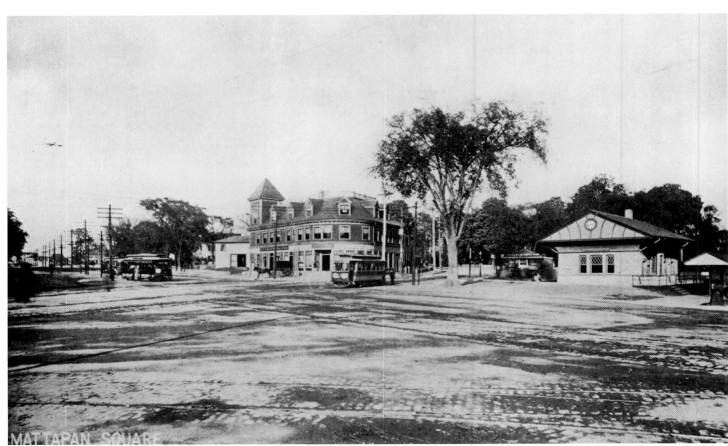

circa 1900

188

remained an area of private estates, farms, and golf courses. After World War I, Mattapan grew as a neighborhood of two- and three-family houses occupied largely by Jewish families who moved from the North and West End. By 1930 it was the biggest Jewish community in the state, the Bronx of Boston. Then, quite suddenly, in the late 1960s and early 70s, the neighborhood turned predominantly black. "Blockbusting," the process was called. Real-estate agents scared homeowners into selling cheap by fomenting racial fears, then resold their houses to black families at a profit. Banks cooperated through a policy called red-

lining — denying mortgages to black families except in certain secretly agreed-on neighborhoods, of which Mattapan was one. It was not one of Boston's finest hours.

The Burt Block, the kind of building that anchors an intersection like this, was demolished in the early 1980s. Currently the square is thriving commercially as an auto-oriented strip. The city plans to plant new trees.

Suburbs are things to come to the city from.
— A child, quoted by Art Linkletter

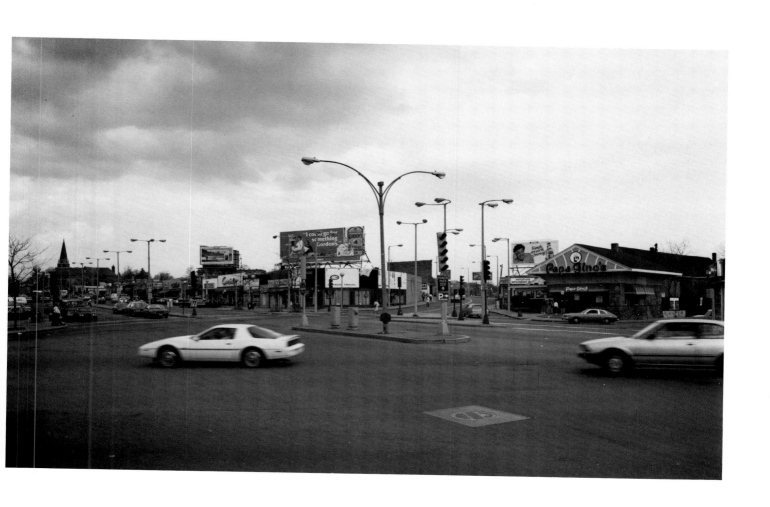

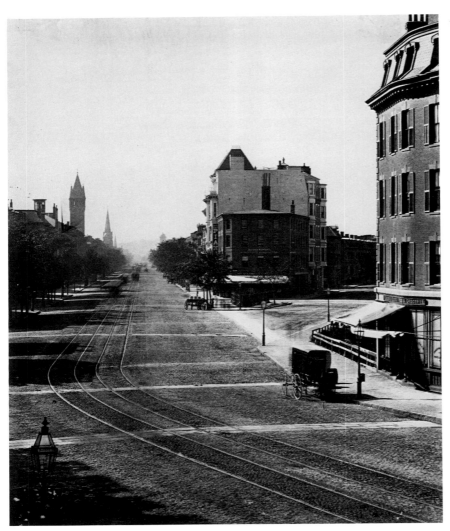

A Neighborhood of Permanent Recycling

A TIME TRAVELER from Victoria's era would have no trouble recognizing this corner of Tremont Street in the South End. But although the frame is the same, the picture has changed many times.

The South End is restless. It goes in and out of fashion, becomes richer and poorer, changes ethnicity. It was built by private speculators on filled land, mostly during the 1850s. Its beautiful brick bowfront town houses, many of them gathered around fenced garden squares in the English manner, were (and remain) the very image of Boston-ness. Yet they were fashionable for only a moment.

Soon another piece of filled land, the Back Bay, was being developed, with Parisian boulevards and water views. It drew the wealthy away from the South End, which turned into a neighborhood of rooming and boarding houses while it was still almost brand new. (A parenthesis: whatever happened to the idea of the boarding house, where the renters had their own bedrooms but all ate dinner together? Didn't it solve a lot of problems we can't seem to solve today, such as loneliness and homelessness for the boarders and a modest income for the proprietor? What would fiction have done without it — Balzac, Proust, Thomas Wolfe?)

Between the times of these photos the cobblestones and the tracks for the horse-drawn trolley have given way to asphalt and zebra stripes. The mansard-roofed Hotel Clarendon, on the right in the old photo, burned in 1969. The tall belfry of the old Shawmut Congregational Church on the left is gone, too, removed as a hazard in the 1950s. For a time the Shawmut became

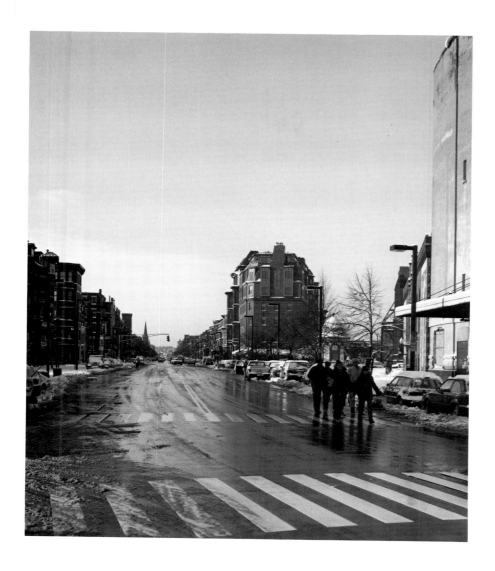

a Pentecostal church. Now it is apartments.

Today the Boston Center for the Arts offers rehearsal, performance and display space for artists in several buildings, including the wonderful Cyclorama at far right. The Cyclorama was built in 1894 for the sole purpose of displaying a 400-foot-long circular wraparound mural of the Battle of Gettysburg. People paid to see the mural as we pay to see movies. The cluster in the center of both photos, originally an apartment house (the St. Cloud) and a lower commercial building (the Mystic Bridge) now houses nineteen condominiums, nine artists' studio-apartments, a restaurant, a cafe, and shops.

Around 1970 the South End, like American cities in general, was bottoming out. It was possible to buy the abandoned shell of a bowfront for ten or twenty thousand dollars. That fact, plus the social diversity here, made the neighborhood a magnet for the Return to the City movement of the 1970s and 80s. By 1990 most of it was con-

dos — and much of the diversity was gone.

Almost everything inside these buildings has changed. New people, new uses, new ways of life and work are comfortable in them, even where the buildings were originally tailored to fit the most special of purposes, like the church and the Cyclorama. We can only conclude that there is almost no such thing as an obsolete building. The South End, ever decaying, ever renewing, proves that just about anything built for people and their purposes will work, with a little imagination, for other people and other purposes.

I do not speak with any fondness, but the language of coldest history, when I say that Boston commands attention as the town which was appointed in the destiny of nations to lead the civilization of North America.
— Ralph Waldo Emerson

Main Street in Mothballs

WE'RE LOOKING AT ANOTHER Boston neighborhood, another local Main Street. But this one is mothballed, like a battleship out of service, awaiting the next campaign. It's one of thousands of downtowns in the United States that died in the last quarter of the twentieth century — victims of the car, the supermarket, the television set, the telephone, and all the other technologies that help us isolate ourselves from one another instead of meeting and greeting at a shopping corner like this.

These fine empty buildings stand at the corner of Dudley and Warren streets in Roxbury, next to the old Dudley station, formerly on the Orange Line.

For a century Dudley was a transportation node. Like airlines today, Boston employed a "hub" system, in which bus, trolley, and rapid transit lines met and transferred at major stations. As happens at such hubs, Dudley became a center of commerce.

We see two buildings, both of them now on the National Register of Historic Places. At left is the Dartmouth, an apartment hotel of 1871 that replaced an assemblage of clapboard sheds and at a stroke transformed a semirural crossroads into a bustling mini-downtown.

By the date of the older photo, the upper floors of the Dartmouth had been converted into offices. But it was still the commercial capitol of the neighborhood. It was designed by an architect named John Roulestone Hall, who gave it a French-style sloping mansard roof.

Even handsomer is the building on the right, also built in 1871, the work of a more notable Boston architect named Nathaniel J. Bradlee, who also owned it. Bradlee called the building Palladio

1934

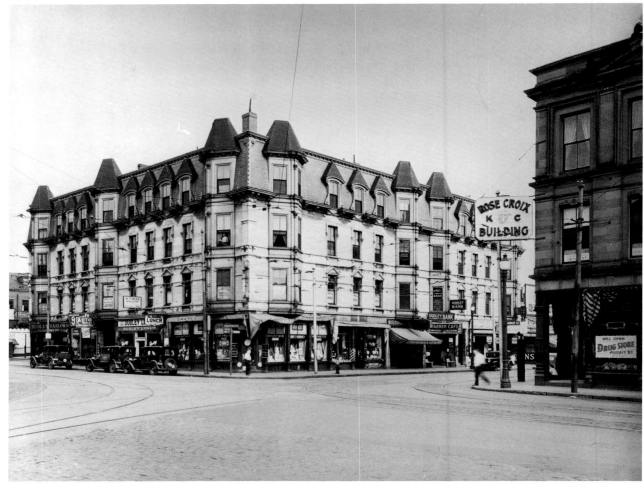

Hall after the great Italian Renaissance architect Andrea Palladio, and he framed the top-floor windows in elegant Renaissance details. Historians think Bradlee may have intended Palladio Hall for his own office.

The Dartmouth has been boarded up for years. Palladio Hall looks little better. No longer a transit hub since the 1986 realignment of the Orange Line, Dudley today is a neighborhood up for grabs.

The buildings are in good shape. The Dartmouth's cast-iron shopfronts are intact, as are its marble walls and much of its slate roof. Palladio Hall's fine sandstone walls remain too. Whatever the future of this ever-changing neighborhood — once Irish, then Jewish, and since 1960 largely African-American — these historic structures have much to contribute.

Architecture is like petroleum or topsoil: a resource we can't afford to throw away. When we leave it idle, as we do at Dudley, we waste not only the buildings but also their partly invisible, very costly infrastructure — streets and curbs and sidewalks and streetlights, gas and water and sewer mains, power and phone lines, manholes and drains. While we abandon so much public investment at Dudley, we simultaneously duplicate it in new development elsewhere. As an example of sheer creative wastefulness, such a practice would probably impress even the Pentagon.

A good critic is one who describes his adventures among masterpieces. — Anatole France

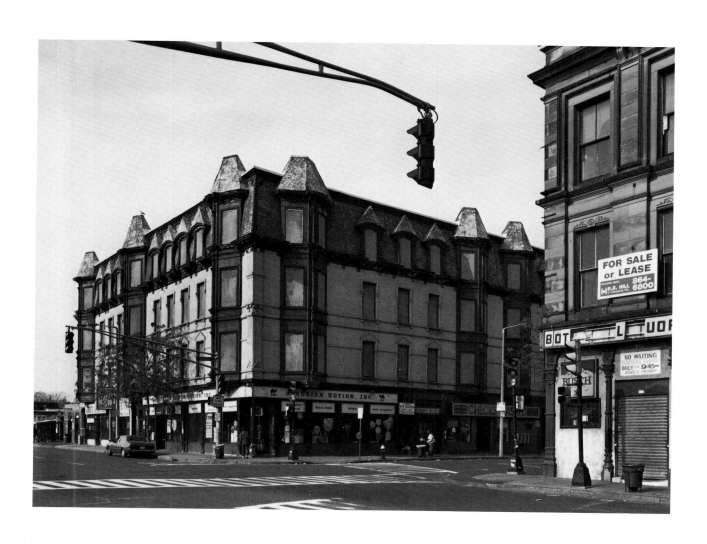

circa 1910

The Shadowed Urbanity of Film Noir

THIS IS A LESSON in cityscape, a lesson about concealing and revealing.

A playwright may withhold the bombshell of the plot until just before the final curtain, increasing our curiosity by doing so. In the same way, the dark curve of buildings at the left in this old view of Upham's Corner seems to beckon us around the corner and down Columbia Road. It hides, yet promises to reveal, what is beyond. It has something of the shadowed urbanity that was to be brilliantly captured decades later by the makers of *film noir*. Such firm, dramatic shaping of urban space is little understood today. The new view, although by no means unattractive, makes that fact clear. Everything is revealed at once in a scene that lacks all mystery, all enticement.

Amos Upham opened a store at a rural cross-

roads in Dorchester soon after 1800. People began calling the crossroads Upham's Corner. A century later, about 1900, his grandson J. H. Upham built a four-story brick building on the same site. It's still there, appearing at the right in both photos. We're looking south along Columbia Road, with Dudley Street on our right and Stoughton on our left.

About the time the younger Upham was building, Boston's planners, having nothing intelligent to do on a slow day, decided Upham's Corner was too lowbrow a name for an important commercial center. They renamed the intersection Columbia Square. This explains why J. H. Upham's building is properly called the Columbia Square Building. Luckily for the poetry of life, the name Upham's Corner has survived the bureaucrats.

The Columbia Square Building is a clean, handsome piece of architecture, a good example of the typical Boston commercial corner block. It housed a Masonic hall on its upper floors and stores (including J. H.'s grocery store) at the sidewalk. To the left of it in the old photo is the equally handsome Winthrop Hall Theater, a vaudeville and movie house built in the mid-1890s, probably originally as a meeting hall. Fred Allen, later a famous radio comedian, made his vaudeville debut here at the time of World War I.

Now the small white First American Bank stands where the Winthrop Hall Theater stood.

Amazingly enough, it is almost certainly a remodeling of the old theater. The theater's tower and upper floors were apparently removed and its façade redone in the Art Deco style about 1930.

The fate of the architect is the strangest of all. How often he expends his whole soul, his whole heart and passion, to produce a building into which he himself may never enter.
— Johann Wolfgang von Goethe

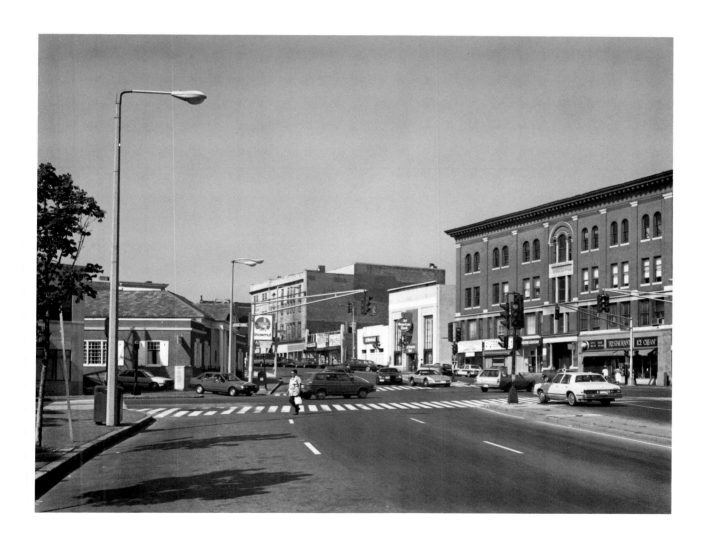

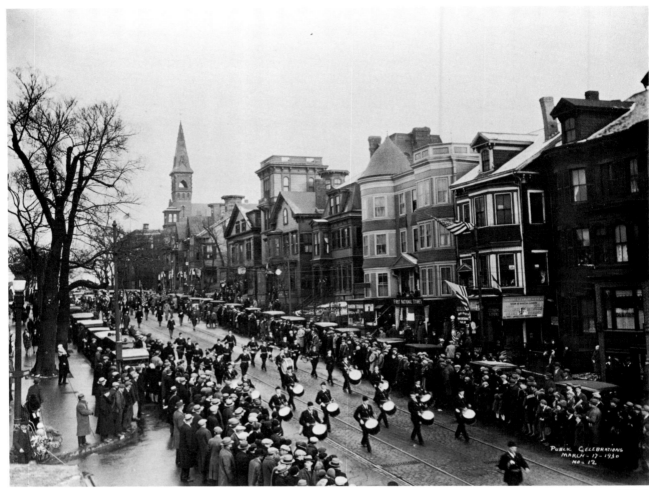

1930

Licking Off the Frosting

ON SAINT PATRICK'S DAY, 1930, when this drum and bugle corps marched down East Broadway in South Boston, James Michael Curley was mayor and the Great Depression was only five months old.

South Boston has probably changed as little as any American neighborhood in the intervening years. That makes the subtle differences all the more fascinating. In 1930, for instance, almost every man and boy wears a hat or cap. The old sidewalks are wider, the trees are bigger, and there are trolley tracks and cobblestones.

Small but significant changes appear in the houses, too. In the 1930 photo, most of them were already half a century old. Yet they still display original ornamental detail in the Italianate or Queen Anne style. We see elaborate wood brackets under the eaves, fancy railings at the roofs, patterned shingle work on the walls, lavish trim around windows and porches.

Today, another half century later, most of those details have vanished. The Tin Men have struck: aluminum siding has gone up, architectural embellishments have come down. In the old view you can spot three octagonal belvederes — tiny rooms poking above the roofs, created for the sole delightful purpose of providing a high lookout over the harbor. In the new photo two of the belvederes are gone, and the third is shorn of its trim and even its windows.

Vanished too are the elaborate mansard roof and gabled front bay window of another house.

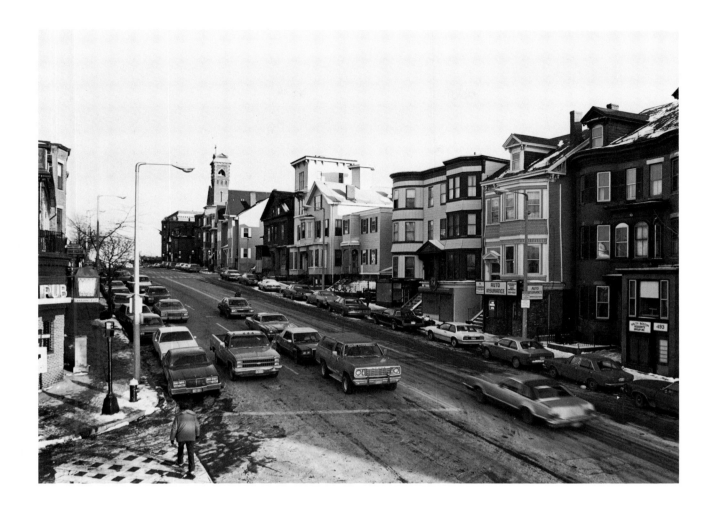

Another has lost a cone-shaped roof over a bay. At the top of the hill, the former Unitarian Congregational church, now the Albanian Orthodox Cathedral of St. George, has lost the steeple and entry tower that its architect, Samuel J. F. Thayer, provided in 1872.

East Broadway has been transformed from an intricate prettiness, a festive, frosted look that recalls Victorian San Francisco, into something plainer and duller.

The changes that have come to East Broadway reflect American taste of the modernist era, when it was thought important for buildings to look efficient and uncluttered rather than ornamental and expressive. So-called functional architecture, however, rarely functions any better than other kinds. Its real goal is to *appear* practical rather than actually to be so. Tastes have changed again now, and perhaps the future will bring a restoration of some of the delightful bric-a-brac these fine houses once boasted.

When I die I hope to be buried in South Boston so that I may continue active participation in the political process.
— State Senator William "Billy" Bulger

Of Trains and Turnpikes

THE PHOTOS REMIND US of the most important change in travel during the last century. This change isn't greater speed — far from it. It's the transformation of travel from a social experience, in which people gathered in stations and on passenger cars, to a private experience, in which we are sealed in isolated cars, having for our companions only the hosts of radio talk and music shows.

Not much is known about this charming railroad station, called the North Side Station and located in Newtonville. It was built for the Boston & Albany commuter line in the 1880s and torn down for the Massachusetts Turnpike in the 1960s. We're looking eastward, toward Boston.

Two of the original track beds are still in use today as part of the Amtrak system and the commuter line to Framingham.

The Boston & Albany expanded its commuter service rapidly during the 1880s. Many of the new stations, although not this one, were designed by H. H. Richardson, who transformed American design with his beefy Romanesque style. Richardson's stations at Brighton, Chestnut Hill, Eliot, Waban, and Auburndale were all demolished in the 1960s for the turnpike or for parking lots. Those at Wellesley Hills, South Framingham, and Woodland survive. All have been altered. The former Woodland station is a toolshed for a country club.

1908–1910

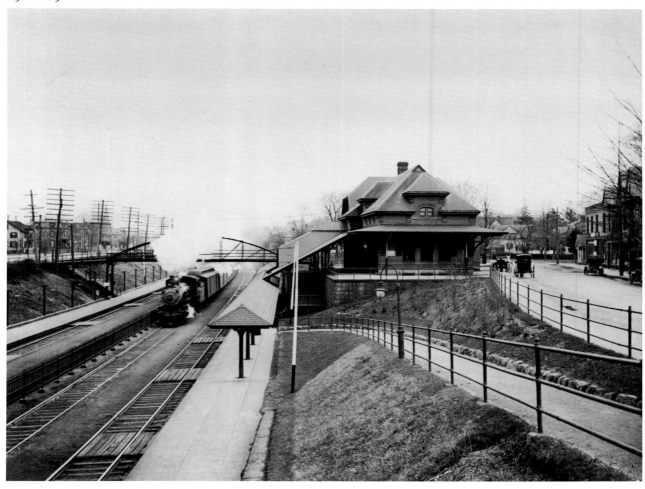

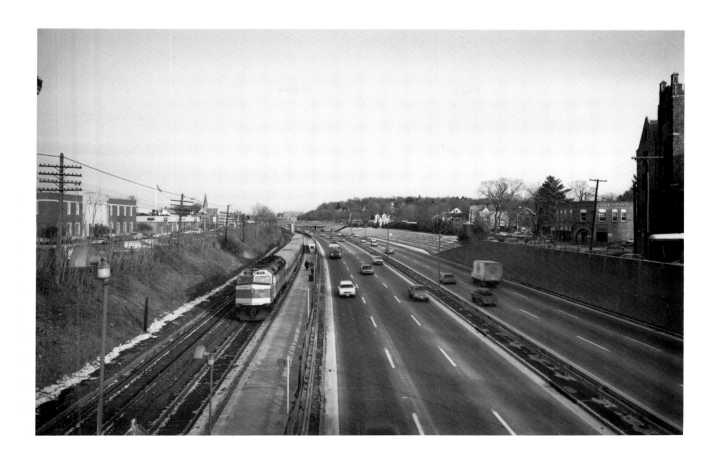

You can feel Richardson's influence here at North Side, too, but the choppy roofs are far too cluttered to be the master's. Nevertheless, the station is handsome. Its bulkiness contrasts pleasantly with the wire-taut bowstring truss of the pedestrian bridge that crosses the tracks.

Stations like Newtonville's created tiny downtowns, small but definite places within the larger metropolis. Even where such commuter stations still exist, they're greatly changed. Gone are the busy services, the meeting and speeding of guests, the telegraph, baggage and freight pickup, the sense of being where the action is.

For a century the train station and the train were among the keen romantic experiences of life. One thinks of all the stories and movies — of *Murder on the Orient Express;* of the young Thomas Wolfe in rural North Carolina, hearing the passing whistle as a promise of adventure, and the men and boys in *Look Homeward, Angel* waiting for the telegraph operator to post, inning by inning, the World Series score; of Nick Carraway's nostalgia in *The Great Gatsby* for "the thrilling, returning trains of my youth"; of Hitchcock's *Strangers on a Train.* The network of steel

was like a delicate spiderweb through which ran magical vibrations. Touching your finger to the rail in Newton, you felt you were in contact with California.

The turnpike, by contrast, isn't so much experience as it is a void that occurs between experiences, a blank page in the book of life. It lacks the drama of trains, and it also lacks the roadside interest of the old "blue highways," with their motels and roadhouses and gas stations. And even its speed is futile, because as travel gets faster and faster we spend more and more of our time engaged in it. You can state it as a law of physics: *The greater the speed of travel in a given society, the greater will be the portion of the average citizen's life that is spent in getting from one place to another.*

Believe it.

All traveling becomes dull in exact proportion to its rapidity. — John Ruskin

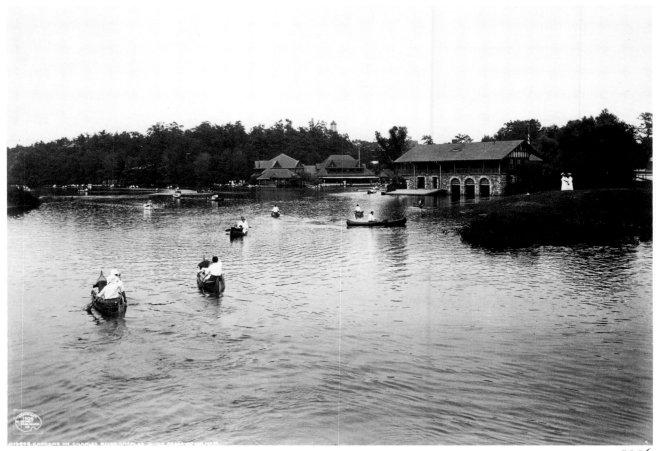

1906

Twenty Dollars a Kiss on the Charles River Lake District

Canoeing has been the sport of choice for a century on this bend of the Charles River, where the towns of Newton, Weston, and Waltham come together.

The old photo depicts Norumbega Park, an amusement ground created in 1897 by the Commonwealth Avenue Street Railway to generate weekend rail traffic — the same practical reason for which Nantasket and Revere beaches were developed. A 1903 Boston guidebook tells us:

Our terminus is the favorite pleasure ground called Norumbega Park, where the trolley company has provided on the shore of the stream a variety of attractions for many tastes, — an open-air theater, an extensive menagerie [zoo], a cafe, and a large boathouse, where canoes and rowboats may be hired.

Norumbega flourished at the height of the fad for fresh air. This was the era of sleeping porches and Boy Scouts, of healthful country walks and Sundays at the beach. An emerging public health movement touted the virtues of sunshine and air, as opposed to the epidemic dangers of city life. On a sunny weekend literally thousands of canoes filled the "lake district" of the Charles, a six-mile stretch between Newton Lower Falls and the Moody Street Dam in Waltham. Canoes flocked forth not only from Norumbega but from at least twenty other public and private boat clubs.

Norumbega Park survived into the 1960s, best known in its later years for the Totem Pole Ballroom (earlier known as the Grand Steel Theater), which presented nationally broadcast shows by the big bands of Artie Shaw, Benny Goodman, Glenn Miller, Ozzie Nelson, Guy

Lombardo, and many others. The park took its name from Norumbega Tower, a monument erected nearby to commemorate a fort supposedly built by the Norse explorer Leif Eriksson in the year 1000 — a fantasy now believed by no one.

An architectural survivor of Norumbega's heyday is the boathouse of the Metropolitan Park Commission police, at lower right in both views. It contained a telescope, camera, and darkroom to help the officers document any improper behavior by canoeists. Kissing was punishable by a twenty-dollar fine. The police boathouse is now the Charles River Canoe and Kayak Service, whose owners, Larry Smith and Dave Jacques, are the lone paddlers in the foreground of the new photo.

Once so bucolic, so genteel, the river scene is now overwhelmed by a Massachusetts Turnpike interchange and a Marriott Hotel. The hotel offers its guests an experience of the natural landscape from their windows. But it denies, by its looming presence, any such pleasant experience to the canoeists on the water.

Where man is not, nature is barren.
— William Blake

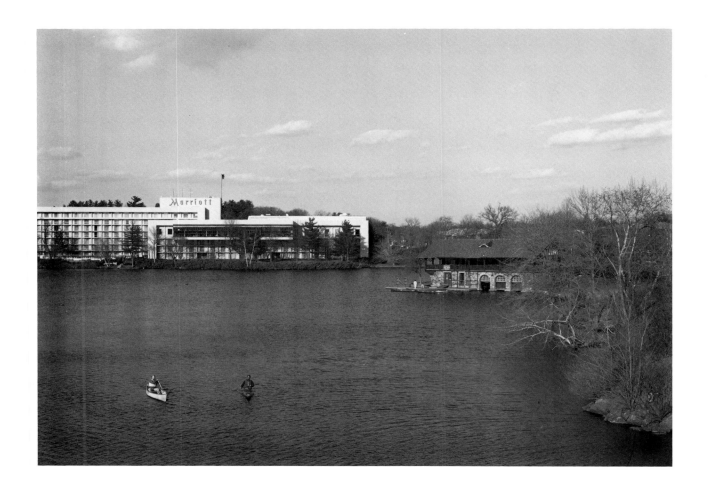

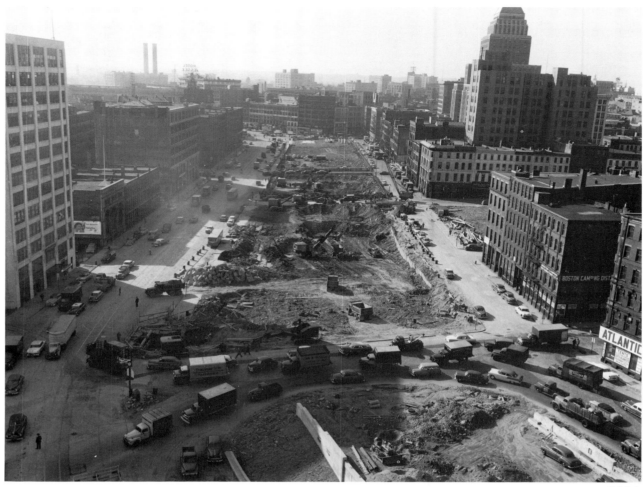

1954

Sewing Up the Wound

Like urban surgeons — and costing even more than real surgeons — the planners of today are trying to suture the great wound in Boston that is the Central Artery. If they succeed, at a price of unknown billions of dollars, the Artery will be taken down and buried in a tunnel.

The old photo shows the Artery's southern stretch through downtown when the road was under construction in 1954. It gives a sense of what the site may look like in 2000, the year by which, if work proceeds according to schedule, it will again be open land. We can see the immensity of the new space that is going to open up downtown. It will be an area roughly equal to Boston Common, though some of that will be taken by new streets.

Already debate is hot over what to do with this recaptured land, which offers the greatest opportunity to city designers since the filling of the Back Bay. Should it be a park? — or would a park feel silly, maybe even be a barrier, just one block from the vast open space of the Atlantic Ocean? Should it be filled with public institutions, such as museums? Or should there be private development, perhaps retail with a few floors of apartments above? Or a mix? The only thing that seems certain is that there won't be any high-rises. The roof of the new Artery tunnel won't be strong enough to bear them.

The new photo shows the Artery as the urban disaster it is today. It's a wide, nearly uncrossable no man's land that divides the city from the harbor. The one thin bridge lures few pedestrians; in most seasons, it feels like a swaying rope across an alpine chasm. The Artery does succeed in moving traffic into and out of downtown. It is the essential feeding tube that nourishes a garden of office towers.

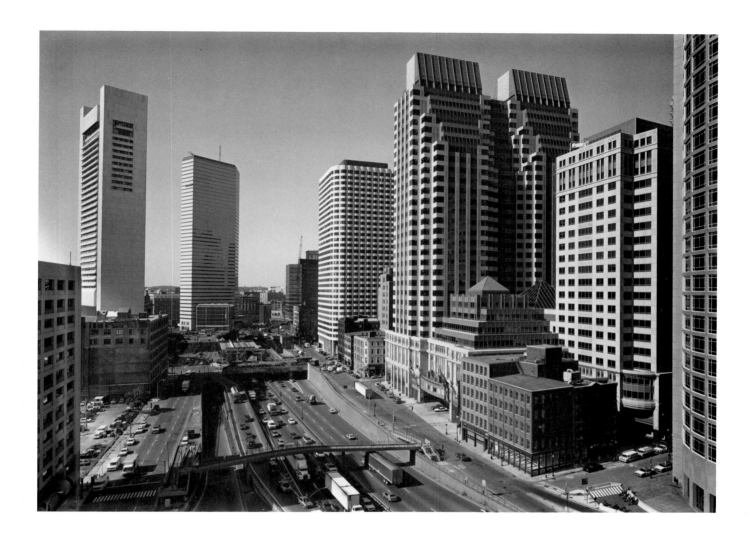

The sharp-eyed may notice, at lower left in the old photo, the tracks of the Union Freight Railway, which once served businesses from North Station to South Boston. Still another of the arguments about the new tunneled artery has been over whether it should include a similar light rail line linking North and South stations. Regrettably, as now planned, it won't.

The Artery is the result of a generation of planners who — panicked by Boston's great economic depression, which lasted from the 1920s into the 1960s — thought they must open an old city to the car, lest it die. By doing so they damaged what is best about downtown Boston, which is the simple circumstance that everybody who works there is within walking distance of everyone else, in a tightly packed, close-grained, unruptured city fabric.

But who can say the planners were mis-

taken? Boston did thrive. It thrived to the extent that it became possible, eventually, to think about putting the Artery underground. The Artery in Boston is like the catalyst in a chemical reaction. Once the reaction is complete, you no longer need the catalyst. But if you don't begin with it, no reaction occurs.

Sometimes it's the task of one generation of planners to undo the work of the preceding generation, though neither is in the wrong.

In the "public" spaces of the theme park or shopping mall, speech itself is restricted. There are no demonstrations in Disneyland. The effort to reclaim the city is the struggle of democracy itself. — Michael Sorkin

VII

OUR OWN TIME

As BOSTON DECLINED in the 1950s, it was feared the center would die. The government began a policy of carpet bombing the city, wiping out whole neighborhoods such as the West End and replacing them with a combination of much bigger buildings and much wider open spaces. All the lessons of good cityscape, so obvious in Boston, one might suppose, seemed forgotten. The primacy of the walkable street, the essential organizing unit of the city, was lost, replaced again and again by a disorder of vacuous plazas and arteries.

Then came a beginning of healing, of knitting Boston back together over the wounds. Plans were made to bury the Central Artery. An interstate highway was stopped and its right of way converted for parkland and trains. And architects outgrew their teenage fear of looking old-fashioned, although the good ones found plenty of ways to be inventive — even subversive — without insulting the past. The city's geography was still changing, and in the same old ways. It was calculated that a mass of earth equal to a football field two miles high would be removed to create a tunnel for the new underground Central Artery. Spectacle Island, a modest dot of green, was selected to receive this latest Boston extravagance of harbor landfill.

The predicted landmass of Boston circa 2010, showing the filling of Spectacle Island

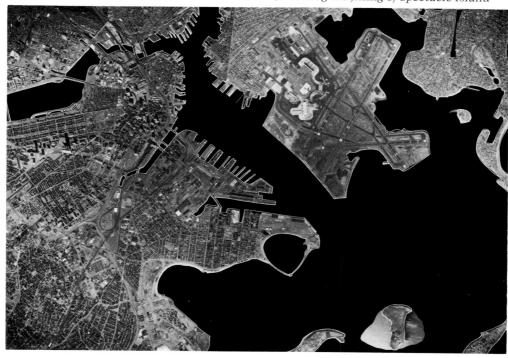

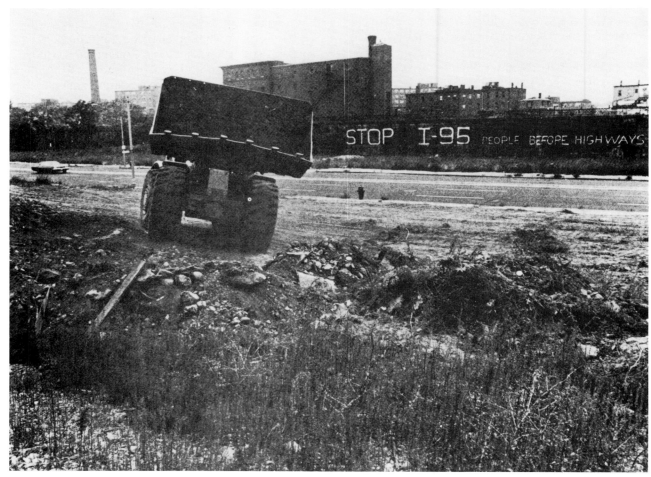

Killing the Interstate

I T WAS AS IF GOD'S LAWN MOWER were to cut a path through Boston.

In the late 1960s, a swath of land four miles long was cleared for a new interstate highway. The swath, called the Southwest Corridor, extended all the way from the Back Bay out through the South End and Roxbury to Jamaica Plain and beyond. A segment is shown in the older photo, where you can also see a significant piece of graffiti: "STOP I-95. PEOPLE BEFORE HIGHWAYS."

Amazingly enough, I-95 did get stopped. Bowing to citizen pressure, Governor Francis Sargent canceled it in 1972. But what to do with the cleared land?

There followed an act of political magic. As usual, Massachusetts politicians were prominent in Washington, including in this case Speaker of the House Thomas P. O'Neill. Half a billion dollars in federal money, earmarked for the interstate, was diverted to another purpose. The corridor became the setting for a park and a rapid transit line. In 1988 both the new Orange Line and Southwest Corridor Park opened.

The new photo, from the same viewpoint as the old, on Columbus Avenue, near what is now Roxbury Community College, shows a chunk of the park today. In the foreground are two of its creators: Anthony Pangaro (left), former director of the Southwest Corridor project, and Ken Kruckemeyer, a South End resident who helped shape the corridor as associate commissioner of the state Department of Public Works.

Corridor Park is a new kind of park, one that responds to the pluralistic society in which we live. Less of a whole than the great nineteenth-

century parks of Frederick Law Olmsted, it is instead a long, connected string of small, local parks and playgrounds, each serving the purposes of its immediate neighborhood. It was designed not by one grand planner but by three separate firms of landscape architects, all of whom worked closely with the park's future users in what turned out to be a model of democratic decision making. Perhaps, by analogy with Olmsted's Emerald Necklace (and bearing in mind the elitism of that phrase), we may think of Corridor Park as the Charm Bracelet.

You can use Corridor Park as a whole, by jogging or bicycling its length, as many do. Or you can use it piecemeal, by shooting baskets or eating a sandwich at the end of your own street. In the first use the park becomes the expression of a larger community, knitting and threading together the diverse neighborhoods it serves. In the second, it becomes the equally important expression of what is local and individual.

Corridor Park is thus a characteristically American place. It's like Commonwealth Avenue in Boston, that grand public boulevard made up of highly assertive private architectural gestures. It is like the Elm Street of any American town, where the vault of trees expresses the oneness of the community, while the varied shapes and colors of the houses behind those trees express the American insistence on individual expression. *E pluribus unum*, as the coins and dollars say: out of many, one.

He who would do good to another must do it in Minute Particulars. General Good is the plea of the scoundrel, hypocrite and flatterer.
— William Blake

A Sighting of the Michelin Man

A WASTELAND OF GRIM TOWERS and empty plazas, Boston's Prudential Center blights everything around it.

In these photos we're standing with our backs to the Pru, looking across Boylston Street at a ragtag strip of buildings that have been cursed by the Pru's presence. The economic boom that transformed other parts of the Back Bay in the 1970s and 80s never made it to this block. That's because a good commercial street needs two active sides, not one, and the Pru's side of Boylston is mostly empty space.

The only real change we see is the Ingalls Building at 855 Boylston, which arrived in 1985. It's an improvement. For one thing, it's tall enough for its place in the city. People often worry about buildings being too high, but they can also be too low. The short ones here don't make a firm enough edge for the wide street space, so the street becomes a formless sea of asphalt and loses its essential character as a corridor shaped and lined by buildings. It's interesting to reflect that in the 1860s, the original deeds for the Back Bay required a minimum height.

The Ingalls Building was designed by the Architects Collaborative of Cambridge. There's irony here. TAC was founded in the 1940s under the leadership of the German master Walter Gropius, who earlier founded the Bauhaus school in Germany. TAC did more than any other firm to establish modernism in Boston. But successful architects learn to roll with the punches. The Ingalls is prototypically post-modern.

It's post-modern in at least three ways. One, it revives a style of the past, appealing to our conventional associations without embarrassment. Two, it exhibits no wish to express with any honesty the manner of its construction

1964

(there's a steel frame under there somewhere). Three, it tries to fit into, rather than challenge, its context, accepting continuity rather than promising a brave new world.

The red brick walls, pale imitation stone trim, and bay windows give the Ingalls the look of a Boston bowfront house, but one that has been inflated to twice its volume. The Ingalls is to a normal house what the Michelin man is to a normal person. If there's a joke there, well, architectural jokes are typically post-modern. And in its attention to urbanism the Ingalls is also post-modern; unlike the Pru with its useless plazas, it fronts the sidewalk directly with retail storefronts.

The Pru, too, is moving with the times. Its owners are filling the worst of its dead plazas with new shops and offices. Arcades will thread the huge development, reconnecting the city streets the Pru now divides. If all goes well, the Pru may some day be a revitalizing agent for the very street frontage it now kills.

Surely things are not so desperate that American architects have nothing better to do than peddle lap dogs, foot warmers, and tea cozies to the Reaganite nouveau riche.
— James Marston Fitch

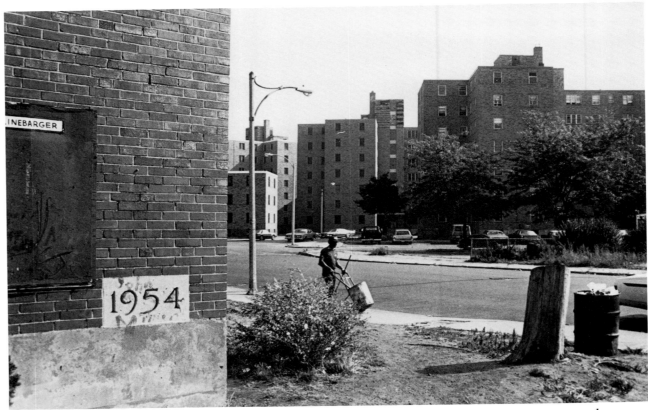

early 1970s

The Return of the Street

COLUMBIA POINT IN DORCHESTER is the site of a former garbage dump. In recent years it has often been a dump of another kind — a home of last resort for institutions nobody else wanted. The University of Massachusetts, the John F. Kennedy Library, and the state archives ended up here for no better reason. They stand like isolated forts on a vacant plain, each ignoring the others.

Columbia Point's most important inhabitant was once similarly isolated, but that has changed. The old low-income housing project, built in 1955, has recently been revamped as Harbor Point for a new, mixed-income population. The transformation is obvious in these photos.

By 1985 the project, like others of its generation, was a boarded-up, crime-ridden disaster. Only 350 families remained, camped out among 1,500 apartments in buildings that looked like yellow brick prisons standing in a compound paved with asphalt.

Then a new ownership team, including some tenants, borrowed money from the state and federal government and asked Boston architects Goody, Clancy and Associates to make the old project work. It reopened in 1989. The new photo shows some of the current residents.

The architects tore down eighteen structures, renovated nine, and (with Mintz Associates) built forty-six new town houses of clapboard or red brick. The idea was to replace the old bureaucratic monotony with the natural variety of an older neighborhood that has grown piecemeal over time.

Even more important, they laced the project with a new grid of streets, giving everybody a front door and an address — a simple feature that nurtures pride and identity. No longer need a tenant say, "I live in the project." Now it's "I live at 16 Maple Avenue." The new streets are planted with trees, and one is a mall, in imitation of Commonwealth Avenue. All terminate with a view of Boston Harbor, where there is soon to be a new park.

Harbor Point has 400 low-income and 900 market-rate apartments, a balance that has

worked well elsewhere. Since you can't tell from the outside which apartment is which, there's no stigma to living here. But Harbor Point isn't out of the woods yet. It's still cut off from the nourishment of the larger city. It needs more shopping and a better sense of connection to everything around it.

The history of this housing project proves a couple of things.

One, you can't solve the problems of the poor by tucking them away by themselves in a single-income ghetto. That is the planners' easy way out. It creates a critical mass of people with problems — like the critical mass of a nuclear reactor — and the predictable result is social fission.

Two, a neighborhood of streets and front doors works a lot better than a precinct of separate buildings standing around in empty space. Modernist architects, especially Le Corbusier, mounted a victorious attack on the whole idea of the city street. They substituted a new ideal of towers standing in parks served by freeways. They were wrong. Good cities are made of streets.

It's depressing to compare the recent history of Columbia Point with that of the Back Bay a century ago. People thought about the Back Bay for decades, planning every street and lot before the first brick was set. Columbia Point has never been planned. Except for the belated grid of the housing project, no one ever laid out a street pattern. Each new building came as a surprise, plopping down wherever it could find room. The result is chaos.

Columbia Point as a whole is a paradigm of the haphazard, wasteful, socially isolating manner in which we've been settling the American continent ever since World War II. Harbor Point, by contrast, is a deliberate reversion to more intelligent methods of the past. As such, it is a hope for the future. It proves once again that there is no such thing as a forward-looking or backward-looking idea. There are only good ideas and bad ones.

To dwell is to garden. — Martin Heidegger

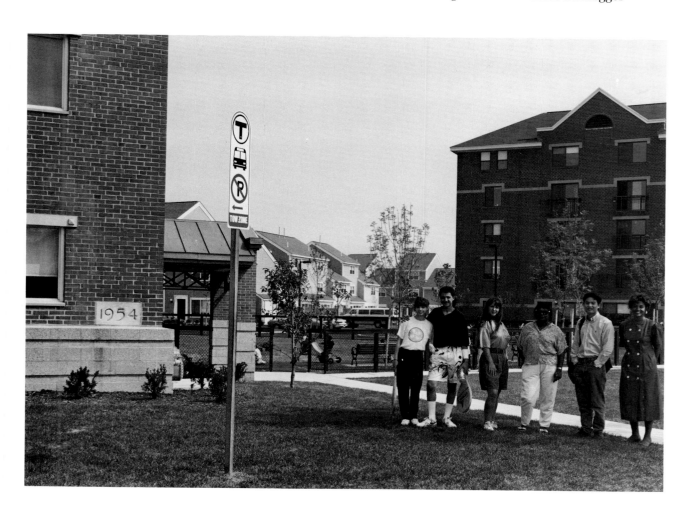

AFTERWORD

THIS BOOK IS BEING PUBLISHED in a decade, the 1990s, when the value of cities is once again being questioned.

We are told that cities have been made obsolete by electronic communications. At last, we are told, it will be possible for us to live and work anywhere we like. "Anywhere we like" in such formulations always means, implicitly, the village or the country.

So what else is new?

Seldom has the romance of America been thought to inhere in its cities. Many people came to this continent to escape from cities and everything cities stood for. They came to escape from order and hierarchy, from ruling classes, from the slums of poverty or oppression — to escape, even, from history itself, which for them was so often a history of degradation.

They came to a continent vast and unpeopled and still unformed. America was a landscape, not a cityscape, and a place apparently without a past. (Only recently have we begun to think of the Europeans not as discoverers but as invaders who erased a native American past.) Magic inhered in the mountains, the rivers, the plains, and the deserts of the great continent, not in the streets and squares of its raw new towns.

It isn't surprising that the central tradition of American thought, growing out of the Romantic movement of the late eighteenth and the nineteenth century, in such figures as Thomas Jefferson, Andrew Jackson, Ralph Waldo Emerson, Henry David Thoreau, Mark Twain, Frank Lloyd Wright, and Robert Frost, has been anti-urban to the point of bigotry. Free Americans were supposed to breathe free air in big spaces. Democracy throve on Main Street, not on Wall Street where the shysters cut their deals.

That tradition is still alive, even if the cowboy in his saddle has been replaced by the guy in the driver's seat of the eighteen-wheeler, who may come from Newark but who — like his heavenly counterpart, the astronaut — scrupulously cultivates a Texan twang when he picks up his CB radio.

Something else distorts our perception of cities. Most of the new arrivals in this country over the decades have lodged first in cities. And so the city has become, in the American imagination, the place where the foreigners live. It is the place where people have funny accents, worship strange gods, and probably can't be entirely trusted.

Scholars have shown, at too great length to need repeating, that even our government harbors such biases. It saps the city and nurtures the suburbs by means of enormous hidden subsidies. The wonder is not that American cities have problems but that they survive at all.

The 1990s may be the decade in which we find out whether the city is only an accident of history, doomed to disappear. We hope that won't prove true. Not, finally, because cities are so beautiful, among the greatest of all works of art. Nor because they employ the earth's resources so much more efficiently than other patterns of settlement. Nor because they keep us in touch with one another and with the past. We believe in all those qualities. But we want cities to survive for another reason.

Cities are *interesting.* Quite simply, cities are the most interesting places on earth. By far. They possess what some philosophers call "a surplus of signifier." A true city always signifies more than can ever be grasped by any one intelligence or by any one generation or by any one system of interpretation.

In that respect, cities resemble the great enduring classics of literature or music or painting. Like *King Lear,* a great city is elusive, plural, frustrating, mysterious, overlapping, never fully clear, able to be read in many ways.

And always interesting.

Our future, perhaps, is a planet of interstate highways, filled with people bouncing like pinballs around among fast-food outlets and amusement parks.

From that vision of hell, only the city can save us.

PHOTOGRAPH CREDITS

All of the photographs except those listed below were taken by Peter Vanderwarker.

INDEX